Cowboy Lingo

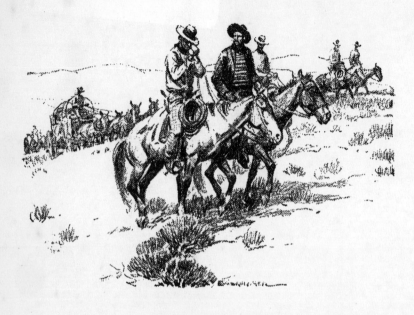

As this troop of cowboys rode over the range, it spread out,
dividing into small parties

Cowboy Lingo

Ramon F. Adams

ILLUSTRATIONS BY
NICK EGGENHOFER

WITH A FOREWORD BY
ELMER KELTON

Houghton Mifflin Company
BOSTON · NEW YORK

First Houghton Mifflin paperback edition 2000
Foreword copyright © 2000 by Elmer Kelton
Copyright © 1936 and © renewed 1964 by Ramon F. Adams

For information about permission to reproduce selections from
this book, write to Permissions, Houghton Mifflin Company,
215 Park Avenue South, New York, New York 10003.

Visit our Web site: www.houghtonmifflinbooks.com.

Library of Congress Cataloging-in-Publication Data

Adams, Ramon F. (Ramon Frederick), 1889–1976.
Cowboy lingo / Ramon F. Adams ; illustrations by Nick
Eggenhofer ; with a foreword by Elmer Kelton.
 p. cm.
Includes index.
ISBN 0-618-08349-9
1. Cowboy—Language. 2. English language—Dialects
—West (U.S.) 3. English language—West (U.S.)—Slang.
4. Americanisms—West (U.S.) I. Title.
PE3727.C6 A37 2000
427'.09—dc21 00-061321

Printed in the United States of America

QUM 10 9 8 7 6 5 4 3 2 1

A Different Western

———

Dedicated
to My Wife

CONTENTS

FOREWORD BY ELMER KELTON

If there was anything Ramon Adams did not know about Western subjects, at least he knew where to look it up. He was a prodigious student of the West and became one of the most frequently consulted authorities on its life and literature.

A quarter century after his death in 1976, antiquarian book dealers still cite his name and his comments about the merit and comparative rarity of books they offer. Collectors and students on the trail of specific information rely heavily on Adams's bibliographies. In that field, he was in a league with J. Frank Dobie and Jeff Dykes.

His interests were broad, but he immersed himself particularly in the range cattle industry and the gunfighters, both law and outlaw. His love of the cowboy life and its unique vernacular led to the first publication of *Cowboy Lingo* by Houghton Mifflin in 1936.

In this book, long out of print but still widely sought for its historical authenticity, Adams offers splendid details about specific aspects of the cowboy's work, his environment, his unwritten but generally accepted code of ethics, his utilitarian clothing and equipment. *Cowboy Lingo* delves into intricacies of ropes and roping, the roundup, brands and earmarks, the chuckwagon, trail driving, outlaws, and guns.

Cowboy speech fascinated Adams. He carried a notebook, jotting down words and phrases that struck him as colorful or especially pertinent to a given situation. In the book he wrote:

> The cowboy was not a highly educated man as a rule, but he never lacked for expression. Perhaps there was a pungency and directness about his speech that seemed novel and strange to conventional people, but no one could accuse him of being boresome. His vivid picturesqueness of phrase was as refreshing as it was unexpected. Never a garrulous person, he developed to a remarkable degree the faculty of expressing himself in a terse, crisp, clear-cut language of the range . . . He was of a strong young race which laid firm hands on language and squeezed the juice from it.

Some scholars today, particularly in urban areas, assume that the cowboy no longer exists, that the subjects Adams treated are relegated to the past. A few even argue that the cowboy never existed at all, at least in the sense embodied in the mythology which has grown up about him. They are wrong. The cowboy *was* real and *is* real. He is still at work on the ranges of the West, but as the author John Erickson has pointed out, it is hard to see him from the interstate.

It is true that his numbers have diminished as mechanization has lessened the need for so many hands. But so long as cattle graze the open range, the cowboy and his horse will remain necessary to their management.

The cowboy's lifestyle and many of his working methods have changed considerably since Adams wrote *Cowboy Lingo*. Today's average cowboy works on ranches where fencing has reduced pasture sizes, especially on private lands in Texas and the Southwest. He is likely to spend more time in a pickup truck than on horseback. He is likely to haul his horse in a

trailer to wherever there is work to be done, and he will haul it home when the work is finished.

On an occasional ranch the cowboy may ride the range on a four-wheeler or a motorbike, though this is still uncommon enough to arouse comment, often of the caustic sort.

Today's cowboy must know more than how to handle horses and cattle. He will on occasion find himself having to serve as a mechanic, a carpenter, and an electrician, as well as having to demonstrate at least a smattering of knowledge about animal nutrition, physiology, and genetics.

In general, the ranching industry has kept up with the times and technology. It has been said, with justification, that ranching methods changed more after World War II than in all the years from the Civil War to the 1940s. New technology has been embraced in areas ranging from range management to genetics, nutrition, and marketing. The cowboy has adapted to these incremental changes as they have come along.

Still, the basics of a cowboy's job remain much the same as in the time of his fathers and grandfathers, the men Adams knew and wrote about. The seasons come and go as they always did, and seasonal activities such as feeding, branding, and shipping are little changed. Winters are still cold and summers hot. The cowboy's clothing and equipment may evolve in minor ways, keeping up with current styles, but the basics are still there: the hat, the boots, the saddle, bridle, and catch rope. Their functions are the same as when drovers trailed southern herds to Kansas and points north.

The reader should bear in mind that cowboy vernacular and to some degree working methods vary regionally. They are not uniform across the West. Adams points out some of these differences but by no means all. The working cowboy of

the Southwest may dress a little differently from the buckaroo of the Great Basin and the Northwest. His methods of work in smaller fenced pastures of privately owned land will of necessity be different in some respects from those of the buckaroo on huge, unfenced, open ranges in those Western states where most of the land is federally owned.

Terminology varies regionally as well. Slang expressions common to the Texas cowboy may mean nothing to the Idaho buckaroo, and vice versa. Therefore, much of what Adams says must be accepted as general rather than specific.

When I was growing up on a West Texas ranch in the 1930s and 1940s, most of the cowboys I knew were also products of West Texas or, in a few cases, New Mexico. Many of the cowboy slang words and phrases cited by Adams are quite familiar to me. Others are not, yet I realize that they were and probably still are common elsewhere in the West.

Some of these regional differences are fading as ease of travel allows many cowboys to get around more and see how things are done in places far from home. Those who follow the rodeo circuit are especially likely to be thrown into the company of their counterparts from distant ranges. Rodeo-arena fashions in clothing and accouterments tend to set patterns for working cowboys everywhere.

Cowboy poetry gatherings, a relatively new development sparked by a phenomenally successful one in Elko, Nevada, a few years ago, are conducted in towns all over the West. Like rodeos, they are bringing together cowboys and enthusiasts from many different parts of the country. They may be contributing at least a bit to the amalgamation of cowboy speech and dress.

...

Though Adams was a native Texan, his upbringing would not seem to have pointed him in the direction of the cowboy. His early interests were in writing and music. Born in 1889 in Moscow, in the pine-woods country northeast of Houston, he moved with his family to Sherman in northeast Texas when he was thirteen. His father operated a jewelry business. Sherman was something of a cattle town at the time, and that may be where young Ramon first developed his strong interest in the subject.

He attended Austin College in Sherman and for a time edited the campus magazine, *Reville*. In addition he studied violin. He joined the University of Arkansas music department in 1912 and for two years taught violin, before moving to Chicago for further training. He eventually returned to Texas and headed the violin department at Wichita Falls College of Music, leading the orchestra in a local theater.

His musical career came to an abrupt end because of an accident all too common in those days: he broke his wrist while trying to crank a Model T Ford. He and his wife, the former Allie Jarman, opened a candy business in Dallas, which they expanded into a wholesale operation that continued until 1955.

Parallel with Adams's career in music was his passion for Western history and lore. He self-published a book, *Poems of the Canadian West*, in 1919. He sold a story to *Western Story Magazine* in 1923. *Cowboy Lingo* in 1936 was followed by *Western Words, a Dictionary of the Range, Cow Camp and Trail*, in 1944. Writers and students of Western subjects have long relied on this book for definitions of terms specific to the West.

In his foreword to *Western Words*, Adams wrote: "I want to

thank the host of sun-tanned, grin-wrinkled cowhands I have
met upon the range and the old-timers with whom I have
talked at cowmen's conventions throughout the West . . . They
are of the breed whose mention in a book would make them
as uncomfortable as a camel in the Klondike. To them I can
only say *muy gracias.* This volume is largely theirs, and I hope
it will serve as a monument to their picturesque speech."

With Homer Britzman, Adams cowrote *Charles M. Rus-
sell, the Cowboy Artist: A Biography,* in 1948. Russell by all odds
was the most honored of Western artists, at least among the
cattle people and Westerners who knew his subject matter
best.

The chuckwagon cook was one of the more picturesque
characters of cattle country. Often he was a stove-up cowboy
looking for a way to make a living without having to leave the
range and the way of life he knew. Adams told his story and
cited many wagon-camp recipes in *Come an' Get It: The Story
of the Old Cowboy Cook* (1952).

He used the pithy language of the cowboy in *The Old-
Time Cowhand* (1961) and again in *The Cowman Says It Salty*
(1971).

It was as a bibliographer, however, that Adams made the
most lasting impression on the Western literary scene. Five
of these are considered standard reference books by writers,
librarians, collectors, and students: *Six-Guns and Saddle
Leather* (1954, revised and greatly enlarged in 1969), *The Ram-
paging Herd* (1959), *Burrs Under the Saddle* (1964), *The Adams
One-Fifty* (1976), and *More Burrs Under the Saddle* (1979).

An avid collector, Adams did more than simply list books.
He collected them. He read them. He studied thousands of
them in libraries, both public and private, from California to
New York. He judged and commented on their historical va-

lidity and readability. He was highly sensitive to errors and outright falsehoods about such famous and infamous Western characters as the James brothers, Wild Bill Hickok, and Billy the Kid.

He once wrote of gunfighter and outlaw books in general: "After reading hundreds, I am like many another researcher before me; never would I have believed, before my investigations began, that so much false, inaccurate, and garbled history could have found its way into print."

Of *American Heroes, Myth and Reality*, by Marshall W. Fishwick, he wrote: "Has a chapter on Billy the Kid in which the author does some debunking of the legends and writers about the Kid. Yet he repeats the old tale about the judge condemning the Kid to be 'hanged by the neck until you are dead, dead, dead,' and the Kid's answer, 'And you go to hell, hell, hell.'" Adams eventually wrote *A Fitting Death for Billy the Kid* (1960), in which he cast aside much of the myth and presented the facts as nearly as he could determine them after eighty or so years.

Of *My Reminiscences As a Cowboy*, by Frank Harris, he made this crackling comment: "Full of inaccuracies, wild imagination, and . . . historically worthless," a sentiment with which J. Frank Dobie heartily agreed.

He could recognize and acknowledge merit too. Possibly the best cowboy autobiography ever written is *We Pointed Them North*, by E. C. (Teddy Blue) Abbott, as told to Helena Huntington Smith. Of that book, Adams wrote: "This is one of the best books in recent years depicting cowboy life, and although it was recorded by a woman, she was wise enough to leave in all the flavor and saltiness of the cowboy lingo. Too often an erudite editor spoils a work of this kind by making it conform to academic standards."

Other Adams books include *The Best of the American Cowboy* (1957), *From the Pecos to the Powder: A Cowboy's Autobiography*, with Bob Kennon (1965), *The Cowman and His Philosophy* (1967), *Wayne Gard, Historian of the West* (1970), *The Horse Wrangler and His Remuda* (1971), *The Language of the Railroader* (1977), and *The Cowboy Dictionary: The Chin Jaw Words and Whing-Ding Ways of the American West* (1993).

Adams was awarded an honorary doctorate by Austin College in Sherman in 1968. He was a member of the Texas Institute of Letters, the Western History Association, and Southwest Writers.

Equally at home in academic settings or at a roundup campfire, Ramon Adams regarded the history and culture of the American West, including the cowboy, to be as worthy of serious study as the history and culture of any other part of the world. His books of fact and folklore, along with his extensive bibliographies, have been invaluable to students, writers like myself, and others who share that view and his love for the West.

INTRODUCTION

The purpose of this little volume is to help preserve one of the most distinguishing traits of the cowboy and one that has never been touched upon with any degree of completeness. His songs have been compiled and preserved very ably; his lore has been recorded with credible care; volumes have been written of his character, his work and woolliness; and reams have been published upon the romance of his life. Every year brings forth more printed volumes concerning this most picturesque of all American characters, yet with all this printer's ink no one has ventured to issue a volume upon his speech, the most striking characteristic of a remarkable type.

He was—and is—picturesque, not only in clothing, in manner and in mode of life, but in speech, and we owe him a debt of gratitude for many things, not the least of which is his contribution to our language. Any manner of life with a rule and flavor of its own strong enough to put a new dress on a man's body will put new speech in his mouth, and an idiom derived from the stress of his life was soon spoken by the cowboy.

I first became interested in the cowboy's "lingo" many years ago by being vividly impressed with his strikingly apt and vigorous figures of speech when privileged to listen to his con-

versation. From then until the present my pencil and note-book have been kept busy. The volume of the notes has grown until it appears selfish not to pass them on to others who might be interested, and at the same time preserve this one untouched feature of a unique personality.

I make no claim that the ground has been covered completely, for with every conversation new metaphors are born, but I do hope that I am able to give the reader a deeper understanding of the man through his speech. Feeling his carefree good-humor we, in turn, forget the worry and strain of our own hectic existence. Unlike us, to him money meant nothing. He would work hard for thirty dollars a month, then spend it all with his characteristic free-heartedness in an hour of relaxation. All he was seriously concerned about was plenty to eat, a good horse to ride, a saddle for his throne, and he was King.

I make no claims to literary ability. If my effort to preserve to posterity this unrecorded phase of the cowboy's individuality has been of interest and of value to any one reader, I shall feel amply repaid for my endeavor. I hope, however, the book will find a permanent place on the shelf with his other published lore.

THE AUTHOR

→ I ←
...............................

THE COWBOY
AND HIS LINGO

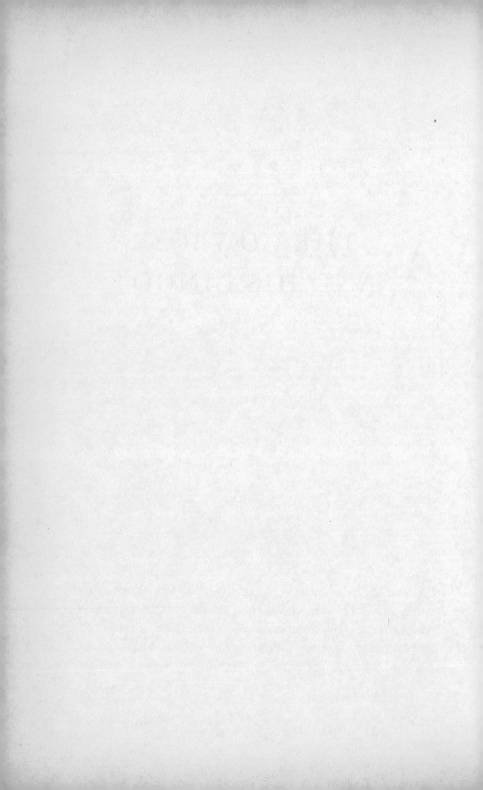

America has never been without the tonic influence of frontier life. The cattleman and his cowboys have been the men who most persistently pushed the frontier farther west preparing the way for civilization. With the exception of the development and influence of his language, every phase of his life, his customs, and his hardships have been recorded. Always in the presence of new features of life and divorced as he was obliged to be from the older traditions of a settled life, in speech, as in other activities, he broke through the restraint imposed by established usage and created a language of his own. The spirit of a creative activity which brought under human control the natural resources of a new country served also to stimulate activity in the creation of fresh word and phrase.

There is always one thing about a man that stamps him for what he is, and that is his speech. The basic reason for the difference between the cowboy and other men rests on an individual liberty, a lawlessness, an accepting of his own standards alone. He was unconscious of his lack of education when among men of higher advantages because he possessed absolute self-poise and sufficiency. His general impatience of rule and restraint, his democratic enmity to all authority, his

extravagant and often grotesque humor, his extraordinary capacity for metaphor—these were indicative of the spirit of the West, and from such qualities its language was nourished.

The cowboy was usually soft-spoken and reserved of manner with strangers, so much so that he gained the reputation of being taciturn and reticent by nature, a conclusion which was erroneous. This reserve fell away in the association of the cowboys with each other, and, when a number of them gathered together, they were boisterous enough, and in their stories, sallies, and railleries there was much coarseness of language. The cowboy did not "loosen up" until among his own kind, but then he could talk aimlessly and volubly, finding plenty to keep the conversation from lagging. In the range yarns he told he usually included detail that served only to make the stories longer. It is true that the cowboy who was "mouthy" was not usually held in high repute in a cow-camp, but "mouthy" in this respect referred to a man who could talk of nothing of interest or of value, but "just run off at the mouth to hear his head rattle."

The cowboy was not a highly educated man as a rule, but he never lacked for expression. Perhaps there was a pungency and directness about his speech that seemed novel and strange to conventional people, but no one could accuse him of being boresome. His vivid picturesqueness of phrase was as refreshing as it was unexpected. Never a garrulous person, he developed to a remarkable degree the faculty of expressing himself in a terse, crisp, clear-cut language of the range, and when he spoke, his hearers had no good reason to misunderstand his meaning.

His peculiar directness of phrase meant freedom from restraint, either of society or convention. He respected neither the dictionary nor usage, but employed his words in the man-

ner that best suited him, and arranged them in the sequence that best expressed his idea, untrammeled by tradition. He was of a strong young race which laid firm hands on language and squeezed the juice from it.

Like all creators, he not only built, but borrowed for his own wherever he found it. He borrowed from the Mexican, the French, and the Indian, and thus at the top and bottom of our map French and Spanish trickled across the frontier, and with English melted into two separate combinations which were wholly distinct, some of which remained near the spot where they were moulded, while other compounds, having the same northern and southern starting-points, drifted far and wide and became established in the cowpuncher's dialect over his whole country.

With a keen sense of humor that took unexpected slants, and an avoidance of unnecessary words, the cowboy seemed to express himself more freely with a slang which strengthened rather than weakened his speech. His utterances were filled with it as the reader will see in subsequent chapters. Slang, since the foundation of the United States, has been the natural expression of its youth, and the cowboy, whatever his years, was at heart always a youth. Many of his terms, however, though slangy in origin, were not intended to be slangy in usage, and they functioned seriously as an integral part of the West's legitimate English.

The more limited and impoverished a person's vocabulary, the greater, as a rule, is his dependence on slang as a medium of expression. This was the case with the cowboy. The early followers of this vocation had little opportunity for schooling and hence resorted to slang for the expression of their thoughts. They left behind a rich mine of vivid expressions that will be used as long as men handle cattle. The examples

of his strikingly picturesque metaphor in slang are legion. No metaphor was too remote for him, no allusion too subtle.

Picturesque as are many languages of the world, there is none more distinctive, more individual, than the "lingo" of the American cowboy. There is nothing more appealing than the jargon of this individual when he is among his own kind.

In dealing with the cowboy's "lingo," mention should be made of his profanity. His blasphemy, however, appalling as it is, had its foundation on arbitrarily created custom, and not from any wish to be wicked. Many of his expressions, while sacrilegious on the tongues of others, were but slang when used by him. The common use of the name of the Deity was with no intention of reviling God. All through the West the word "damn" descended from the pinnacle of an oath to the lowly estate of a mere adjective unless circumstances and manner of delivery evidenced a contrary intent. Words could be an insult or a term of affection, according to the tone in which they were spoken. Therefore, men frequently were endearingly addressed with seeming curses and apparently scourging epithets.

His swearing was, to no small extent, a purely conventional exhibition of a very human and quite boylike desire to "blow off steam," but it became so habitual that, though most cowboys endeavored to refrain from it when in the presence of decent women, few of them were able long to "keep the lid on their can of cuss-words," and they admitted that they "spoke a language that wasn't learned at their mother's knee."

To observe a riot of imagination turned loose with the bridle off, one must hear a burst of anger on the part of one of these men. It would be mostly unprintable, but you would get an entirely new idea of what profanity means. The most obscure, remote, and unheard-of conceptions would be dragged

forth from earth, heaven, and hell, and linked together in a sequence so original, so gaudy, and so utterly blasphemous that you would gasp and be stricken with admiration.

The cowboy did not depend upon the commonplace, shopworn terms of the town plodder. It should be said, however, that it was an uncommon thing for him to burst forth with his full powers without fair justification. For this purpose he had a most astonishing vocabulary, and in dealing with a detestable range-horse, or in striving to make a half-wild, long-horned, obstinate steer behave himself and go the way he should, nothing but its vigorous employment appeared to fit the circumstances of the case. For use upon such occasions, and also upon sundry others, every well-equipped cowboy of the old times had acquired and kept at his command what appeared to be the entire resources of the Anglo-Saxon speech that could be worked into phrases of denunciation, and when he intermingled with them an assortment of picturesque and glowing Spanish expletives and terms of opprobrium, as he frequently did, the earth trembled. Profanity sat naturally and easily upon his tongue and without it his speech would have been less effectual.

Powerful expletives demand courage and inventiveness. The cowboy possessed both these qualities. His curses seemed to smoke and sizzle and scorch the atmosphere. They seemed to emit odors, like exploded gunpowder. Sometimes his words were of no known language; he invented them for his own devices, but there was no misunderstanding their meaning. Yet his list of unprintable words did not need to be large, for he was an artist at constantly varying his combinations and putting tonal force into them. Some men devoted considerable thought to the invention of new and ingenious combinations of sacrilegious expressions.

To specialized phrases of this sort the admiring public ac-
corded a sort of copyright, so that the inventor was allowed to
monopolize for a time both the use of his productions and
the praise that they evoked. These individual creations were
known as "private cuss-words," and the voicing of such were,
under tense conditions, a danger signal or a challenge.

Taken all in all there was an Homeric quality about the
cowboy's profanity and vulgarity that pleased rather than re-
pulsed, but which polite society is not quite willing to hear.
The broad sky under which he slept, the limitless plains over
which he rode, the big, open, free life he lived near to Na-
ture's breast, taught him simplicity and directness. He spoke
out plainly the impulses of his heart.

He used profanity as a healthful exercise, as a tonic for irri-
tated nerves, and was therefore ordinarily in a good humor so
that the strength of his "cuss-words" was usually spoiled by a
good-sized grin.

⇥ II ⇤

THE RANCH

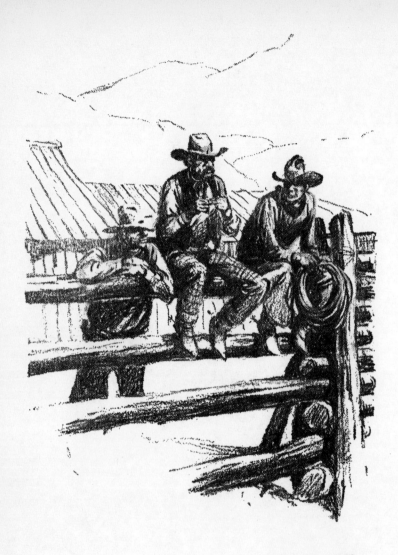

*The top rail of the main corral was referred to as
the "op'ra house"*

The first impulse of the pioneer cattleman who had entered a virgin district with his herd, and established his headquarters there, was mentally to claim everything within sight and for a long distance beyond. But when the second one appeared with his stock, the two would divide the district, and each keep on his side of the division line as agreed upon. There was nothing to prevent their appropriating the country in this manner and arbitrarily defining the boundaries of their respective ranges, and with this practice there developed the theory of "range-rights"—that is, of a man's right to his range in consequence of priority of occupation and continuous possession—although none asserted actual ownership of the range-land, nor did any of them really own as much as a square yard of it. Those were the days spoken of as "free-range," "free-grass," or "open-range" days. The latter term, however, might mean several different things, according to the speaker's use of the term. It might mean a certain locality that was "open" as distinguished from nearby land that had been closed. Or it might mean the whole cow-country, or even the people inhabiting it.

"Ranch" is an alien word that has been engrafted into our language through the operations of Western livestock men,

and is a simpler form of the Spanish-American *rancho,* which means a farm, but particularly one devoted to the breeding and rearing of cattle or stock, and also a cabin or a hut, or a collection of them, in which the ranchmen may live. With his characteristic disposition to make the most of everything, the Westerner employed "ranch" as a verb as well as a noun; as in "ranching," and "to ranch." The Spanish *hacienda,* meaning a plantation, ranch, or landed estate, was sometimes used in the Southwest.

The "range" is to be distinguished from the "ranch." "Range" was the open country, while "ranch" implied a fenced range. The distinction was not always clear. Cattlemen referred to the grass lands as the "range" and to their occupation as "ranching."

Range custom also restricted the term "rancher" to members of the proprietor class, but "ranchmen" included employees as well as employers. *Rancheros,* the Mexican Border's synonym for ranchmen, received a like differentiation.

As an employee the rider was a "cowboy" or "cowpuncher," no matter if his charges were cows or horses, there being no such term as "horse-boy" or "horse puncher." If he became a ranch-owner, he lost those titles and became a "rancher." If he raised cattle, he was either a "cowman," "cattleman," or "cattle man," but if he raised only horses, he was a "horse man." "Cattleman" and "cattle man" were identical, but "horse man" was a man who raised horses, and "horseman" was either a mounted person or one versed in horsemanship.

In selecting a ranch site the ranchman's main consideration was locating near "a piece of water" and establishing his "water-rights." In the beginning there was no thought of securing water from wells or of impounding it in large dirt

ponds called "tanks." He usually established his "camp" along some stream, occupying either or both banks.

The pioneer ranch outfits as to buildings were rather primitive affairs. At the outset almost anything that could be made to serve the purpose was considered good enough. Where timber was available, a roughly built house of unhewn logs with a "dirt roof" was the quickest and easiest building of a permanent character to construct, but many a man who began business in a small way got through the first year or two in a "lean-to shack" or a "dug-out." In the crudeness of conditions he might not have had either a lamp or candle. If such was the case, he invented a light by filling a tin cup with bacon grease into which was placed a twisted-rag wick. This he called a "bitch." As he prospered, other buildings were added and perhaps his headquarters were rebuilt with style or enlarged.

The ranch, together with its buildings, cattle, and employees, was spoken of as the "spread," "layout," or "outfit," though the latter word had divers meanings. It variously signified, according to its context, the combined people engaged in any one enterprise or living in any one establishment, a party of people traveling together, or the physical belongings of any person or group of persons.

The word "lay" had rather a broad application. Not only might it refer to the general environment of a ranch as a "good lay" or a "tough lay," but a chance throw with a rope might be called a "lay," or if a stranger came along with no bed in which to sleep, one cowboy might, in the way of asking him to share his bed, say, "There's the lay, turn in."

The various buildings on the ranch had their particular slang names. The main house, or house of the owner, was

known as the "white house" (its usual color, if painted), the "big house," "Bull's mansh," or "headquarters." The "bunk-house" was equally well known as the "dog-house," "dice-house," "dump," "shack," or "dive," while the "cook-shack," if it was a separate building, was spoken of as the "mess-house," "grub-house," "feed-trough," "feed-bag," "nose-bag," or "swallow-an'-git-out trough."

One of the important institutions of the ranch was the "corral." This was a pen circular in form and built of stout horizontal wooden rails which were supported by posts set firmly in the ground. The rails were lashed to the posts with green rawhide, which contracted when they dried and made the entire structure as rigid and strong as though made of iron. The corrals were made circular that there might be no corners into which animals might dodge, or into which an entering herd might crowd a beast to its physical injury. They were often called a "round pen" in Texas. These corrals were bare except for a vertical, round timber set firmly in the ground at the center of the enclosure and known as the "snubbing-post." A fence on each side of a corral entrance, which flared out for many feet to shunt the edges of the en-tering herd into the pen, was known as a "wing fence." A small "corral" used for branding was the "crowding-pen."

The narrow, boarded passage which usually connected one corral with another, and which was used for branding ma-turer cattle, was called a "branding-chute," "squeezer," or "snappin' turtle."

A corral used for capturing wild horses was a "trap corral." The gate opened easily inward and closed behind so that the animal could not escape, and, of necessity, was located far from the headquarters of the ranch.

The top rail of the main corral was referred to as the "op'ra

house" because it was the favorite seat of the cowboys in watching another ride a bronc within the enclosure. These spectators were said to be "watchin' the op'ra" or "ridin' the fence."

The hitching-post, or rack, in front of the ranch-house was called a "hitchin'-bar" or "snortin'-post."

Some ranches had "feed-racks" in a "feed-lot," a small enclosure that was generally connected with a corral. Others had "stack-yards" where hay was stacked for the winter feeding of cattle and horses. Some of the smaller ranches which did not have barns perhaps had a number of "straw-sheds," a winter shelter made of posts and covered with hay. The buildings and corrals were usually protected against winter winds and snowstorms by "windbreaks," one or more rows of trees, a tall fence arranged on the windward side, or by being built near the rise of a natural barrier.

A pasture of very few acres at a permanent camp, usually without water and with the grass used up, into which horses were thrown overnight to avoid catching in the morning, was known as a "pony pasture" or "starve-out." A "bronc stall" was a narrow enclosure where a wild horse could be tied inside with just enough room for him to stand. Once a horse was in such a place, he could do nothing but snort, and a man's hand could be placed on him without fear of getting bitten or kicked. It was a gentling place for bad horses and used at many ranches, especially where many horses were broken to work in harness. The cowboy, however, seldom used such a contrivance, but did his gentling in the middle of a bare corral or wherever he happened to be.

Upon the larger ranches in the old days there were established "line camps" or "sign camps." Cowboys were stationed at these outpost cabins to "ride line" or "ride sign," which

meant to turn back cattle straying from the "home range," follow the tracks of those which they missed, watch for "rustlers," "tail-up" cattle during storms, pull them from "bog-holes," and do everything else within their power for the protection of their employer's interests. The cabin in which they stayed during this time was known as the "shack," "hooden," "Jones's place," or "boar's nest," taking the latter name because its occupant was a man more interested in his duties as a cowhand than in culinary or housekeeping art.

Fences built by ranchmen near outlying boundaries of their range were "drift fences." Experience taught them that in severe winters these proved to be deathtraps for cattle.

A sled made of the fork of a tree and supported by standards as used upon some ranches was called a "lizard." A "go-devil" was a taut wire which stretched from the top of the bank of a stream to an anchorage in midstream and carried a traveling bucket for the water supply. A solid wall of gravel and mortar was known as a "grout" to the cowboy.

To put things into an orderly condition was to "shape up," and to enter into a partnership was spoken of as "throwing in" with another.

A cattleman with small holdings was a "little feller," and his ranch was spoken of as a "one-hoss outfit," while his cattle were called a "cow-pen herd." One who "packed" his commissary in a sack upon the back of a mule, or pack-horse, was a "greasy-sack outfit," and in a section where it was the custom to use tents, an outfit that did not do so was spoken of as a "pot-rack outfit."

Selling a ranch by the books, commonly resorted to in the early days, sometimes much to the profit of the seller, was known as selling by "book count." "The books don't freeze" became a byword in the Northwest during the boom days

when Eastern and foreign capitalists were so eager to buy cattle interests. "Range delivery" meant that the buyer, after inspection of the seller's ranch records, and with due regard to his reputation for veracity, paid for what the seller purported to own, and then rode out and tried to find it.

The mysterious way news traveled on the frontier was known as the "grapevine telegraph."

To be "square" and "onto his business" had a very broad meaning on the open range. A man entitled to such testimonials to his worth had to possess the qualities of unflinching courage, of daring, and of self-reliance; and with these he had to be as ready and willing to "stand by" a brother cowman as to do his duty efficiently in everything that might happen to come up in the work of the day. To say of a man that he was "square" was to pay him the highest compliment possible.

No matter how rude and primitive in appearance the ranch-house, nor if it seemed to lack every means of convenience and comfort, its hospitality was there. Its doors were lockless and swung open at the touch of the hand. The wayfarer, whoever or whatever he might be, was welcome to shelter and food. He might go on his way next morning or next week; it was all the same. He knew when he was ready to leave. No questions were asked. When the time came for going, he mounted his horse and rode away. If there were any farewell words, they were few and not of the "thanking" kind. "Thanks" were not "good form," but were likely to be irritating. The silent good-bye of a wave of the hand by host and guest was preferable. An offer to pay by a guest was a grave offense and brought upon him the scorn and contempt of every man on the ranch.

If the owner was away from home, it was no reason why a hungry man or horse should not be fed. It was far to the next

ranch. All felt free to help themselves. The result of this necessity was an unwritten code forbidding the disturbing or carrying away of anything, unless it be sufficient food to last the guest until he could reach the next ranch. You were welcome at all times to food, shelter, and horse-feed.

No rider ever approached a rancher's dwelling, if the latter was at home, without receiving such invitations as, "Light an' line yo' flue with chuck," "Crawl off an' feed yo' tapeworm," "Climb down an' eat a bean," "Get off an' rest yo' hat," or, "Fall off an' cool yo' saddle." If the guest happened to be in a wagon, it was, "Drop yo' traces an' rest awhile."

To one unacquainted with ranch-life, it might appear to be one of dreary monotony, but to the cowboy it was a life of many activities and of much charm. This charm, in a large measure, came from the freedom and the occasional exciting episodes, but most of all from the vigorous good health that went hand in hand with it in the pure and exhilarating air of the plains.

✦ III ✦

THE COWBOY
AND HIS DUTIES

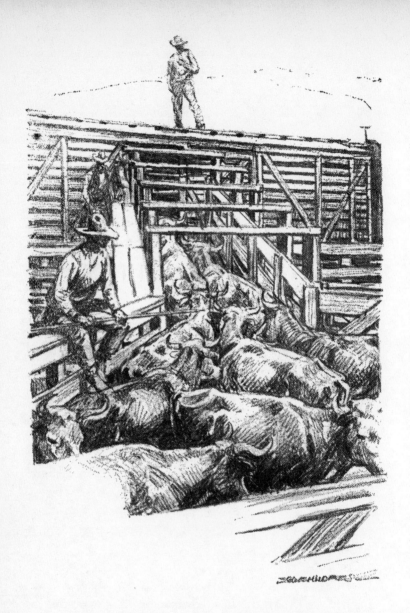

*Originally the word "cowpuncher" applied only to the
chaperons of a shipment of cattle*

A good cowhand had to be much more than a good roper and rider. He had various other duties to perform and he had a language for both the performer of this special duty and for the duty itself.

To begin with, the owner himself had divers titles, such as "presidente," "ramrod" or "rod," "big auger," "old man" or "caporal." The foreman was the "top screw," "straw boss," and "cock-a-doodle-doo." The word "foreman" was rarely used by cowboys, the word "range boss" being the most common term, or they spoke of him as the one "running the outfit." A "boot-black cowpuncher" was a man who came from the East to go into the cattle business to "raise some T-bone steaks" for what money there was in it, and called thus by the old-time cowman, while a "buggy boss" was an Eastern owner who rode around in a buggy on his inspection tour because he did not ride horseback well.

Originally the word "cowpuncher" applied only to the chaperons of a shipment of cattle. In a true sense a "cowpuncher" might be the best cowman in the country or he might be a man who had never straddled a horse, but had been hired for this special job. The word was a misnomer for the cowboy, though it came into general use and was usually

shortened to "puncher." The "prod-pole" was the symbol of his office. This instrument was a pole about six feet long, with a steel spike on the end and with a heavy handle. It was used to prod cattle into stock-cars. It was also equipped with a flat-headed screw driven into it near the business end and extending out a short distance at right angles from the pole. When a "down steer" refused to respond to the numerous jabs and swearing, the end of the pole with the attached screw was then engaged with the matted end of his tail, and by sundry twists, turns, and pulls on the pole a severe strain was applied to this very sensitive appendage. Cowboys who accompanied a shipment of cattle were also known as "bull nurses."

While "punching" became the accepted term for herding cattle, allowing the puncher either to "punch" or "herd" them, colloquial English would not let him "punch" horses, but made him speak exclusively of "herding" them.

"Buckaroo" was a term used in the Northwest for cowboy. The terms "baquero," "buckhara," and "buckayro," each a perversion of either the Spanish *vaquero,* or the Spanish *boyero,* were also used. *Vaquero* was from *vaca,* meaning cow, and was originally applied to Spanish and Mexican cowboys; the term *caballero,* meaning horseman, was also used. The cowboy was known, too, by such slang names as "ranahan" (which really referred to a top hand), "saddle-warmer," "saddle-slicker," "saddle-stiff," "leather-pounder," "cow-poke," "cow-prod," or "waddie," but the most common term used in the cattle country was the simple title of "cow-hand" or "hand." A "pure" was one loyal to his employer, but such a person was held in contempt by the rustler and was called by him such names as "sheep-dipper," "saint," "pliersman," and "bucket-man." A "big scissor-bill" was one who did not do his work well, and a

"pumpkin-roller" was the name given to a grumbler or agitator; they were also called "freaks," the cowboy, being such an uncomplaining and loyal soul by nature, felt that such a person did not belong to the calling. A "hill-billy cowboy" was one working for an outfit that ranged pretty well up in the sticks. The cowboy expert at running cattle in the brush country, "where the brush was so thick a bird couldn't fly through and snakes had to climb to see out," was known as a "brush-hand," "brush-popper," "brush-thumper," "brush-whacker," "brush-buster," or "limb-skinner."

If the cowboy's immediate special duty was to inspect and repair fences, he was known as the "fencer" or "fence-rider," and was said to be "ridin' the fence." A "fence-wagon" was the vehicle used to haul the tools and material for building or repairing the fences. A "fence-stretcher" was a tool for pulling the fence wire tightly from post to post, or by means of a roll of wire attached to a wagon which stretched the wire by its progression. If the special work of the cowboy was to keep the windmills in repair, he was the "mill-rider," "miller," or "windmiller." If he fed cattle in the winter by throwing hay from the "stacks," he was a "feeder" or "hay-shoveler." The term "feeder" was also applied to one, generally a farmer in the "corn belt," who purchased range cattle to fatten them for the market.

When his duties commissioned him to roam over a territory containing "bog-holes" or "pot-holes" and pull mired cattle from such pitfalls, the cowhand was, during that time, known as a "bog-rider" or "pot-hole rider." If these treacherous traps were at a distance from "headquarters," he usually established a temporary camp known as a "bog-camp." The puncher who represented his brand at an outside ranch on a round-up was a "rep," "strayman," or "outside man." When

one was delegated to visit ranches, sometimes as far as fifty or more miles away, and pick up any stray stock branded with his employer's brand found anywhere, he was called a "renegade rider." He would take his gather to the home ranch as often as possible, change horses, and go again.

"Line-riders" were men who patrolled a prescribed boundary to look after the interests of their employer. These men were interchangeably called "line-riders" or "outriders," though, strictly speaking, a "line-rider" had a regular beat while an "outrider" was commissioned to ride anywhere.

Many cowboys became as well versed in "sign" lore as the early plainsmen, the traders and trappers, had to be. All manner of tracks, trails, and marks were to them data from which to draw conclusions; some peculiar movement of an animal indicated the presence of some other animal in the neighborhood; by the course and even the "feel" of the wind they forecast changes in the weather; a broken limb of a tree, a crushed weed, the débris around a camping-place, the flight of a buzzard or other birds, were to experienced cowboys what signboards and advertisements are to dwellers in settled communities.

"Riding sign" was the act of riding the range to follow animals which had strayed too far afield and turning them back, or rescuing beasts from "bog-holes," turning them away from loco patches, and doing anything else to protect the employer's interest. A great deal of the excellence of the early cowboy depended upon his ability as a "tracker" or in "readin' sign," and he took much pride in this talent. A "blind trail" was one with indistinct markings and sign, where perhaps the man or animal being tracked "didn't leave enough tracks to trip an ant"; a "cold trail" was the vernacular for old markings in following a trail. To "cut for sign" was to examine the

ground for tracks and droppings, the two signs. A "plain trail" was one with clearly visible sign in trailing, and "slidin' the groove" was following a trail that was so clearly blazoned that it could not be lost. A trail just traversed, or to go back over such a trail, was to "back-trail."

It was said of a good tracker that he "had a nose so keen he could track a bear through runnin' water," "could follow a wood-tick on solid rock in the dark o' the moon," or "could track bees in a blizzard"; but if he failed to acquire a goodly amount of this ability, it was said of him that he "couldn't find a calf with a bell on in a corral," "couldn't find a baseball in a tomato can," "couldn't track an elephant in three feet of fresh snow," "couldn't follow a load of loose hay across a forty-acre field of snow," or "couldn't track a wagon through a bog-hole."

The "horse-wrangler" was usually a boy, or, in cowboy language, a "button," "doorknob," or a "fryin' size." The word "wrangler" was a corruption of the Spanish *caverango*, meaning a hostler. The day "wrangler" was a "wrangatang," "horse-pestler," "horse-rustler," or "jingler," and the "night-herder" was called a "night-hawk"—one of those fellows who claimed he "swapped his bed for a lantern." Though the latter's duties —keeping the saddle horses from straying too far away— were identical with those of the day wrangler, colloquial usage caused the day man to "wrangle" horses, and the "night-hawk" to "herd" them. This same usage made men wrangle the horses, and not wrangle *with* them. During the moving of camp on round-up, when it was the duty of the "night-hawk" to drive the "hoodlum wagon," he became known as the "hood." Occasionally near the Southern border the Mexican name of *remudero* was used for "wrangler."

Usually the wrangler's job was considered the most menial position in cow work. He had to help the cook gather wood

and "hook up" his teams. His most important duty was to "loose-herd" the *remuda* where the grass grew best until it was needed at the round-up grounds for a change of mounts, which was often three or four times daily. In spite of its unpopularity with real cowhands, the position of horse-wrangler was an important one, and one at which many of the "top riders" served their apprenticeship.

"Tenderfoots" was a name originally applied to imported cattle, but later was attached to human beings new to the country; both cattle and humans were also called "pilgrims." The term "greener," "juniper," and "shorthorn" were also applied to humans. An "Arbuckle" was a green hand, so called on the assumption that the boss had sent off Arbuckle premium stamps from the popular package coffee to pay for his extraordinary services; a green hand was also often called a "lent," while a cotton-picker was a "lent-back." A "chuck-eater" was a man from the East who came to learn ranch work, and perhaps everything he did "gave him away like a shirt full o' fleas." If he could not "ketch on" to the work required of him, he was a "knothead." A tenderfoot in "custom-made" cowboy regalia and devoid of range experience was a "mail-order cowboy." A gaudy tenderfoot was said to be a "swivel dude."

The term "laning" or "laning a cow to hell" is expressive of the action of an untrained helper. Through inexperience and all-around dumbness he got on the opposite side to assist you, forming a lane that kept the animal from turning. A man of experience came up from behind and on the same side the party he was assisting was on. A man old in the ways of the West was sometimes called a "rawhide," and was said to be "bone-seasoned" or "alkalied," the latter term meaning that he was acclimated to the country.

The appellation of "chuck-line rider" was applied to any-one who was out of a job and riding through the country. Any worthy cowpuncher may be forced to "ride chuck-line" at certain seasons, but the professional "chuck-line rider" was just a plain "range bum" or "saddle tramp" and was despised by all cowboys. He was one who took advantage of the coun-try's hospitality and stayed as long as he dared wherever there was not work for him to do and the meals were free and regu-lar. The "chuck-line rider" was also sometimes said to be "ridin' the bag-line."

A "hazer" was one whose duty it was to assist the "buster" to break a horse. His business was to terrorize the horse by yelling, waving his hat, and pounding the brute with a quirt. He was also used, especially when the horse was broken out-side the corral, to keep the animal turned so that his bucking would not take him too far away. The "pick-up man" was a horseman who stood by ready to take the horse being ridden by a contestant in a rodeo at the judge's signal that the ride was over.

One duty of the cowboy at certain seasons was the plowing of "fire-guards." These were made by plowing two parallel sets of furrows, some fifty yards apart with four furrows to each set. The grass between the sets was purposely burned by men who were trailed by water-laden wagons. "Back-fire" was an-other term used in fighting prairie fires and meant starting a new fire in front of the one to be fought. Along the zone se-lected for the "back-fire," a horseman trailed a bundle of burning fagots, or a rope soaked in kerosene, and the flames thus started were held in check on their homeward side by straddling them, or beating them out with wet gunnysacks, allowing the side toward the main fire to burn until it met the oncoming one and they burned themselves out.

A *corrida* or "cow crowd" was an outfit, or unit of cowboys. In later days when many of the ranches began catering to the East for its patronage, delineating their location and climatic advantages as a recreational retreat, they were called "dude ranches," and the men, usually former cowboys, who served as guides to the guests, were called "dude wranglers" or "S.A. cowboys."

"Shadin'," in cowboy parlance, meant hunting a "black spot," or shade, for a few minutes' rest or to eat a snack, and did not necessarily mean that the boys were "throwin' off," or soldiering on the "old man." When the boys dropped down for a few minutes' "shadin'," cinches were loosened and if it was a steady old horse the bits were taken from his mouth for easier grazing, but the headstall and reins were left on. "Shadin'" afforded an opportunity to pull off boots, straighten wrinkled socks, smoke a cigarette or two, and do a lot of "augerin'"! The talk would run from *risqué* stories old and mild to a general discussion of the boss's business and how it should be run.

To be "set down" was to be fired without having a horse to ride away, and such an act has sometimes led to gunplay.

The cowboy had many other duties, each of which had its individual name, and they will be mentioned under the proper chapter as we proceed.

A first-class cowpuncher was the original jack-of-all-trades. He could make a rope, shoe a horse, doctor livestock, and see after the ailments of his companions; he could cook his meals and act as a barber for his fellow worker; he had to be able to interpret the whims of Mother Nature; deep and knowing and sincere was his philosophy of life in general.

⇥ IV ⇤

........................

HIS COSTUME
AND FURNISHINGS

*It took a cowboy to wear cowboy clothes, one raised
in the saddle*

The cowboy was as of a race apart, distinct in dress as well as in speech, and showed no relationship with any of the many classes from which he had sprung. His garb added much to his picturesqueness, but considerations of the picturesque had nothing to do with the fixing of his characteristic dress. It was a product of conditions that was adapted to the service it had to render; and its wearer had no thought of real or imaginary theatrical effects the combination might produce. It was worn solely because it was the dress best suited to the work in hand. There was a practical reason for every appurtenance of it, planned upon lines of such stern utility as to leave no possible thing which could be called dispensable. His clothes somehow didn't seem to fit so well on a man that's "growed up with a collar 'round his neck." It took a cowboy to wear cowboy clothes, one raised in the saddle.

Among the most picturesque items of his costume were his "chaps." This word was his abbreviation of *chaparejos,* the Spanish for leather breeches or overalls. These skeleton overalls served as an armor to protect his legs from injury when he was thrown, when he was carried through brush and cacti, and many other mishaps, as well as being a protection against

rain and snow. Near the southern border they were occasion-
ally spoken of as "chivarras."

Like everything else associated with the cowboy, his cos-
tume received its quota of slang terms. "Chaps" made of goat-
skin, worn with the hair side out, were often called "angoras";
occasionally sheep pelts were used and called "woolies," or, if
they were made of bear-skin, they were "grizzlies," and all
came under the general classification of "hair pants." "Chaps"
made of plain leather, and worn, as in Texas, with wide flap-
ping legs, were called "bat wings," or "buzzard wings." These
merely snapped around the legs and were opened out when
taken off. The plain leather "chaps" worn in the Northwest
were often fringed and had to be pulled on over the boots.
These were dubbed "shotguns."

The "armitas" were simply well-cut blacksmith's aprons,
usually made of home-tanned or Indian buckskin and tied
around the waist and knees with thongs. They protected
the legs and clothes and were cooler to wear in summer than
"chaps." They were often called "chinkaderos" or "chigad-
eros," and were more or less "dress-up" garments. They were
seldom seen on the later-day range, for their use passed with
the oldtime range customs. These "riding aprons" were some-
times very elaborately embroidered in colored silk with the
ends fringed and had to be cut on a special pattern to make
them "hang right."

The cowboy never used the word "trousers," but always
spoke of "pants" or "britches." The garment known as "Cali-
fornia pants" was common on the range, and his "Levis" were
overalls, called thus from the name of Levi Straus, of San
Francisco, the pioneer overall manufacturer of the West.

Another distinctive article of the cowboy's garb was his
hat. Its interchangeable titles were "hat" and "sombrero." Al-

though both were used throughout the West, the Northwest leaned toward "hat" and the Southwest toward "sombrero"; also it might slangily be called "Stetson" or "John B." after this maker's name, whether it was "genuwine" or not. Other slang names used with less frequency were "hair-case," "conk-cover," "lid," "war-bonnet," or it was sometimes referred to as a "ten-gallon" hat. Silk hats of the East were "plugs" or "stovepipes," while derbies were "pots," or "hard-boiled hats." The buckskin thong depending from either side of the brim of a hat at its inner edges, to hold it on, was called "bonnet-strings" rather than by its Spanish *barbiquejo,* the latter word being rarely used except near the southern border.

Typical and striking features of the cowboy's costume were his high-heeled boots. They were a traditional expression of ethnic pride and no amount of uncomfortable binding of the feet would make him surrender this style. Price was no object, very often two months' salary or more going into one pair of boots. They were often called "custom-mades" or after the name of their maker, the cowboy with pride having small use for the ready-made variety. Boots made with flapping "pull-on" straps at the top were slangily called "mule ears," and the short-type boots of later days were sometimes spoken of as "peewees." When the cowpuncher bound up his feet with sacks to keep them from freezing in cold weather, he called such sacks his "California moccasins."

His spurs were necessary implements when upon a horse and a social requirement when off its back. In performing the work to be done on horseback, they were as necessary in con-trolling the horse as the reins upon the bridle. They were kept in place on the foot by a chain passing under the wearer's in-step and by a "spur leather," the latter being a broad, crescent-shaped shield of leather laid over the instep. Naturally they

received a full share of slang names, such as "hooks," "gut-hooks," "galves," "grappling-irons," "can-openers," and "pet-makers," or, as in the case of the large Mexican spurs, "Chi-huahuas." An inferior spur was dubbed a "tin belly."

The "buck hook" was a blunt-nosed, upcurved piece added to the frame of the spur and used to hook in the cinch or in the side of a plunging horse, and the "shank" of most spurs turned downward to allow the "buck hook" to catch without interference by the "rowels" or wheels. Spur rowels were made in many different styles. The larger the rowel, the less cruel it was. The old-time "army rowel," about the size of a dime, was very cruel. The "long-pointed rowel" was also looked upon with disfavor. The "goose-neck" with the "Texas-star rowel" was a popular spur, as was the "flower rowel," rowels shaped like the petals of a daisy, and the "sun-set rowel," a large spur with many points set close together and giving the minimum of punishment.

The little pear-shaped pendants which hung loosely from the end of the axle of the spur rowel, and whose sole function was to make the music that the cowboy loved to hear, were called "danglers" or "jingle-bobs."

The cowboy's bed was made of blankets and "parkers," "suggans," or "soogans," which were heavy comforts often made from the patches of pants, coats, and overcoats. If these latter were stuffed with feathers, they were called "hen-skins." His bed was carried rolled in a "tarpaulin," this being the Westerner's name for any canvas not especially entitled either as "pack-covers" or "wagon-sheets." It was usually shortened to "tarp," and referred to the piece of canvas seven feet wide and sixteen to eighteen feet long in which he rolled his bed when not in use and with which he was covered

at night. His bed was called by the various names of "lay," "hot roll," "velvet couch," "shake-down," "crumb incubator," or "flea-trap." When he divided his bed with another, he was said to "split the blanket" or "cut the bed." To "spool his bed" or "roll the cotton" was to roll his bed up and pack it for moving camp. To fail in this duty was a serious breach of camp etiquette. The latter term, "roll the cotton," was also commonly used to mean that the one spoken of was moving camp or taking a trip. In referring to a "Tucson bed," the cowboy meant the experience of sleeping in the open without covering, or, as he expressed it, "using yo' back for a mattress and yo' belly for a coverin'."

He carried his own personal effects, his "thirty years' gatherin'," in his "war-bag," "war-sack," or, as it was also called in the extreme Northwest, his "poke." This latter term was also called "parfleshes," or "porfleshes," a corruption of the word "parfleche." The various useless little trinkets he collected were "do-funnies" or "ditties," the latter name being also given to practically any tool or contrivance unfamiliar to him. His personal belongings of odds and ends were also spoken of as his "plunder."

When the cowboy donned his best "Sunday-go-to-meetin' clothes," he put on his "full war-paint" or "low-necked clothes." If all this "slickin'-up" caused him to "put on dog," he was said to be "swallow-forkin'" or was "all spraddled out," or was "puttin' on more dog than a Mexican officer of revenue." It might be said of him that he "walked like a man with a new suit of wooden underwear," was "struttin' like a turkey gobbler at layin' time," had "splendor that'd make a peacock go into the discard," was as "important as a pup with a new collar," or as "cocky as the king of spades." When he

went to a dance, he might express himself as "duding-up to put in a good hoof." Perhaps, if his boots were new, they "squeaked like they was made out of goose quills." If his wardrobe was meager, he "didn't have 'nough clothes to dust a fiddle." One puncher, in speaking of another who was pretty run down at the heels, said "his boots were so frazzled he couldn't strike a match on 'em without burnin' his feet."

As the saying goes, "humans dress up but the cowboy dresses down." This is literally true. The first thing he put on when arising was his hat. When he discarded his clothes, he "shucked" them. The only laundry with which he was familiar was a "hand-and-spit laundry."

His "slicker," or oilskin coat, was called a "fish" and could always be found rolled neatly behind the cantle of his saddle. A stiff shirt was "bald-faced," "boiled," or a "fried" one. "Clean straw" meant clean sheets. An imitation leather or carpet bag bought at a store for a trip was a "go-Easter," but the traveling bags used by Easterners were "boughten bags," while trunks were "coffins."

A "poncha" was a covering made by cutting a hole for the head through a blanket's middle. Rawhide moccasins were often referred to as "teguas," and the little silver shell-shaped ornaments with which the puncher was so fond of decorating his chaps, bridle, saddle, boots, and other apparel were "conchas."

His neckerchief was often dubbed a "wipes." He very commonly wore gloves as a protection against cold, manual injury, or burns in roping, but many of the gentry scorned their use, claiming that it was "cheaper to grow skin than to buy it."

The costume of the cowboy is permanent because it is harmonious with its surroundings. It is correct because it is ap-

propriate. It will remain as it is so long as the cowboy himself is what he has been, and still is—a strong character, a self-poised individual, leaning on no other soul. By the costume we may know the man. We cannot fail to recognize a nature vigorous far beyond those weak degenerates who study constantly upon changes in their own bedeckings.

→ V ←

..

HIS RIDING
EQUIPMENT

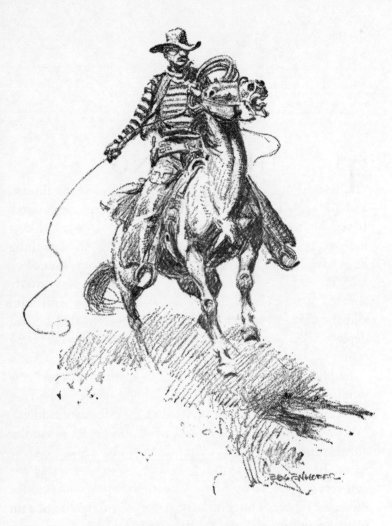

*When all is said, it was the man on horseback
who made the West*

The cowboy's saddle was his workbench and his throne, and his love for it was one of the traditions of the range-land. It was his most prized possession and very commonly cost more than the horse he placed it upon. It was the last thing he was willing to part with, and when the expression, "he's sold his saddle," was used, it meant that he was utterly "broke." Even in death his saddle was associated with him, and the phrase, "he's sacked his saddle," meant that he had departed this life, and had prepared the way for the "long trail."

Saddles in the West went under the general names "cow saddles," "range saddles," or "stock saddles," while in the East these same saddles were referred to as "Mexican saddles," "Western saddles," or "cowboy saddles." But styles in saddles changed from time to time and each change took a specific name. In the early seventies the saddles were short, shallow, and very clumsy, being neither comfortable nor practical for range use. These saddles had a large flat "horn" the size of a tin plate, being large enough, as the cowboy said, "to play a game of seven-up on," and were slangily called "dinner plates."

The next style came during the early eighties and was called the "apple horn." The horn was almost round and

about the size of a small hen's egg. The seat was deeper and the stirrups not more than half as wide as the old models. From that time on, saddles improved rapidly until their evolution took them through the various shapes of the stock saddle to the present day. Variations in the shape of the saddle created special names for it, as "Brazos," "California," "Nelson," "Frazier," "Oregon," "Vasillia," "Cheyenne," "White River," "Ellenburg," etc., these names being designated by the shape of its "tree" or frame.

In order to describe the technical names of the different parts of the saddle, it might be well to mention their position. The "tree" was the frame made of strongly built hardwood. The cowboy often spoke of his saddle by this name, as we heard one say he "slapped his *tree* on" and another say he "laced his *wood* up." This "tree" was comprised of a longitudinal "fork" and a transverse "cantle," and upon the front end was bolted a metal "horn," which went by such slang names as "nubbin'," "apple," "Lizzie," "biscuit," and many others. The curved portion of the under side of the "fork" of the saddle was known as the "gullet."

This whole frame was covered with a broad, curved leathern plate known as the "skirt" or "basto," the latter being from the Spanish *basto,* meaning a pad or packsaddle. The shaped pad used to put under the "basto" was a "corona." The leather lining of the skirt was often called the "sudadero." Fitting closely around the base of the "horn" and "cantle" on top of the "skirt" were the "front jockeys" and the "back" or "rear jockeys." When the "skirt" and "rear jockey" extended no farther than the "cantle," there was sewn to the "cantle's" base, a broad leather which was called an "anquera." The leather side extensions of the "seat" of a saddle were called "side jockeys," the "seat" itself being that part on which the rider sits, and

said to be the "easiest thing to find but the hardest to keep."

The broad, short band, made of woven horsehair, canvas, or cordage, and terminating at each end with a metal ring, was the "cinch," from the Spanish *cincha*. On each side of the "tree" was attached, for each "cinch," a second metal ring called the "rigging ring," "tree ring," or "saddle ring," and from which hung a long leather strap called the "latigo." This strap, after being passed successively through both the "cinch ring" and the corresponding "tree ring," was fastened below the latter much after the fashion of tying a four-in-hand necktie. Some Texans used the "latigo" strap which buckled and these were referred to as "trunk straps." The act of fastening the saddle upon the horse's back by drawing the "cinch" up tight by the "latigo" straps was called "cinching up" — the cowboy never merely "cinched." While the average cowboy spoke of a "cinch," many of the Texans spoke of it as "girth." If there were two cinches, they were "front" and "hind" or "rear cinch," but the Texan said "front" and "flank girth."

Saddles with one cinch were "center-fire," "single-rigged," "single-fire," "single-barreled," and "California rig," while saddles with two cinches were "rim-fire," "rimmies," "double-rigged," "double-fire," and "double-barreled." On the "double-barreled" saddle, the "rigging rings" were placed one at the base of the "fork" in front and the other at the base of the "cantle." If the saddle was made for only one cinch, the rings were located halfway between, right in the middle of the saddle, and such a saddle was known as a "center-fire rig." Place the cinch halfway between the "center-fire" and the cinch that is far up in front and it becomes a "three-quarter rig." Then there is the "seven-eighths" and the "five-eighths," taking their names according to the location of the cinch. The middle leathers attached to the tree of the saddle connecting

with, and supporting, the cinch by latigos through the "rigging ring" were called the "rigging."

From each side of the saddle hung the "stirrup leathers," starting from grooves cut in the wood of the tree and ending with the stirrups. Where the seat's leather covering extended only to this groove's rear edge, it was known as a "three-quarter seat," and where it covered the entire seat, covering the upper portion of the stirrup leathers, it was known as the "full seat." A flat leather plate, overlaying the stirrup leather when the latter issued from the saddle's side, was known as the "seat jockey" or "leg jockey." The leather shield sewn to the back of each stirrup was the "rosadero." A Spanish term, sometimes used near the border, for stirrup leather was "acion."

"Stirrups" are the foot supports of the saddle and are usually made of wood bound with iron, brass, or rawhide, but sometimes all iron or brass. In the old days they were of wood, extremely wide, and were known as "ox yokes," or "ox bows," but in later days the style favored the narrow stirrup. The wedge-shaped leathern cover which covered the stirrup front and sides, but opened in the rear, were called "tapaderos," from the Spanish *tapadera,* meaning lid or covering. Its literal meaning was toe-fender, and was usually shortened to "taps." Like everything else, the cowboy had slang names for them, such as "eagle bills," "mule ears," "bulldogs," or "monkey nose," each taking its name from its shape. Stirrups without "taps" were "open stirrups."

Stirrups connected with a strap or rope passing under the horse's belly were "hobbled stirrups." This had the advantage of furnishing a firm anchorage during bucking, but was held in contempt by real riders.

Rodeos set the pace in saddle fashions, and through the years they ran the gamut of all forms and shapes, from the

"skeleton bronc tree" and "form-fitters" to "bear-traps," until the rodeo association adopted what is now known as the "committee," "contest," or "association" saddle. Their use is now compulsory at all large contests. It is built on a modified "Ellenburg tree" and medium in height. There is nothing about it which will permit the rider to anchor himself, and, as the cowboy says, "it gives the hoss all the best of it." The saddle also inherited many slang names, such as "hull," "kack," "tree," "wood," and "gelding smacker." A saddle covered with fancy stamped designs was his "full stamp," and one without a horn or pommel was a "muley."

While the cowboy had an elaborate vocabulary of forceful adjectives at his command, he found himself unable fully to express the disdain with which he regarded the little pad-saddles and short-hitched stirrups of the Eastern rider. The most contemptuous names he could give them were "hog skins," "kidney pads," "pimples," and "postage stamps."

Saddles with very little bulge in the fork were "slick forks," and those with an unusual bulge or roll were "freaks," "form-fitters," or "bronc saddles." A "buck strap" was a narrow strap riveted to the leather housing of the saddle just below and on the off side of the base of the horn. The "saddle strings" were the little rawhide strings whose underlying purpose was to hold the saddle leathers together, but the ends were tied and left hanging, which added to the appearance as well as usefulness in tying on packages. The one fastened to the horn and used for securing a rope was called the "horn string." A leather covering that fitted over the saddle in one piece, covering the whole rig from cantle to horn, was a "macheer," or "mochiler." "Montura" was also an occasional name for the saddle, and "cantinesses" were saddle pockets. Special saddles used for carrying camp equipment, etc., were "pack-saddles,"

"kyacks," "cross-bucks," or "aperejos." The wide leathern or canvas bags, one on either side of a "pack-saddle" and hanging from the crosses on the saddle's top, were called "alforki." This was a Spanish word which suffered much from American spelling, having been forced to appear as "alforge," "alforka," "allforche," and many other forms. A "maleta" was a bag made of rawhide, while a "morral" was a fiber bag from which a horse was fed. It was usually carried on the horn of the saddle when used, and was also called "nose-bag."

The bridle, "headstall," or "bridle head" was the headgear of the horse, composed of a "crown-piece," "brow-band," "throat-latch," and, on either side, a "cheek-piece." The bridle was sometimes also called a "freno." The "bit" was the metal bar which fitted into the horse's mouth. Derived by the range directly from Mexico, the bit was of Spanish and earlier Moorish type, and its function was to suggest physical pain rather than cause it. There were many kinds of bits, each with its individual name and partisan.

The bit might be a "straight bit," a straight, hard iron, or a "broken bit," two pieces of metal joined by a swivel and held by the rings of the bridle straps or reins, or a "chain bit," made of a short piece of chain. The "grazing bit" or "snaffle bit" was a small bit with a curb in the mouthpiece. The "half-breed bit" was one that had a narrow, croquet wicket hump in the middle of the mouth-bar, two or two and a half inches in height, and within this hump a "roller," or vertical wheel with a broad corrugated rim.

The "spade bit," or "stomach pump," as it was sometimes called, was one with a piece shaped like a broad screw-driver on the mouth-bar, three or four inches in length, and bent backward at its top. The "ring bit" was a metal ring which, fastened at the top of the port or near the summit of the

spade, according to which was present, and passing through the horse's mouth, surrounded the lower jaw. This cruel Spanish bit was not looked upon with favor by the American cowboy. Occasionally, though very rarely, some fiendish rider might add barbed wire or other contrivances to the bit, making a regular "tool chest."

The little roller inserted in a bit to make a chirping noise was called a "cricket." It gave the horse something to amuse himself with with his tongue, and created a music that the cowboy loved to hear.

The "reins" were fastened to the "bit ring" on either side, or were commonly fastened to a "bridle chain," a chain about six inches long which, in turn, was fastened to the "bridle ring." Reins were either "open reins," being not tied together, but each independent of the other, or they were "tied reins," that is, the ends were fastened together. The end of the latter reins very commonly continued into a flexible whip which was called a "romal." This word is from the Spanish *el ramal*, meaning literally a branch road, a division, or a ramification. So, attached as it was to the bridle rein, the *ramal* became but a ramification of the rein, a handy addition that may be used as a "quirt" or dropped from the hand without fear of being lost. Most riders preferred the "open reins," however, because by merely dropping them the trained range-horse would be "tied to the ground," and, too, there was less danger of the rider becoming entangled when thrown.

The "quirt" was a flexible, woven leather whip, made with a short stock about a foot long, and carrying a lash made of three or four heavy and loose thongs. Its upper end ordinarily was filled with lead to strike down a rearing horse which threatened to fall backward. A loop extending from the head provided means of attachment to either the rider's wrist or to

the saddle-horn. The word is derived from the Mexican *cuerta*, meaning whip; and this, in turn, is from the Spanish *cuerda*, meaning a cord. The slang name "quisto" was some times used. A "cow whip," on the other hand, was a long whip used to pop rather than to lash cattle.

The "hackamore" was usually an ordinary "halter" which carried reins instead of a "leading rope," but it offered to the rider no control over the horse other than that which the mere pressure on the animal's neck could effect. The word was a corruption of the Spanish *jaquima*. The "hackamore" was commonly used as a bridle, but in the place of a bit a "bosal" was used. The latter was a leathern, rawhide, or metal ring around the horse's head immediately above the mouth, and used in lieu of a bit. The reins were attached to the "bosal," and their pulling operated to shut off the horse's wind. It was held in place by the cheek-pieces and a looped cord, commonly made of braided horsehair passing from the "bosal's" front upward and over the top of the horse's head. This cord was called a "fiadore," or sometimes, in corrupted form, "theodore."

The "war bridle" was a brutal hitch of rope in the mouth and around the lower jaw of the horse. The "ghost cord" was a thin string tied about the tongue and gums of the horse, and thence passed below the lower jaw and up to the rider's hand. It could be used as an instrument of extreme cruelty.

The "twitch," sometimes confused with the "ghost cord," was entirely different. It was a small loop of cord with a stick through it and was used to punish a held horse by placing the loop around the horse's upper lip and twisting the stick. It was frequently called a "twister."

The equipment used by cowboys might differ in different sections of the West, but the work they performed was about

the same, for it was done by riders following the same profession, but raised to different methods and ways. If they rode for a century, they would not change, for they had learned to do hard and dangerous work in certain ways and with certain styles of gear.

When all is said, it was the man on horseback who made the West; it was the riding man who added new stars to the flag and cast, forever, the glamour of romance and adventure over the West, a West that was won and conquered by the men who sat in saddle leather.

✦ VI ✦

......................

ROPES AND ROPING

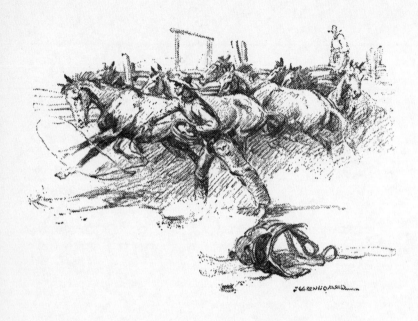

One of the neatest throws in common use was the "mangana"

The rope was so essential to cattle work that without it there would have been no cowboys. Wherever one saw a cowboy he saw a rope suspended in a neat coil from the right side of his saddle-horn, and it was not a matter of affectation or mere ornament. On the range they say that the cowboy did everything but eat with his rope. No matter what the job was, he would first look it over to see if it could be done with a rope and saddle horse.

Any man with nerve, strength, and ability to stand punishment could learn to ride a bucking horse, or "bulldog" a steer, in a comparatively short time, but proficiency in the handling of a rope was the most difficult of all cowboy attainments. It must be learned through years of practice.

This important tool of the cowboy was made of many different materials. It varied a good deal in different parts of the West. In California, Nevada, and eastern Oregon, the sixty-foot rawhide reata is still in use. In Texas, the rawhide rope has practically disappeared, replaced by a thirty-five-foot length of "manila," mostly of softer fiber and looser twist than is used in other states. The Mexican "maguey"—pronounced "McGay"—was made from the fiber of the century plant. It was a splendid rope, but owing to its extreme stiffness many

ropers did not care for it. A "hair rope" was never used as a
"reata." They kinked too easily and were too light to throw.
They were very pretty, however, and were used as saddle reins
with a "hackamore" and as "tie ropes." A "tie rope," particu-
larly a hair one, was often called a "mecarte"—pronounced
"McCarty." "Hair ropes" were rarely over twenty-five feet
long, and one made of alternating black-and-white strands of
horsehair was called a "pepper-and-salt rope."

Lengths varied from twenty-five feet to fifty and sixty feet,
the short rope being in favor for steer-roping, calf-roping,
and corral work, as branding, etc., and the longer rope for
outside catching, where one may have to make long throws at
wild stock and also where the roper "dallies" his rope around
the horn of the saddle instead of tying fast.

Thickness of ropes depended upon what was intended to
be done with them. For steer-roping and heavy work seven-
sixteenths hard twist pure manila was generally used, and for
light work three-eighths manila or three-eighths cotton and
Mexican maguey ropes were mostly preferred.

Until they were stretched or suppled and the loop knot
pulled down, the ropes were practically useless because of
their stiffness, and, to use the cowboy's term, "y'u couldn't
throw one of them into a well." Once the stretching process
had been accomplished, they became a thing of life in the
hands of a "smooth" roper. Often a new rope was drawn over
a flame or torch to singe the "whiskers" off. When the rope
had been properly stretched and was ready for work, it was
said by the cowboys to "sing," which meant that it flowed
freely through the loop, making a hissing sound as the loop
was thrown.

The rope of the West had many uses. Its first duty of the
morning was to rope out the mounts for the day. With it a

fractious bronc would be snubbed to a saddle-horn or a "snubbin'-post," saddled and mounted. In the absence of corrals, it was used to "stake out" the cow-ponies to grass; it gave them limited freedom while nature provided their roughage. Without it cattle could not have been branded in the early days before "chutes" and "squeezers." When on the range, it served as a "rope corral" for the remuda while the boys roped out their mounts. When put to this use, it was called a "cable." It served to pull mired cattle from bog-holes. It rescued drowning men by throwing it as a life-line and pulling them ashore. It was used effectively as a "quirt" by doubling one end. When cattle became sluggish, it could be used as a "bull whip" by tying it at the saddle-horn and letting it drag to the desired length. Any experienced hand could make it "crack like a blacksnake, slip hair and tear hide." It was an effective rattlesnake weapon. When the chuck-wagon hit quicksand and other bad places, the boys would "tie on" and pull by the saddle-horns. It was an aid in scaling otherwise unsurmountable heights. By casting it to a limb or rock above, it would assist one in pulling up almost any steep incline and he could descend by the same process without hazard.

Many a load of wood has been "snailed" to camp by the saddle-horn. In the early days it furnished the cowboy recreation by the roping of wildcats, mountain lions, wolves, and grizzlies. It tied his bed up, secured his packs, helped in his fighting of prairie fires, hobbled his horses, tied up corral gates, and served as his guide in snowstorms when tied from his bunk door to the stable or the woodpile.

It was occasionally used with unfailing success to pull or jerk a drunken, boisterous, and threatening puncher from his horse to sober him up. In working wild horses, a throw line called a "W" was sometimes used, being tied to a forefoot,

then up through a ring in the belly-band, and back to the wagon. When the horse became unruly, he would be thrown to his knees, and by bruising them a few times he would desist. It has been used as a "jerk-line" in guiding ox teams. Aside from its numerous and commonplace uses, it was, in the absence of judge and jury, used to mete out justice to the elusive horse thief or wholesale cattle rustler. The accusers would not be worked up to shoot on sight, but employed the rope as a spectacular warning calculated to spread terror in the minds and hearts of his comrades as they confronted the lifeless body of their pal dangling from the unstable end of a pitiless rope.

The general Eastern idea was that the rope must be designated by the terms of "lasso," "lariat," or "reata," but in the West it was called just plain ordinary "rope." The "lariat" primarily was a rope used for tethering or picketing animals, especially when made of horsehair. Sometimes it was made of grass, and of course was often used for any purpose for which a rope might be needed. The term was frequently used in the Southwest, but was called "rope" in the Northwest. The name was a contraction of the Spanish *la reata*, the literal meaning of which may be expressed as "the tie-back." It may also be called "reata," or "riata." "Lariat" may be used as a verb, as "to fasten" or "catch" with a lariat, but "reata" is never used as a verb. "Lasso" was a long line, usually made of hide, with a running noose. While its name was introduced into our range country by Mexicans, the word is not of Spanish origin, but came from the Portuguese *laco*, which has a meaning equivalent to "snare." As with "lariat," the word is used as a verb, too, as "to lasso." But very early in cattle-raising on the plains the cowboy began calling the "lasso" a "rope," and within a few years the latter became the common term for it. Among

stockmen of the Pacific Coast, however, "lasso" took a firmer hold, and that section is the only one using the term to any extent.

The knotted or spliced eyelet at the business end of a rope for making a loop was called the "honda." The term is Spanish and originally had reference to the receptacle in a sling for holding a stone or other article to be thrown. Experienced ropers prefer to make their own "hondas," since a manufactured one of bone or metal may easily blind an animal if struck in the eye by a misplaced or careless cast.

The cowboy called his rope by such slang names as "line," "clothes line," "string," "hemp," "manila," "whale line," "lass rope," "twine," "cat-gut," and many others. He sometimes called his "lariat" his "ketch-rope" to distinguish it from other ropes. Using a rope with an extra large loop was spoken of as using a "community loop," "cotton-patch loop," "Mother Hubbard loop," or a "Blocker loop," the latter taking its name from John Blocker, of Texas, a noted roper who used this style loop. It was turned over when thrown and went over the steer's shoulders and picked up both front feet. Users of small loops were called "small-loop men."

"Building a loop" was the shaking out of the noose in preparation for a throw, called by some ropers "shakin' out," and meant the opening of the noose with a few quick jerks toward the front as the right hand grasped the rope at the "honda." When one threw a rope intent on a catch, he was said to throw a "hungry loop," but if he missed, he "wasted a loop." "Dab" was a slang word used in speaking of roping, as "dabbed his rope on." He was also said to "pile it on," "snare," "smear it," "stack it on," or "take the pins from under it." One of the neatest throws in common use was the "mangana," which meant catching the animal by the fore feet, usually re-

ferred to as "fore-footing." It was seldom used outside of a pen, but could be thrown from the saddle or on foot. Another form of the "mangana" was called the "mangana de cabra." The loop was thrown in such a way that it made a figure 8, catching the neck of the running animal in the upper half of the figure and its fore feet in the lower half. It was used mostly upon calves and was not good on larger animals with spreading horns. To "peal," used as a verb, meant to rope an animal by the hind feet. This throw was commonly used for "stretching out" the animal that had been roped by the head or neck. The loop formed a figure 8, and if cast successfully caught a hind foot in each half of the figure. The word was from the Mexican *pial,* but was more commonly spoken of as "heeling," or "picking up his hind feet."

The term "hooley-ann" was a roping term and the throw was used mostly to catch calves out of a bunch and to rope horses. The roper rode with his loop in his hand, and when the chance presented itself, he swung the loop backward instead of forward, and as it came over it was turned in such a way as to cause it to flatten out before it reached the head of the animal to be roped. Just one swing and it could be tossed thirty feet forward. The size of the loop depended upon the distance it was to be thrown and the size of the animal. A good calf-roper who used the "hooley-ann" might be thirty feet from a wee tot of a calf and start a loop that a beef steer could pass through, but the noose ran out by reason of the distance, and by the time it reached the calf, it was barely large enough to pass around the calf's neck.

When the roper's loop slipped over the shoulders of the roped animal and tightened around its belly, it was said to be "belly-roped." This furnished much hilarity to everyone except the roper.

"Whirling" was the act of whirling the noose of the rope about the head until sufficient speed was developed to make a throw at the object at which it was aimed. On the other hand, many of the best ropers were "rope-tossers," and, instead of swinging the rope around their heads before throwing, spread it out behind and to one side, and with a quick, graceful throw, or toss, launched it with unerring aim over the head of the animal at which they threw. It was customary to use this method in most sections of the cattle country, as "whirling" was more apt to alarm the animal, especially in a horse corral.

"Steer-roping" was the art of capturing, "busting," and "hog-tying" a range steer single-handed, commonly called "steer-busting." A "dog fall" was putting a steer down with its feet under it. Throwing an animal violently was "busting" it, or the cowboy stated that he "rolled it." To "fair ground" was to rope an animal, throw the rope over its back while still running, then throw the animal violently to the ground, where it usually lay long enough to be hog-tied. "Hog-tying" was the tying together of the animal's legs, usually two hind and one front, with a short piece of rope called the "tie-rope" and slangily referred to as the "hoggin'-rope" or "piggin'-string." When a lassoed steer throws off the rope by means of dodging and wriggling movements, he is said to be "hornswoggling," and he certainly "hornswoggles" the cowboy from whom he escapes. To throw an animal by tripping was said to be the "California."

What the cowboy called the "roll" was a corkscrew, wave-like motion of the rope, which, traveling along it to its end, would land on the object roped with a jar. He often made use of this to free his noose from its prey. To "run on the rope" was said of an animal, especially a horse, when he started away and was snubbed up violently. It was a part of the edu-

cation of the range-horse. The "snubbing" was done by throw-
ing the home end of the rope with a "half-hitch" around some
fixed object, usually a "snubbing-post."

By "picket" the cowboy meant to stake his horse out, and
the rope he used for this function was called a "picket-rope,"
the Texan's term, however, remaining as "stake-rope." The
wooden stake driven into the ground and to which one end of
the "picket-rope" was attached was a "picket-pin," or "putto,"
the latter word being derived from the French *poteau,* mean-
ing post. The hobbling of horses also had their various terms.
To "cross-hobble" was to hobble one front foot to the hind
foot on the opposite side, while "side-line" was to tie together
the front and hind foot on one side of an animal to prevent it
traveling at speed. "Clogs" were made by taking strong,
forked sticks about an inch and a half or two inches in diame-
ter, and about two feet in length, and lashing them with
rawhide thongs on the front legs of a horse as a hobble. These
were used principally in the "brush country."

Taking a simple turn or two around the saddle-horn with
the home end of the rope after a catch was called "dallying."
Other technical terms for this form of roping were "daling,"
"vuelting," "felting," or "dale vuelting." All of these inter-
changeable terms were derived from the Spanish phrase *dar
la vuelta,* which means to give a turn to a rope, or to belay it.
A man using this form was called a "dally man." On the other
hand, there were men who tied their ropes hard and fast to
the saddle-horn, this being called "tying fast," and the users
of such a method being called "tie men."

A "rope corral" was a temporary corral used at the cow-
camp away from headquarters and made by tying the rope to
the wheel of the "hoodlum wagon" or other objects or being
held by four or five cowboys to form an obtuse U, and used to

pen the saddle horses until they could be caught for saddling.

One of the invaluable uses of the rope in the West was for the fastening of "packs" upon "pack-mules" or other animals. The "diamond hitch" was one of the best and most common. It produced upon the top of the pack, when completed, the figure of a diamond, hence its name. The hitch, when correctly thrown, was remarkable for its ability to absorb the slackness generated at any particular point and firmly to imprison the held packages within its grasp. An ordinary knot is *tied,* but a "diamond hitch" was always spoken of as "thrown." The difference was due to the fact that in the latter case a rope forty or fifty feet long was used on an average pack-load, and the running part of this was thrown back and forth across the animal as the hitch was fashioned. The "squaw hitch" was another packer's knot.

To drag an object with a rope, such as a piece of wood for the cook's fire, was to "snail" or "snake" it. A "hot rope" was one that slipped through the roper's fingers until it burned the flesh. The little wooden pegs used in making horsehair ropes were called "doll babies."

Trick roping came in for many technical names of which we mention the most common. The "body spin" was accomplished by bringing a wide, spinning loop up and over the head and thence down around the body during the spinning. "Juggling" was a body spin which repeatedly raised and lowered the noose from the ground to the limit of the operator's reach above his head and was also called the "high-low." The "merry-go-round" was made by spinning an independent noose around and clear of the body, using first one hand and then the other. The "ocean wave" consisted in flipping a noose backward and forward in an undulating movement. The "complex spin" signified the spinning of two nooses, one

horizontal and the other vertical, or both alike, operated sep-
arately, one in each hand. "Roll-overs" were spins started ei-
ther vertically or horizontally, and the noose being made to
roll over the shoulders, or one or both arms. "Skipping" was
to jump into and out of a vertical noose and keep it spinning;
this trick was also called a "hop-skip." "Star-gazing" meant to
start a body spin and slowly assume a sitting posture, then lie
down on the back, spinning all the while. The "sitting spin"
consisted of jumping in and out of a spinning noose from a
sitting position. The first act in ordinary trick roping was to
start the rope spinning, either in front of the body or around
the head. Then the noose was enlarged and rapidly darted
from side to side, vertically, spinning to the right and then to
the left, in a stunt called the "butterfly."

The cowman of the Old West recognized the value of his
roping ability, and gave hour upon hour to its mastery. It was
his custom to toss a loop at almost all available marks, and
there was virtually nothing with hair, fur, or feathers to be
found on the range that had not at some time succumbed to a
deftly flung rope. At a round-up where thirty or forty men
were working, the "top rope men" stood out sharply above the
rest.

✦ VII ✦

......................................

CATTLE

*"Critter" was another word he used to designate "cow"
as a general term*

The West created many technical distinctions in speaking of its cattle. No matter what the sex, it was a "calf" when it was "born," "dropped," or "come along." If a male, and reserved for breeding purposes, it became in turn a "yearling bull," a "two-year-old bull," a "three-year-old bull," a "four-year-old bull." If not so reserved, he became a "yearling" for a year and then a "steer" until he was full grown, then became a "beef." On the other hand, a female, after her first year became a "heifer," then a "two-year-old cow," and so on successively until she also went into the "beef" grade. A "long yearling" was an animal eighteen months old or older, and full-grown cattle were spoken of as "grown stuff."

Yet, in spite of all these distinctions, the cowboy, when speaking of cattle, more often used the word "cow," and in using this generic term he meant everything from a suckling calf up to a ten-year-old bull. Those animals of exclusive feminine gender were called "she stuff," or, if an individual was pointed out, the sex was designated as "that three-year-old heifer" or "that brockle-faced steer." "Critter" was another word he used to designate "cow" as a general term. Following his distinctions still further, we find that he was apt to call a

cattle ranch a "cow ranch," but never spoke of the range as a "cow range," nor the cattle country as a "cow country."

The ranchman spoke of cows as "head"; as, "I have three thousand head on this range." Speaking of cattle grouped together, he referred to them as a "bunch," while he called a group of horses a "band." In using the word "stock" or "livestock," he used the word "bunch," and told you "band" was incorrect.

The terminology of the range, in speaking of "dry stock" and "wet stock," was confusing to the tenderfoot. By "dry stock" the cowboy meant such bovines, regardless of sex and age, that were giving no milk, while the phrase "wet stock" signified such cattle or horses as had been smuggled across the Rio Grande River after being stolen from their rightful owners. The term soon became used and applied to all stolen animals. Cows giving no milk were also sometimes called "strippers."

Since the beginning of the cattle industry in America, the cowboy has exercised his talents in giving the animals in his charge nicknames and slang titles.

The old "longhorns" of the brush country of Texas were called "brush-splitters" and "cactus-boomers." Those from the coast country of Texas were "coasters" or "sea lions" that "came right out of the Gulf" of Mexico. A "scalawag" was a worthless "cut-back," generally wild and old, while a "mossy horn" was a Texas longhorn steer six years or more old whose horns had become wrinkled and scaly. He was also called a "moss-back" or "wrinkle-horn." Outlaw cattle of the brush country were called "ladinos." To get these cattle to the "shipping pens" or "shipping point," it was often necessary to resort to "necking." This word, in range terminology, had an altogether different meaning from that which prevails in more

metropolitan circles. On the range, an unruly cow or one with roving proclivities was often "necked" or tied to a more tractable animal, the animal used for this purpose being called a "gentler." This was especially resorted to in the days of the longhorn. After the two animals had worn themselves out trying to go in different directions at the same time, the wilder one was enough subdued to move along in company of its fellows. "Kneeing" was also sometimes resorted to. This was the splitting of the hide on a wild steer about an inch and a half between the knee and the ankle on one fore leg and cutting a small leader or tendon. When the steer was turned loose, he found that he could walk, but his running days were over. This operation was also called "doctoring."

"Tailing" was the throwing of an animal by the tail in lieu of a rope. Any animal could, when traveling rapidly, be sent heels over head by the simple process of overtaking the brute, seizing its tail, and giving the latter a pull to one side. This would throw the animal off its balance, and over it would crash, onto its head and shoulders. Though the slightest yanks frequently were capable of producing results, many men assured success through a turn of the tail about the saddle-horn, this supplemented sometimes, in the case of cattle, by a downward heave of the rider's leg upon the straining tail. Such tactics were resorted to frequently with the unmanageable longhorns, and a thorough "tailing" usually knocked the breath out of a steer, and so dazed him that he would behave for the rest of the day. It required both a quick and swift horse and a daring rider.

"Bull-tailing" was a game once popular with the Mexican cowboys of Texas. From a pen of wild bulls one would be released, and with much yelling a cowboy would take after him. Seizing the bull by the tail, he rushed his horse forward and a

little to one side, throwing the bull off his balance and "busting" him with terrific force. American cowboys were more humane and seldom indulged in this as a sport.

A "maverick" was an unbranded animal of unknown ownership. The story of the origin of this word has often been told, but often incorrectly, so we will repeat the true version here. It was derived from Samuel A. Maverick, a Texas cattleman and lawyer, who took over a bunch of cattle for a debt before the Civil War and placed them in the charge of a black man on the San Antonio River about fifty miles south of San Antonio. The man, knowing nothing of cattle and having taken to the bottle, failed to brand the increase of the herd and suffered them to roam far over the country. In 1855, Maverick sold his entire outfit, brand, range, and all the rest to Toutant de Beauregard, a neighbor stockman. It was a kind of "blanket" deal, and according to its terms Beauregard, in addition to the number of cattle present and actually transferred in the trade, was to have all the others, branded and unbranded, that he could find on Maverick's range. Beauregard, being a careful man, then, it is said, instituted a systematic search, a round-up that covered not only Maverick's range, but several counties, and wherever his men found an unbranded cow-beast they claimed it as a "Maverick," put Beauregard's brand on it, and drove it in. It was under these circumstances that the term "maverick" became applied to unbranded cattle. The term spread over the entire cattle country and found such common usage that it has found its way into the dictionary. "Orejana" was another term for an unbranded animal, but it was used almost exclusively in California, Oregon, and Nevada.

Bueno is a Spanish word, meaning "good," but during the open-range days in the Southwest it was also used as a cattle

term, and meant that the animal called thus was "good" in that it had not been claimed by anyone at the round-up, and that its brand could not be found in the brand book. Such animals were "good" pickups because they were supposed to get by brand inspectors at shipping points and market centers.

A case of theft tried in 1895 at Springer, New Mexico, against three men who had shipped a trainload of such cattle to Cheyenne, Wyoming, proved the popular use of this term. At this time New Mexico was a Territory and the judges of the courts were men from the East. Defendant witnesses swore that the defendants, according to their knowledge, had bought so many head of "buenos" from a certain party. The judge, being unfamiliar with the word, called for expert testimony on the meaning of the term and learned that an animal of unknown ownership was commonly called a "bueno." Some of the noted brands of the West were so well known that their animals could stray a thousand miles from home and their identity could be determined by the brand, and consequently this animal could not be a "bueno." The term was applied only to animals bearing brands that were unknown to that section.

A "dogie" was a scrubby calf that had not wintered well and was anaemic from the scant food of the cold months. In its truest sense it meant an orphan that had lost its mother at a tender age and had existed on grass without nature's starting food of milk, growing up woolly, "pot-bellied," and stunted in appearance. It was also called a "dogy" or "dobie." It was, in the language of the cowboy, "a calf that has lost its mammy and whose daddy has run off with another cow." The Mexican name for such a scrub was *sanchos,* and the word "leppy" was also used to indicate an orphan calf. Cowboys broadened the term "dogie" to mean all classes of cattle, and

in the old trail song, "Get along, little dogie," while driving up the trail, they meant all cattle, big, little, old, and young. An orphan calf, all belly, "fat in the middle, and poor at both ends," was called a "wind-belly." A runty calf was also sometimes called an "acorn calf." "Markers" were animals with certain coloration or other marks easily distinguished and remembered by the owner and his riders. Such animals have frequently been the downfall of rustlers when used as proof of theft.

The cowboy spoke of cattle that were rejected for one reason or another on round-up as "cut-backs" or "culls." "Scrubs" were animals that did not rank high as to breeding and flesh, while "cold-blooded stock" were cattle or horses without any thoroughbred or "hot blood" in them. When the ranchman spoke of improving his breed, he referred to it as "grading-up."

Cows without horns were called "muleys" or "can't hook cattle." Most every "muley" cow was called something endearing when she was not being "cussed." Being harmless they couldn't defend themselves against other cattle, and accordingly at night they slept on the edge of the herd instead of staying inside it and consequently were always noticed by the night-herders. Cows that had been dehorned by ranchmen were said to be "snubbed."

When ticks had undermined the supporting cartilages of an animal's ear causing it to droop, this animal was spoken of as a "gotch-ear." Also a "gotched" animal or one "droop-horned" was called a "mocho." A thin cow in early spring was often referred to as "just a ball of hair."

Cattle that were shipped or driven to the corn belt for fattening before marketing were spoken of as "feeders" or "poverty cattle." Weak stock which had not wintered well and

needed some special attention to put them into shape again were called "hospital cattle."

Cattle that had to be driven out of canyons onto the plains during a round-up were called "windies." These cattle were usually contrary and hard to drive, and by the time they had been got out of the canyon, the cattle, the horses, and the cowboys were about exhausted; hence the name. Wild stock which ranged high in the cedar thickets were called "cedar-breakers." To "put to grass" was to turn stock onto a fresh range or put them into a pasture.

To hold a herd of cattle on a new range until they felt at home was to "locate" them. To let them scatter somewhat and yet herd them was called "loose-herding." To hold them in a compact mass was "close-herding" them. Cattle were inclined to remain in the territory with which they were acquainted. That became their "home range." Yet there were always some which moved farther and farther out seeking grass and water. These became "strays," the term being restricted to cattle, however, as horses, under like circumstances, were spoken of as "stray horses," and not merely "strays."

Cattle will drift day and night in a blizzard until it is over. You cannot stop them; you must go with them or wait until the storm is over and follow. Such marching in wholesale numbers was called a "drift," and if the storm was prolonged, it usually resulted in one of the tragedies of the range. The cowboy made a technical distinction in reference to the number of these errant animals. The single animal or a small bunch were referred to as "strays," but when a large number of brutes were "bunched up" or "banded up" and marched away from their home range, and so long as they stayed together, the group was said to be a "drift." The wholesale death of cattle as a result of blizzards, and sometimes droughts, over a

wide range of territory was called a "die-up." Following such an event there was usually a harvest of "fallen hides" and the ranchman "needed skinnin'-knives instead of brandin'-irons." Cattle were said to be "pitted" when "blizzard-choked"; that is, caught in a corner or a draw, or against a "drift fence," during a storm.

Some ranches used the system of "blabbing" their calves when they found that some lusty calf was still nursing an emaciated cow after he should have been weaned. This "blabbing" was done by fastening a thin board to the calf's nose by a metal ring. These "blabs" were also called "butter-board weaners." A "spike weaner" was a circle of wire with spikes and served the same purpose.

Speaking of cattle being "locoed" meant the result of feeding upon the toxic loco weed. An animal addicted to it would run about frantic and crazy, as though intoxicated. In reference to humans this term meant that the person spoken of was foolish, absurd, crazy. The word is Spanish, meaning mad, crazy. "Warbles" are the larvae of the heel-fly. The egg hatches on the hair and the tiny larvae burrow under the skin causing itching and discomfort. Cattle suffering from them were said to have "cattle grubs," or "wolves."

When the cowboy spoke of "dusting" a cow, he meant that he threw dust in her eyes. The cow, unlike a bull or steer, keeps her eyes open and her mind on her business when charging, and a cow "on the prod" or "on the peck" was more feared by the cowboy than any of his other charges. To stir up cattle unnecessarily and get them heated was "chousin' 'em" or to "mustard the cattle." A cow that could not be kept in a pasture by a fence was known as a "fence-crawler," or "breachy." To "can" a cow was to tie a tin can about the animal's neck to prevent it from fence-breaking.

In the early days when cattle were so plentiful in Texas with no market outlet, many cattle were slaughtered for their tallow. Removing the hides, horns, and hoofs, and placing the rest of the carcasses into a huge tank and cooking them for the tallow, was called "tanking," and such an establishment was called a "tallow factory."

The Indian name for beef was "wahee," and many of the old frontiersmen adopted it from their association with the Indian on the trails. Hereford cattle were called "white faces" or "open-faced cattle" by the cowboy, and a "cattaloe" was a hybrid offspring of buffalo and cattle. A "cimmarron" was the Mexican name for an animal, either horse, bovine, or even human, that, deserted by all his friends, ran alone and had little to do with the rest of his kind. When the cowboy spoke of "mixed cattle," he meant cattle of various ages, grades, and sexes. The term "slick ear" was usually applied to horses, though also to maverick cattle. In strict usage it meant an animal which had not been ear-marked.

Although a cow is the most stupid of animals, when a cowboy said that a man had good "cow-sense" he meant to pay him a high compliment.

No matter by what name cattle were called, there is no denying that they not only saved Texas from financial ruin, but went far toward redeeming from a wilderness vast territories of the Northwest.

VIII

HORSES

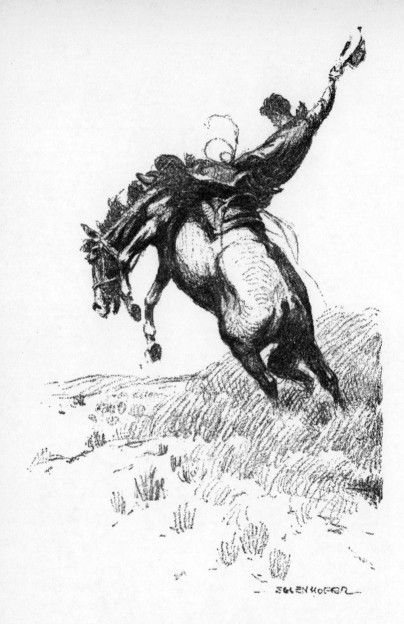

Some horses were inclined to pitch regardless
of their years in service

It has always been the disposition, if not the prerogative, of mankind to boast of the tools with which he works. In this respect the cowboy was no exception. From the dawn of ranching he has been dependent upon the horse for transportation. He might on occasions enthuse about his saddle, his boots, or his spurs, but it was his horse that always came in for the major praise. His horse became his pal, his constant companion with whom he talked as though with a human to break the lonely hours on the silent trails. Small wonder that the pride of every puncher was his horse and that much romancing has been engaged in by him as he sat around the campfire and related stories of the skill, ability, and almost human understanding of his "mount."

When the cowboy spoke of his "mount," he did not merely mean climbing astride of a horse, but the number of horses assigned him for his personal use while he worked with a certain outfit. Such a "mount" was also often referred to as his "string." Changing mounts was routine work with a cow outfit, but it was by no means devoid of interest—to the contrary, it was a potential thrill producer. If someone was pitched off or had to "pull leather" to stay on, it became a good subject for conversation the rest of the day. Some horses

were inclined to pitch regardless of their years in service—this was especially true in the spring when the grass got green. Often if they were saddled and allowed to "soak" for a while and eased off, they would not buck, but it would be a very different performance if the puncher mounted without untracking his horse and grabbed him with his spurs. And there would be no eight- or ten-second limit as provided for rodeo contestants.

The number of horses allotted to the men varied according to the kind of country worked over, the size of the ranch, and the work to be done. In the mountains, west of the Continental Divide, a greater number were required than on the plains. In general, however, seven head might be considered an average mount. These consisted of two "morning horses," two "afternoon horses," two "cutting horses," and a "night horse." In addition, on practically all the ranches that raised their own horses every man was allowed all the "broncs" he wanted to ride. Therefore, each man generally had from two to three half-broken horses in his mount. They were used on short rides and broken gradually, for in actual cow work a "bronc" was useless.

These extra saddle horses carried on the round-up or on the trail, and not at the time under saddle, were called the "remuda" or "remontha," the latter being a corruption of the Spanish *remonta*. They were also referred to as the "caballado" —from the Spanish which Mexicans degraded into "cavayer" or "cav-a-yah," and the American cowboy pushed farther into "cavvieyah, "cavvy," or "cavvoy." This term was used in the Southwest, but the term more commonly used was "saddle band" in the Northwest.

As with cattle, the cowboy divided horses into many technical classifications and gave them fitting names. The "mus-

tang" was a wild horse restricted to the unmixed variety, and the name came from the Spanish *mesteno*. Contrary to public opinion the hordes of wild horses found on the Western ranges when the first ranches were being established, were, practically speaking, never used for cow-horses. One reason for this was the difficulty of capturing them; the main reason, however, was that unless one was caught before the age of two years, it would never cease trying to escape and go back to the wild bunch. "Cayuse" was the name of the wild horses of Oregon, so named after the Cayuse tribe of Indians, an equestrian people, while "bronco" was the appellation given to wild or semi-tame horses. The word was often contracted into "bronc" and was from the Spanish *broncho*, meaning rough, rude. Though known as a "bronc" the first year, he was called a "last-year's bronc" the second season. A wild mare was sometimes called a "mockey."

The word "pony" had nothing to do with the animal's size, and in the Northwest practically every horse was called by this term. A "cow-horse" or "cow-pony" was one experienced in cattle work. A good cow-horse had one eye for the cow ahead and one for the ground; he inherited that gift. If he fell, he was lost; such, by nature, were eliminated. Nothing upon the range caused so many serious accidents as falling horses; and of nothing else was a puncher more afraid. Without good intellect no horse could ever be developed into a good cow-horse.

"Stock horses" were the brood mare and colts. Young horses, colts, and fillies were also sometimes called "potros." "Work horses" were those used in harness to wagon or scrapers. A "manada" was a band of mares with stallion, pronounced "menatha" in the Southwest. "Fuzz-tails," usually shortened to "fuzzies," were range-horses. "Willow-tails" were

horses, usually mares, which carried a long, loose, coarse, heavy tail, these qualities never being an indication of good breeding. These animals were also called "broom-tails," or "broomies." A horse having a tail with but little hair was called a "rat-tail."

There was as much difference in cow-horses as there was in cowboys. One horse may look pretty much like another to a stranger, but to a puncher who knew his mount, every horse had its own individuality. Real "top" horses were as scarce in a cow outfit as "top" hands, but it was seldom that a "top" hand was found without a "top" horse. The work which demonstrated a "top" cow-horse was cutting and roping. The percentage of "tops" was about one in twenty. The balance were good only for "day-herding" or "riding circle," and were called "churn-heads," "jug-heads," or "crock-heads." By these terms the cowboy meant that the horse spoken of was hard-headed, had a lack of intelligence, and had to be pulled around considerably before he was made to understand what was wanted of him.

A "cutting horse" was one highly trained for the act of cutting out cattle. A good "cutting horse" was not common; one was generally too valuable to be used anywhere but in the herd. Such a horse entered thoroughly into the spirit of the game, and found out immediately the animal his rider was after; he would then follow it closely of his own accord through every wheel and double at top speed. He was generally considered the acme of perfection of horsedom in ranch work. A horse may evidence certain natural cow-sense when first broken, but the coveted title of "top cutter" only came after years of training and experience. Such a horse was the pride of the entire outfit, especially if he could cut cattle without the bri-

dle, and the puncher who could boast of one in his "string" was the envy of his fellow workers.

A horse for such work had to be mentally, as well as physically, alert. He had to possess speed and action, and know when and how to use it. Once the animal was selected and started from the herd, the horse must anticipate and counter every move to prevent the animal from turning back. When the edge of the herd was reached, the animal had to be rushed sufficiently to send it away from the herd and the horse and rider went no farther than was necessary in order to save time and extra steps. All this had to be done in a manner that would excite the cattle the least amount.

While the horse may have appeared to need no assistance from his rider, an unskilled man was apt to catch a fall, or at best to hinder the perfect work of the horse. A horse and rider that understood each other made a combination that was a joy to watch and deserved to be the topic of conversation when good cow-horses were discussed. Such a horse was called by the slang names of "carving" or "chopping" horse, or was said to be a "good whittler," or "good chopper."

A "cutting horse" which possessed the talent of stopping short in his tracks when galloping in one direction, changing his direction, and instantly bounding off on a new course, was called a "peg horse," "peg pony," or "pegger." It was said that he "could turn on a quarter and give you back fifteen cents in change," "turn on a biscuit and never cut the crust," "turn on a button and never scratch it," or he "could cut a gopher from his hole."

Another high-type horse in cattle work was the "rope horse." Roping was the hardest work, the most dangerous, and required the most skill of man and horse. Each had to be

wide awake every minute. Mentality, rope, saddle cinch, nothing could be allowed a second's slack, or accidents would happen.

Many think that to catch is all there is to roping. In catching the critter the work had just begun. Slack had to be instantly taken and kept up. In order to perform this work successfully, the horse had to have strength and intelligence, both well trained; the same was true of the rider. The cow at the other end of the rope was not asleep. The top roping horse knew when the rider took his rope down and what he wished. He would go like a bullet to the left of the cow, but never past her. There he would stay until the rider cast his rope, then he would do his stuff—and he knew when the throw missed.

If the roper tied onto the animal, and pulled lightly back on the reins, the horse would sit back, hind feet well under him, fore feet well out in front, hard on the ground, and receive the shock. Did the rider give him the least pressure on the left side of the neck with the reins, he would whirl instantly, facing the catch. A good horse would hold, rider or no rider; never allowing a cow to get a side run on him—that would throw him on his side; or give the rope an inch of slack—that would allow the rope to wind him up. Experience taught him the consequences of both blunders.

Another valuable horse, especially in trail work, was the "night-horse." These horses were generally the surest-footed, the clearest-sighted, and the most intelligent horses that a cowboy had in his "string." He was ridden only at night, and while his work was frequently easy, it was, again, likely to be exceedingly hard. In every "remuda" there were certain horses known to be "night-horses," no matter what cowboy might inherit him for his mount. Their sure-footedness and ability

to detect an animal in the dark was uncanny, and they could find their way back to the "wagon" on the darkest night. Many night-guards have been ridden by dozing cowboys who, nodding the hours through, sat in the saddle upon a horse that needed no touch of the bridle rein, but jogged the circle around the herd with faithful regularity, and put back every cow that attempted to escape from it. Good "night-horses," along with "cutting" and "roping" horses, were prized beyond price and generally loved by the man who rode them. The cowboy's humorous and affectionate name for his "night-horse" was his "night-mare." A horse so trained that when the reins were laid on the left side of his neck turned to the left and on the right to the right, was said to be "bridle-wise."

Mares with a bell around the neck, used in some parts of the cattle country to keep the saddle horses together, were called "bell mares," and the Mexican's name for these was "re-mudera." Where horses ran off their home range, they were said to "break range." Horses that had the habit of leaving the remuda and pulling for the home ranch or to parts unknown were called "bunch-quitters," and range-horses living upon bunch grass were referred to as "bunch-grassers." An easy-gaited saddle horse was called a "saddler," and one that could travel great distances at high speed was a "long horse." What the cowboy called a "Sunday horse" was one with an easy gait, usually a single-footer with style, and he was used when the cowboy went "gallin'." Sometimes near the southern border one heard the names "mesteno" and "caballo" used in speaking of a horse.

In the olden days when means of transportation were not so plentiful, each cowboy often owned a couple of private horses which were carried around with the "remuda." These

were called his "individuals" and were ridden by him only at his pleasure. Then in case he was fired or quit suddenly, he only had to throw his "bed-roll" on one, draw his pay check, mount the other, and jog away down the trail looking for another ranch home.

The cowboy's humorous reference to horses of long-legged punchers was "walkin' sticks," and a horse that secretly foraged the camp kitchen to indulge his acquired tastes was called a "pie-biter." An Indian pony was sometimes referred to as a "cuitan," and the "navvy" was a Navajo Indian pony, said to be about the poorest specimen of horse-flesh on earth.

A "fresh horse" was one that had had a few months' rest and had gained a good amount of flesh and sometimes a very "bad heart" since he was last ridden. A "spoiled horse" was one abused at the breaking period until he had his character ruined—a man-made "outlaw." Such horses fought every time they were ridden and were placed in the "rough string." Outlaw horses furnished some diversions and considerable practice in riding, and one or two "snuffy" horses were usually placed in each cowboy's "string." When a man took a new job, the boss usually pointed out to him six or eight horses which were his for use, very seldom giving him any information regarding them. Information was frequently taken as an offense; to tell him nothing was a compliment—a good way to start a new man off. Bad horses were variously referred to as "oily broncs," or "salty broncs," and were said to be "snuffy," "spooky," "snaky," or to have "snake blood" or "snake eyes." A "man-killer" or "killer" was a vicious horse that resorted to every tactic to kill his rider, and when he had succeeded in killing a man he was said to have "a notch in his tail." A "stampeder" was a horse easily frightened and one which ran away blindly.

A horse's physical defects furnished many slang names to the cowboy's lingo. He "paddled" when he winged out his front feet; he was said to be "forging" when he struck his front shoes with the toe of his hind ones. He was said to be "coon-footed" when he had long and very low pasterns, and "clear-footed" when he was able successfully to dodge gopher holes, etc. "Hog-backed" was a roached back, or the opposite of "sway-backed." "Falls out of bed" meant pulling back on the halter rope, and a horse with a torn lip where the bridle bit rested was said to "smoke his pipe." A "stump-sucker" was a horse having the vice of biting or getting his teeth against something and "sucking wind." "Cold-jawed" meant that he had a hard mouth, while "smooth mouth" was the reference to an aged horse, and "toothing" was looking at a horse's teeth to tell his age. In the southern border country a wind-broken horse was spoken of as being "salado" or "salowed." A "wring tail" was a horse of nervous disposition that had been ridden to exhaustion and spurred to make him go, causing the habit of wringing his tail as he ran.

A broken-down horse was a "plug," and if one was in poor condition he was "shad-bellied," "slab-sided," "crow bait," "buzzard bait," or a "boneyard," and had "bed-slat ribs." In speaking of such a horse, a cowboy once said to us that "that old hoss was dead, but jes' wouldn't lay down." One bloated on grass was "grass-bellied," "wind-bellied," "whey-bellied," or "pot-gutted."

To overrun a horse was to "jigger" him and to overheat him was to "bake" him. To ride a horse until his back became sore was to "beefsteak" or "gimlet" him, and such sores were called "set fasts." The catarrhal disease common among horses and known as "distemper" was slangily called "epizootic" by the cowboy.

The question as to whether one can tell the good or bad qualities of a horse by its color will probably never be settled on the range. Some riders preferred one color, some another. But, after all, "color don't count if the colt don't trot" seemed to be the rule, even if most cowboys did have favorite colors for riding. As far as can be learned, there are only three colors, with their variations, that can be said actually to affect the efficiency of an animal. Those are white, "pinto," and "buckskin." A white horse, "chalk-white," was a horse that was likely to suffer from constitutional weakness as a result of inbreeding, while a "pinto," also known as a "paint," "piebald," "pied," or "calico," was a descendant of the Indian ponies, and while they were very strong and hardy, they never attained great size. The "claybank," or "dun," was universally noted for its tremendous endurance. The buckskin showing dark stripes about its legs above and below the knees and hock joints, or along its spinal column, which the Southwest called a "bayo coyote," was particularly endowed with great endurance. They were descended from a distinct breed of Spanish ponies. Black horses were said to suffer most from heat; "bays" were generally supposed to be the most vicious, and "chestnuts" tenderest of skin, and most easily injured. Other colors in horses received the cowboy's own classification. The "grulla" was a mouse-colored horse, the "moros" one of bluish color, the "trigueno" a brown horse, while a white horse that was covered with small brown freckles was called a "flea-bitten"; and "stew ball," or "skew-bald," was a black-and-white spotted horse.

When the cowboy needed his horse shod, he said he "had to have his pony plated." If he did not do this work himself, he had it done by a "hoof-shaper," his name for a blacksmith,

and this man had to be able to "tack iron on everything that flew past" if he was onto his business. The cowboy also had his own terminology for the various types of shoes. A smooth shoe was called a "slipper," one with calked heel was a "shoe," while one with both heel and toe calked was a "boot."

A horse with endurance was said to have "bottom." Tangles in a horse's mane were called "witches' bridles." "Snubbing" was the act of tying a horse's head to some fixed object, while "sacking" was using a sack or blanket in breaking a horse. This was filliped about the animal to get him used to it.

"Talkin' hoss" was a subject that never grew old with the cowboy. If one could listen to the conversation of a bunch of punchers at work, he would find two thirds of it about horses. They extol the merits of one and deplore the shortcomings of another. Trading and swapping was continuous, although every cowboy generally had one or more horses that money could not buy. It often happened that cowboys quit and left a ranch where they had worked for years because some higher-up had come out to the ranch and decided to take their pet horses away from them. On this subject the cowboy was very apt in the use of his figures of speech. Anyone who has been around horses have heard them snort, but it took a cowboy to express it as "he snorted like he had rollers in his nose." One cowboy, in speaking of the speed of a certain horse, said he was "as fast a hoss as ever looked through a bridle." In speaking of a horse's gentleness he was apt to express it as "this hoss is so gentle y'u could stake 'im to a hairpin," or, "he's as gentle as a family broken cayuse." A very fitting description of a horse shaking himself was uttered by Tex Coleman when he said, "This hoss shakes hisself like a dog leavin' water till the saddle pops an' cracks."

One method of capturing wild mustangs was to "crease" them. This meant that the person must first get within close shooting distance of this most animated target. He must then place a rifle bullet in the top of its neck, grazing the cords of the neck just enough to stun the animal and knock it down so that it can be tied down before recovering from the shock. One must be not only a mighty good shot, but extremely lucky, to make a success of this method; it was very easy either to break the neck of the animal, simply give it a scare and a slight wound, or score a clean miss.

"Walking down" was another method of capturing wild horses, and it called for following them by relays fast enough to keep them in sight and giving them no chance to rest or eat. After several days of this, the mustangs were exhausted enough so that the riders could approach and begin their turning in any direction desired.

The horse's intelligence and docility were developed in proportion to the extent of his contact with mankind. In the old days, when cow-ponies were caught, saddled, and ridden to be turned loose again without other handling, it was natural that these qualities were not in evidence. It was owing to their treatment and not to their disposition that they acquired a bad name.

The Western horse possessed an individuality and a self-reliance uncommon in horses raised more or less in confinement. It was not necessary to guide him around treacherous holes when galloping full speed across a prairie-dog town, neither was it necessary to look out or stones and rocks along the road. When he was led to a strange watering-place, he was very careful to satisfy himself that the bank was not boggy, and before he would trust his weight in the mud, he would test it with first one foot and then the other.

Really to know horses, how to care for them, keep them in good shape, and, at the same time, get the maximum of work out of them, was a great deal more essential to the cowboy than merely being able to "scratch hell out of anything that wore hair."

✦ IX ✦

..

RIDING

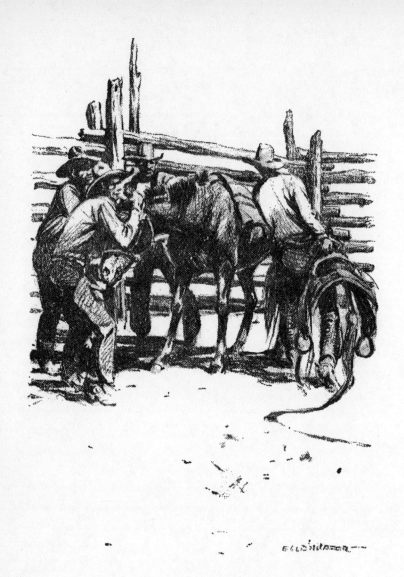

Often he was merely "eared down" by a "hazer"

Riding bucking horses on a ranch and at a rodeo had a distinctive difference. Except when a puncher wanted to put on a little show of his own, the riding of a bucking horse on a ranch was a matter of necessity—if he couldn't ride, the boss probably would hire someone who could. If the performance started when the rider was well away from the camp or wagon, it meant that he must maintain his seat or else— And the else would include, in addition to a good hard fall, a walk to camp and an appeal to the other boys to see if he had enough saddle to salvage. At rodeo performances the prizes were the attraction. Here the riders rode for a predetermined number of seconds, while the puncher on the ranch had to ride until the horse was conquered.

There is always something inspiring in the battle of man and horse. That is why people flock to see a rodeo. The bucking horse of the West is looked upon with awe and with something of a superstition by everyone save the cowboy. He simply regards the worst of the lot as a critter to be tamed sooner or later.

If the "buster" had plenty of time, he might spend a good part of it teaching the bronc the terrors of the rope. The roped horse might drag him around the corral a few times,

but eventually the man would get the rope looped around the firm "snubbin'-post," in the center of the corral. After the horse had "run on the rope"—that is, dashed to the end of the rope and got thrown a few times—he would soon learn the futility of fighting the "string." If, when breaking the bronc to "lead," he pulled back on the rope, he was said to "set back." After he was broken to "lead," the buster started "sacking." He fanned a saddle blanket around the brute, eventually dropping it on the bronc's back many times. Frequently he put the saddle on and let the horse buck with the saddle alone just to convince him that the rig was on his back to stay.

Frequently not so much time was spent in preliminaries, but the horse was thrown, "blinded" with a sack or cloth over his eyes to keep him quiet, and saddled by main force. Often he was merely "eared down" by a "hazer" who held the horse by the ears with his hands or teeth to distract his attention. When obliged to ride without the help of a "hazer," the rider would divert the horse's attention by sticking his thumb in the brute's left eye. When he "got his wood on him" and "got the tree laced up," he "forked," "hairpinned," or "stepped across" the animal and yelled to the men who held the ropes to "shoot," "turn loose," "ease up," "throw off," or "let 'er go." From the "op'ra house," the top rail of the corral, or the side lines, perhaps, came the unwelcome advice to "stay with 'er," "cinch 'er when she bucks," "rise to the trot," "tickle 'er feet," "waltz with the lady," "throw in yo' gut-hooks," "bust 'er wide open," "shove in the steel," "rake 'er," or "scratch 'er." "Breaking" or "gentling" a horse was the conquering, taming, and training of the animal by force and fight.

"Cheeking" a horse, in cowboy parlance, meant "gittin' up in the big middle of 'im" without giving the horse a chance to run or begin pitching before the rider gets set in the saddle.

To mount a horse in this manner the cowboy grasped the cheek strap of the bridle just above the bit and pulled the horse's head as far toward the saddle as possible, while he turned his stirrup toward the horse's fore leg so as to place himself as far out of range of the hind feet as possible. The right rein was in normal position along the horse's neck, the left was grasped with the cheek strap. The cowboy placed his left foot in the stirrup, moved up and down a time or two without making any effort to get into the saddle. If the horse stood good, he would ease lightly into the saddle and, when his feet were set in the stirrups, would release the cheek hold and be ready for the horse to pitch or pace. If the rider did not know the horse, he would "cheek" him the first time he rode him.

Bronc-riders went by such slang names as "bronc-buster," "bronc-peeler," "bronc-twister," "bronc-snapper," "bronc-breaker," "bronc-scratcher," "bronc-squeezer," "flash-rider," "bull-bat," "jinete," or "rough-string rider." A "contract buster" was a rough rider who leased his services at so much a head. They were usually owners of small ranches, or else were men who, as itinerates, wandered about the range and temporarily sold their services to such establishments as could not afford to maintain a first-class rider of their own. "Bronc-busters" were specially gifted men who became a class of themselves and took to the hazardous trade of horse-breaking as a steady business. Probably the most important qualifications a man could have for this roughest of all man games was nerve and self-assurance. If the "buster" ever became afraid of a horse, the horse seemed to realize it even more quickly, sometimes, than the rider himself. In that case, the affair usually terminated by the horse conquering the rider instead of the rider conquering the horse.

When a horse lowered his head between his fore legs preparatory to start bucking, he was said to have "bogged his head," "swallowed his head," or "stuck 'is bill in the ground." When he started to buck, it was said that he "boiled over," "broke in two," "came apart," "folded up," "kettled," "shot its back," "slatted its sails," "unwound," "hopped for mama," or "wrinkled his spine."

The ways of a bucking horse were more devious than the ways of anything else in flesh. No two animals bucked exactly alike. Each, however, had a descriptive title, as had everything else in the West. "Bucking on a dime" was said when the horse did his bucking in one spot. "Bucking straight away" consisted of long jumps straight ahead without any twists or rearings, an easy horse to ride. A "high-roller" was a horse that leaped high into the air when bucking, also called a "high-poler." "Pitchin' fence-cornered" or "fence-wormin'" was said when the horse left the ground headed in one direction and landed in another. When a horse reared wildly and vaulted upward, pawing frantically with his fore feet, he was known as a "cloud-hunter."

A peculiarly exasperating variety of bucking horse was the "weaver." His feet never struck the ground in a straight line. He had a peculiar weaving motion which was very disconcerting to a man who had not the firmest of seats in the saddle. The "pioneer bucker" was an animal that bucked in circles and figure eights. He was called a "pioneer" because he was always seeking new territory. "Sunfishing" was a term used when a horse twisted his body into a crescent, with its horns alternately right and left, or, in other words, when he seemed to try to touch the ground with first one shoulder and then the other, letting the sunlight hit his belly. Such a horse was called a "sunfisher." "Swapping ends" was a movement

peculiar to a bronc where he quickly reversed his position, making a complete half-circle in the air; sometimes called "windmilling." "Walkin'-beamin'" or "pump-handle" bucking was the see-saw effect of a bucking horse, wherein he landed alternately on his front and hind feet. A "pile-driver" was a horse that humped his back and came down with all four legs as stiff as ramrods, and "high he goes an' hard he hits." The result was a grinding shock that would drive any ordinary man's spine through his hat, but the watchful cowboy, sitting limply in the saddle gave no sign.

A horse which jumped about with arched back and stiffened knees at a pretense of bucking was said to "crow-hop." "Cat-back" and "goat" were also terms for half-hearted pitching. A "show bucker" was a horse that bucked hard, straight away, and with nose between front feet, though not difficult to ride. In rodeos he looked good from the grandstand, but was never used in the semi-finals. When a horse bucked backward, he was said to be "crawfishin'." A sudden shift in the gait of a bucking horse was called the "double-shuffle."

"Jack-knifing" was a clipping together of the front and rear legs sometimes as a part of a "straight buck." A "fall-back" or "rear-back" was when a horse reared on his hind legs, lost his balance, and fell backward; such a horse was also called a "cinch-binder." The "throw-back" was when the horse hurled himself backward intentionally, and this was a trick of a "killer." A "spinner" was a horse which went up and whirled backward instead of up and forward, and when he leaped forward in an upward jump, and turned, feet in air, landing on his back, he was said to "pin-wheel." Any horse that bucked was termed a "bucker." A "blind bucker" was a horse that lost his head when ridden and bucked into and through anything.

Using the spurs in the act of riding came in for many of

the cowboy's technical and slang terms also. "Scratching" was the act of keeping the feet moving in a kicking motion in riding bucking horses, and one of the acts necessary to win at any real bucking contest. "Raking," synonymous to "scratching," was generally applied when the rider gave his legs a free sweep, rolling the rowels of his spurs along the horse's sides from shoulder to rump, and was one of the highest accomplishments coveted by the bronco-buster. "Bicycling" was the act of "scratching" with first one foot and then the other in the manner of riding a bicycle. "Coasting on the spurs" was riding with the spurs locked in the cinch or under the horse's shoulder blades, and not tolerated in contests. "Screwing down" was the act of sinking the spurs into the cinch and failing to move the feet in a kicking motion as provided by rodeo rules. The cowboy was said to "curry him out" when he "raked" with his spurs; "reefing" and "combing" were also terms used. "Throwing the steel" was using the spurs freely, and the spur marks on a horse's hide were called "hundred an' elevens." A cowboy riding without spurs was said to be "slick-heeled," and one riding without locked spurs or tied stirrups was said to "ride slick." "Fanning," used as a riding term, meant to slap the horse with the rider's hat. "Blowing a stirrup" was losing it, which disqualified the rider in a contest.

"Riding the shows" was competing for prize money at rodeos. "Riding safe" was sitting close to the saddle, legs tightly clinched against the horse's sides, and spurs firmly set in the cinch, while "seeing daylight" was a term applied when a rider left his seat with each jump of the horse, so that spectators could see between rider and saddle. "Riding straight up" consisted in the rider sitting straight up in the saddle holding one hand on the reins and the other in the air. "Sit-

ting close to the plaster" was keeping a close and firm seat in the saddle; also sometimes spoken of as a "close seat." "Riding with a slick saddle" was to ride a bronc without a "saddle roll," without "hobbled stirrups," and without "grabbin' the apple"; a real buster scorned the use of any device which gave him an advantage over the horse. "Riding it out" was staying with a horse until he was conquered. "Sloppy riding" was sitting loosely in the saddle allowing the body to flop about in response to the pitching of the horse.

"Monkey style" was a riding term which involved the rider's seizing the horn of the saddle by one or both hands, pushing himself sideways out of the saddle and standing in one stirrup, with his knee on that side flexed, and his other leg at its midway point between hip and knee resting horizontally across the saddle's seat. His flexed knee-joint and his hip-joint thus collectively absorbed the shock of the bucking horse.

There were several ways for the rider to secure the advantage over the horse. One was the use of a "saddle roll," or "bucking roll." This was a roll of blankets tied across the saddle, just behind the horn; these helped to wedge the rider in the saddle, and make it more difficult for the horse to throw him. The same effect could be gained by the use of a saddle with a large "fork swell" to give him more "knee grip." Another was the use of "locked spurs." This was done by tying a string around the rowel so that it would not turn; without doing this the spurs did not assist the rider in staying on; on the contrary, they acted as a sort of ball-bearing in throwing him. Still another method was the "hobbled stirrups," which meant tying them together with a rope running from one side to the other under the horse's belly; this prevented the

stirrups from flopping, while the horse was bucking. To the real rider the use of these makeshifts was an unpardonable offense.

After the "buster" had ridden a bronc a few times, he turned him over to the riders as "gentled" or "broken," but it would be a long time before the rider who inherited him could ride him on duty without first riding him long enough to take the kinks out of his back which the cowboy spoke of as "topping off," "uncorkin'," "unroostering," "settin' the hair," "workin' over," "kickin' the frost out," "smoothin' the humps out," or "ironin' him out."

To catch hold of the saddle horn during the riding of a bucking horse was known by such terms as "chokin' the horn," "clawin' leather," "grabbin' the nubbin'," "grabbin' the post," "pullin' leather," "reachin' for the apple," "shakin' hands with grandma," "squeezin' the biscuit," "squeezin' Lizzie," "safety first," "huntin' leather," "takin' leather," "touchin' leather," and many others.

How to fall was one of the first things the rider of a bronc must learn. He must know how to kick free of the stirrups and save himself from being dragged by one foot; to just grow limp and hit the ground rolling. A rider always knew he was going a jump or two before he was actually gone, and would look for a soft place to land, taking pains to roll beyond reach of kicking heels and striking fore feet. A fall had no terrors for the seasoned cowboy, for he had had many of them.

When the horse "unloaded" his rider, he "turned the pack" and the victim was said to be "chucked," "dumped," "spilled," "landed," "bit the dust," "chewed gravel," was "eatin' dirt," went "grass-huntin'," "kissed the ground," "landed on his sombrero," or "sunned his moccasins." One cowboy of our acquaintance, in relating his experience with a vicious horse,

said: "I had trouble gettin' my wood on him, an' when I did get my tree laced up, it didn't do me much good 'cause I didn't get settled 'fore I goes sailin' off, flyin' low an' usin' my face for a rough-lock 'til I lost 'nough hide to make a pair o' leggins." Another, telling of a similar experience, admitted that he "pulled leather 'til he nearly pulled the horn out by the roots," but he lost his hold and soon went flying off, "his hind legs kickin' 'round in the air like a migratin' bull-frog in full flight"; he added that he "didn't break anything, but all the hinges an' bolts were loosened." Such sentences illustrate the typical speech of the cowboy. It seemed to come to him as second nature. Another rider made the statement that he once was thrown in a cactus patch, and "it took a week to pluck 'im so he wouldn't look like a porcupine." We once heard a cowboy tell another, who had just been thrown pretty hard, "If y'u'd try 'er ag'in an' manage to hit the same place y'u'd git water, shore." To "stay in one's tree," "stay in one's pine," or "stay in one's old ellum fork," meant to remain in the saddle.

When the horse "hid his head an' kicked the lid off," or "warped his backbone an' hallelujahed all over the lot," the comments upon his ability were such as, "he's a beast with a bellyful of bed springs," "frolicsome little beast," "real hunk o' death," "cutey, little grave-digger," "he's tryin' to chin the moon"; and perhaps the rider was warned that the horse would "buck his whiskers off," or "he'll throw y'u so high the birds'll build nests in yo' hair 'fore y'u light," or "he'll stomp y'u in the ground so deep y'u'll take roots an' sprout."

If the horse was a bucker of ability, he was a "gut-twister," and it was "like ridin' a cyclone with the bridle off," and it "took a man with whiskers to ride 'im." Of the man making a good ride it was said that "he sets that bronc as easy as a hoss-

fly on a mule's ear," that he was "stickin' like a tick makin' a gotch-ear," or it was "jes' like buckin' off a porous plaster," and you "couldn't have chopped him loose from that hoss with an axe." About the man who had little riding ability it was said he "couldn't ride a covered wagon," or "couldn't ride nuthin' wilder than a wheel chair."

"Thumbing" was jabbing a horse with the thumb to provoke further bucking. What cowboys in other sections called "bucking," the Texan called "pitching." "Light riders" were men who kept themselves in balance upon and with the horse and could ride for long distances without retightening the cinches or galling the horse's back, no matter how heavy their poundage. A "flying mount" was leaping from the ground to the saddle without using the spurs; also called "running mount," and in Wild West shows, "pony express mount." To "make for a horse" and mount on the run was known as "takin' a run."

"Scratching gravel" was climbing a steep bank or hill on horseback. Ordinary riding was known as "rackin'," or "jiggling," but "snappin' broncs" meant breaking wild ones. The cowboy on a headstrong horse, if he was in an open country, let him go "'til he run down his mainspring."

In this chapter it might be proper to mention another feature of the rodeo, known as "bulldogging." To "bulldog" a steer, the "dogger" threw his right arm over the brute's neck, the right hand gripping the neck's loose bottom skin or the base of the right horn or the brute's nose, while the left hand seized the tip of the animal's left horn. The "dogger" then was clear of the ground; and, by lunging his body downward against his own left elbow, so twisted the neck of the steer that the latter lost its balance. When the rodeo "bulldogger"

leaned over and fastened his teeth in the upper lip of the bull-dogged steer, he was said to "bite 'im lip."

The act of leaning forward and alighting on the horns of a steer in "bulldogging," in a manner to knock the steer down without having to resort to twisting the animal down with a wrestling hold, was called "hoolihaning," and the act was barred at practically all recognized rodeos.

Riding a bucking horse, if not an art, was certainly a contest requiring skill, courage, and strength, especially if it happened to be a horse that had been spoiled or had acquired the habit from general cussedness. We doubt if there was any one thing in connection with ranch work or a rodeo performance that was more exciting than a good rider on a bucking horse.

→ X ←

........................

THE ROUND-UP

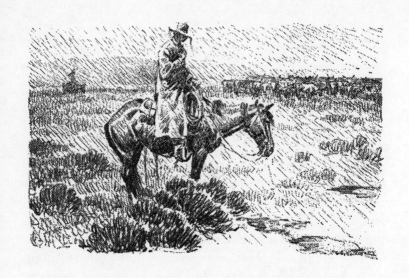

Again it was cold, rainy, and disagreeable

One of the "wholesale" operations in handling range cattle in the old days of free grass and fenceless pastures was the "round-up." It was a harvesting of cattle, a great gathering-up and a sorting-out; and a branding of beasts, young and old, that were without marks of ownership burnt into their hides. While the "round-up" was a proposition quite different from that of putting and driving a large herd on the trail, the two, as spectacles or pictures, were the great companion pieces of the range-cattle industry in the old days.

The "round-up" of the earlier days was called a "rodeo," from the Spanish word *rodeo*, but in later days this latter word was used strictly for cowboy contests. The primitive forerunner of the round-up in Texas was a getting together of a few neighboring stockmen to look over each other's herds for stray animals. These small neighborhood affairs did not include a thoroughly organized, systematic search of a large extent of country and of an equally systematic identification of the ownership of all the cattle so collected, that were the purposes of the great round-up of the open range in later years. These neighborly gatherings were called by the various names of "cow hunts," "cow work," "work," "cow drives," or were spoken of as "running cattle."

The round-up of the open range developed as the cattle business increased and extended. It was one of the necessities that arose with the general occupation of the country by cattlemen with enlarging herds and from certain of the circumstances that attended this "crowding" of the range. As ranches and herds became more numerous, ranges began to overlap their borders, and the opportunities for cattle of neighboring herds to intermingle were many and easy. Therefore, the stockmen had to adopt co-operative plans, and under it work each other's ranges to gather up in one operation and sort out the cattle upon them. In other words, they adopted the round-up system, in the broad sense of the term. Its general methods varied in detail in different sections and even in localities, but in the main they were much the same.

There were two round-ups a year — one in the spring, the other in the fall. The "spring round-up," often called the "calf round-up," was the most important and was for the branding of the "calf crop." This round-up, or "general work," as it was sometimes called, began when the grass came in the spring. This time of the year in a cow-camp was measured, not by calendar dates, but by the "comin' grass," when the range began to "green up."

The "fall round-up," or "beef round-up," was for the purpose of gathering all cattle for shipment to market, and for the branding of late calves or those overlooked in the "spring work." It was conducted along much the same lines as that of the earlier part of the year, but the work was usually done with more deliberation, for the animals then were heavier in flesh and fat. These round-ups were the most important functions in cattle-land, and the term "work" was applied to all this rounding-up, branding, and gathering.

Before the "spring round-up" the cattlemen of a district met and chose some experienced cowman to be the general superintendent of the approaching district round-up. He was commonly known as the "round-up captain," "round-up boss," or "wagon boss." He was boss over all and his word was law, no matter if he did not own a hoof. The owners of the cattle were as much under his orders as any common puncher or horse-wrangler.

The "round-up captain" selected, from among the cowboys he knew to be of good judgment, as many lieutenants as he thought he needed. These subalterns would be in command of groups of cowboys that were to scour the range thoroughly in search of vagrant cattle as well as of the large bunches. The plan of the campaign that was to cover a broad extent of wild country was carefully worked out with a view of producing the most satisfactory results within the allotted time. Giving directions to the riders where to start the drive was called "tellin' off the riders." Orders from the captain were referred to as "powders."

As this troop of cowboys rode over the range, it spread out, dividing into small parties, and presently these scattered until its men were separated by distances that varied according to the topography of the country. Each man had to hunt out all the cattle on the ground over which he rode, and, if it were much broken, careful searching for scattered individuals or small groups was necessary. Gathering up these cattle by ones and twos, and by small groups, and driving them ahead to a designated "holding spot," was called "riding circle," the "holding spot" or "parada grounds" being the location selected for the working of the herd. Occasionally one heard such a herd spoken of as a "petalta," which meant a herd rounded-up for cutting out.

As soon as the converging "circle riders" had urged their quarry onto the designated "holding spot," they surrounded the captured cattle and held them in "close herd," or, in other words, in a compact group.

After a pause sufficient to allow the men to change their horses, the concentrated mass of cattle was invaded by cowboys astride nimble-footed ponies that, both by instinct and training, were specially adapted to "cutting out" animals from the herd. "Cutting out" was the act of separating cattle, which process meant that the rider, sighting an animal to be segregated, rode between it and the body of the herd, and, after much dodging, hied it to where the "cut" was being formed.

This "cutting out" called for bold and skillful horsemanship and involved some personal danger. The cattle were gradually divorced from the main herd and driven before the "tally man," and then, as indicated by their brands, were distributed among various subsidiary "holding spots," one such spot being allotted to each ranch represented. The cattle at each such spot collectively formed what was termed a "cut" or "day herd."

Often after the first day, when work was pressing there was what was known as the "night drive." Small squads of men, consisting of one or more from each outfit, were sent ahead ten or fifteen miles from the mess-wagons to camp on their own hook, and very early in the morning begin driving cattle in the country around designated for the next day.

During the "fall round-up" such cattle as were "cut" for shipment were known as the "beef cut." Those not wanted were the "cut-backs"; the "culls" were also in this class.

The final cattle driven in from the circle on round-up were called the "combings." All coulees, canyons, foothills, and flats

must be "combed" thoroughly for hiding cattle. The "maverick" could only exist as proof of bad "combing."

Whatever "strays" from foreign ranges were encountered were, at the round-up's conclusion, shoved toward their home range if there was no "strayman" of its brand present, this neighborly process being styled "throwing over."

A round-up where the final bunching of cattle was not within a corral, but in the open, was called an "open round-up." "Moonshinin'" was working on round-up in a country so rough that packs had to be used in place of chuck-wagons.

Cattle belonging to outfits not using the immediate range were cut out of the round-up herds by the men representing them and were also thrown into the "day herd." When the "rep," "outside," or "strayman," as these riders for other concerns were called, believed he had reached the outside limit of the "drift" from his company's ranges, he cut out from the "day herd" the cattle so far gathered, took his mount of ten or twelve saddle horses from the remuda, packed one of them with his camp bed and personal plunder, and, in native lingo, "dragged it for home." Several other cowboys coming from ranges close to his would "throw in" with him, and all drive back in one bunch.

Many riders like a "rep" job because it called for no "day-herding." The reason for this was that the "rep" had to be on the "cutting grounds" so as to look through every fresh herd that came in off every day's "circle," cut out and brand the cattle that belonged to his outfit, and throw them into the main head.

Standing "day herd" or "day guard" was supposed to be the cowboy's Purgatory. The days were long, and whether he rode much or little his attention must be on the herd constantly.

Sometimes the day was hot; again it was cold, rainy, and disagreeable.

There were four periods of guard during the night, and "cock-tail." "Cock-tail" was despised by all. On that guard one must get out at the time when men love to sleep. It was morning; cattle were beginning to move, and while you were busy holding them your friends were getting their breakfast and hot coffee. "Killpecker" was the guard from sundown until eight o'clock; also called "bob-tail guard." The "graveyard shift" came at one A.M., and the others had various slang names also. "Relief men" were those relieving the preceding guard, while "off herd" meant off guard duty.

The expression "standing night guard" was seldom used. Night-guarding was known as "singin' to 'em." "Hymns" were what the cowboy called the songs he sang to cattle; they were usually of religious tunes accompanied by profane words. Upon night guard, all must go in their turn, usually two men on each guard. Reaching the herd, they would ride in opposite directions around it, and so continuing, if all went well, until they were relieved. If the night was dark and stormy, night-guarding was truly a man's job. Cattle were restless, one could have no light, must not even strike a match. The least unusual thing might start a stampede. This was very dangerous, hard to handle, and expensive to the owners. It was upon such nights that the cowboy said "y'u'd have to ride a mile to spit." Upon pleasant nights the work was not hard, but one had to stay in the saddle all the time, and the hours were long and lonesome.

When cattlemen over a wide range of territory pooled their resources and men, it was often spoken of as a "pool round-up."

To "prowl" was to go back over a territory after a round-up in search of cattle which may have been missed.

The round-up seasons were often spoken of by the cowboy as "sleepin' out," or "bedding out," for at this time he did his sleeping in the open where he learned to study and love the stars. These stars became his guide, his clock, and his almanac. They became his friends and his solace, and when he fell asleep there was peace in his heart, and no matter what his sorrow he was ready to face it in the morning.

It is fitting to refer to the round-up as a thing of the past, although in some parts of the Western country it lingers in emaciated form—little more than a ghost of what it used to be. The term still is in common use, but greatly extended in its application and may be applied to almost any sort of gathering together. If a herd of cattle was to be moved from one fenced pasture to another, or if a bunch was to be driven to a railroad station for shipment, rounding-up the animals was one of the preliminaries. But the real thing was a different proceeding. The great, wide, open plains formed its true field of action, but as fences came in, it passed out.

✦ XI ✦

...........................

BRANDS AND
EAR-MARKS

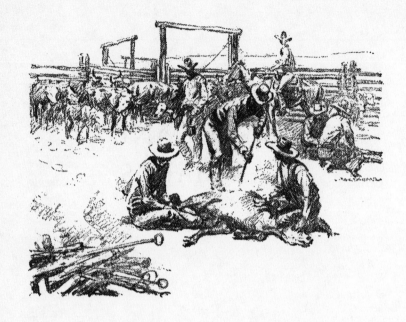

Branding soon became a systematized business

The language of brands is a special language requiring particular knowledge, both symbolic and useful, and this knowledge marks the genuine cowman more than anything else. It cannot be bought with anything save experience. A volume could be written about the origin of brands, their use and methods of application, but it is our purpose to endeavor to stick with the language of the cowboy as each phase of his work is dealt with.

There are many kinds of brands as well as innumerable forms and each had a name of its own. They were the cattleman's mark of identification, his trade-mark. Branding soon became a systematized business, and brands had to be registered with the proper official of his county, or State, a written instrument claiming the exclusive right to burn, upon a particular part of an animal, a particular design, and certain specified cuts in the ears, or other skin. If no one had a prior claim upon this design, it was formally allowed, and entered into the official "brand book."

If a man wished to sell an animal, the buyer could place his own brand upon it. Yet how could this be done without making his fellowman suspicious that he had stolen the animal outright? This necessity invented the "vent brand," the origi-

nal bill-of-sale. The original owner placed his brand upon
another part of the animal, which meant that he had deeded
the animal to the new owner, whose brand it also bore. Such
a brand had the effect of cancelling the ownership brand, and
was the acknowledgment of a sale. The word "vent" came
from the Spanish *venta*, meaning sale. "Counter-branding"
had the same effect. When a brand was superseded, by pur-
chase or by discovery that it had been wrongly or erroneously
placed upon an animal which bore it, the practice formerly
was for the purchaser, if it was a sale, or for the proper owner,
if a case of wrongful branding, to burn a "bar" through the
existing brand, as one would cross a word in writing. He then
put his own brand above or below it, and again on that part of
the animal where it properly belonged, if this superseding
mark was differently situated. At a later period of the cattle
industry "counter-branding" was done by duplicating the un-
desired brand and placing the new or rightful one upon the
animal where it belonged, eliminating the use of the "bar"
through the discarded brand.

With the opening of the cattle trails there came into use
another brand called the "road brand." This brand of en route
ownership saved many cattle for the drovers, as cattle fre-
quently strayed or stampeded on the trip. The brand origi-
nated in Texas during trail days when a law was passed that
all cattle being driven to market beyond the northern limits
of the State were to be branded with "a large and plain mark,
composed of any mark or design he may choose, with which
mark it shall be branded on the left side of the back behind
the shoulder."

There was another brand, used only in Texas, called a
"county brand." It consisted of a separate prescribed letter or
group of letters for each Texas county, and, if employed, went

always, and unlike other brands, upon the animal's neck. Trail cattle which changed ownership often upon their home range, then went up the trail to government agencies, might, at the end of their journey, have their hides thoroughly etched, or, in the language of the cowboy, be "burnt 'til they look like a brand book."

A "running-iron" was a branding-iron made in the form of a straight poker or rod curved at one end, and was used much after the free and fluent style in which shipping clerks mark boxes. Texas, in the seventies, passed a law against the use of this "iron" in branding. This was a blow aimed at the "rustler," whose innocent single iron would tell no tales if he were caught riding across the range. After this law it became the custom to use branding-irons made of a fixed stamp or pattern. Brands made with this latter iron were called "set brands" or "stamp brands." The iron itself sometimes went by the slang name of "scorcher."

Brands were composed of letters, numbers, symbols, monograms, and numerous combinations of each. The reading of brands was an art. To the tenderfoot, brands were so many picture puzzles, and he was almost sure to misread them, and often dazed by their queer jumble of lines, letters, and curves. The cowboy, on the other hand, took great pride in his ability to call them correctly. He unconsciously recorded the brand of every animal within his vision, and could see brands from a distance that would be impossible for the unpracticed eye.

Bar 6

Triangle D

Brand language, like other languages, followed certain rules. The characters of a brand read from top to bottom, as "Bar 6," outside to inside, as "Triangle D," and from left to right as "T Bar O."

T Bar O

Boxed E

Open A

Y Bench

Drag 7

Flying V

Forked S

Forked
Lightning

Lazy Y

A "boxed brand" was one whose design bore framing lines, as "Boxed E." An "open brand" was a letter or figure not boxed, although the letter "A" having no cross-section was also called an "Open A." A "bench brand" was one resting upon a horizontal bracket with its feet downward as a bench, as "Y Bench." A "drag brand" was one with a bottom projection which angled downward to some degree, as "Drag 7." A "flying brand" was one whose letter or figure had wings, as "Flying V." A "forked brand" was one with a V-shaped prong attached to any part of the letter, as "Forked S," but the old brand shown below and marked "Forked Lightning," was not called "Forked N," as might be supposed.

Any letter or figure "too tired to stand up" and lying on its side was called a "lazy brand," as "Lazy Y." The "rafter brand" was one having semi-cone-shaped lines above the letter or figure similar to the roof of a house, as "Rafter K." A "rocking brand" was one resting upon and connected with a quarter-circle, as "Rocking H"; if the quarter-circle had been unjoined, it would read "H Quarter-Circle." Similar symbols were not always called the same in different sections. For example, the brand "Rocking T" might be so called in one section of the West, but the famous

Rafter K

Rocking H

H Quarter
Circle

Rocking T

Swinging J

ranch in Texas using this brand called it "T An-
chor." A "swinging brand" was one suspended
from a quarter-circle, as "Swinging J." The "run-
ning brand" was one with curves at its end, as
"Running W." The "tumbling brand" was one
leaning in an oblique position, as "Tumbling K."
The "walking brand" was one with lower designs
like feet or legs, as "Walking R."

Running W

Tumbling K

Walking R

A letter or figure having one or more enlarged
termini was called a "bradded brand," such as the
"Bradded L" or "Bradded Dash." The "barbed
brand" was made with a short projection from
some part of it, as the "Barbed 5." A straight line
was usually called a "bar" if it rested in a horizon-
tal position. If it ran through a part of a letter, it
became a "cross" as "Cross C," or "Cross L." If it
was perpendicular, it was apt to be a "one," some-
times an "I," but if it leaned at an angle it was
called a "slash." A brand using this symbol lean-
ing, one one way and the other another, was called
the "Cut and Slash." The straight horizontal line,
if long, as John Chisum's brand, which extended
from shoulder to tail, was known as the "Fence
Rail." When it was added to as shown in the
illustration, it was called a "Knot on a Rail" or a
"Bug on a Rail." The old brand "Kid on a Rail"
was made as shown. A straight line connected

Bradded L

Bradded
Dash

Barbed 5

Cross C

Cross T

Kid on a Rail

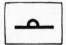

Knot on a Rail

Slash

Cut and Slash

Hobbled O

Double Circle

Diamond T

Diamond Tail

Barred
Diamond

Diamond
and a Half

with a circle on each end was called "Hobbled O."

The "O" if perfectly round, was called an "O" or a "circle," but if it was flattened to the least degree it was called a "Mashed O," a "Squashed O," or a "Goose Egg." If only a part of the curved circle was used it was called "three-quarter circle," "half-circle," or "quarter-circle," depending upon the amount used. A "circle" within a "circle" was known as a "Double Circle."

The "Diamond" was another symbol commonly used. The "Diamond T" was made as shown in the illustration, while a "diamond" with the addition of a tail was a "Diamond Tail." A bar running through the diamond was called the "Barred Diamond," and the "Diamond and a Half Brand" was made as shown in illustration so marked. The "Dotted Diamond Brand" was made with four dots, two at each side of the "diamond," but a "diamond" with a dot placed inside became the "Diamond Dot Brand"; the "Open Diamond O" was made as shown in illustration marked "Open Diamond O."

A brand, such as the figures 33 with the top of the "3" made with a horizontal line, was not called a "thirty-three," but designated as a "Square-Top Thirty-Three." If the "3" was upside down, the brand was not called the "Upside Down Three,"

Dotted
Diamond

Open
Diamond O

Square Top
Thirty-Three

Crazy
Three

but a "Crazy Three." The symbol of the moon was also used in branding and its name depended upon its position. For example, the moon in a horizontal position would be called the "Wet Moon," while a moon in a nearly vertical position would be a "New Moon," and was the "Man in the Moon" when the full circle was used with the markings shown in the accompanying illustration.

Wet Moon

New Moon

Man in the Moon

Roman numerals were also used. Such a brand as "IV" was not called an "I V," but the "Roman Four," yet when the numeral "X" was used, it was called after the letter rather than the numeral, as "LX" was the "L X Brand" instead of the "Roman Sixty." The monograms found on the hide of a cow differed distinctly from their Eastern relatives which were found on handkerchiefs and upon aristocratic stationery. Such brands as the "JA," "Pup Brand," and the "Bob Brand," are good examples. Similar to the "Monogram Brand" are those devices of letters and numerals combined, as "Four J Brand," the "Nine K Brand," or the "Seven-up Brand." Numerals were also made in monogram form, as the "Twenty-Four Brand," or the "Seventy-Six Brand."

JA

Pup

Bob

Four J

As mentioned before, the same brands might be called by different names in different parts of

Seventy-Six

Twenty-Four

Seven-Up

Nine K

Pot Hook or
Straddle Bug

Terrapin or
Doodle Bug

Lazy S or
Long S

Two-Pole
Pumpkin

Wallop

Quien Sabe

the country. What was called a "Pot Hook" in one section was called the "Straddle Bug" in another. The brand called the "Terrapin" on one range, was called a "Doodle Bug" on another. What was called a "Lazy S" in one State might be called, especially if made long, the "Long S" in another.

Every conceivable symbol was used in brands. Triangles, bells, pots, kettles, tools, spurs, bits, hearts, and countless others. These were usually easy to read, but there were many that even a cowboy would be at a loss to call correctly, had he not lived in the immediate vicinity and heard it spoken of. Brands coming under this class were the "Two-Pole Pumpkin," the "Wallop," and the "Quien Sabe," the latter, a famous brand of Texas, getting its name from the fact that when its owner was asked what he called it, he answered "Quien sabe," the Spanish for "Who knows?"— and "Quien Sabe" it has been called ever since. The "Gourd and Vine," the "Hog-Pen," and the "Porcupine" all came under this oddly named classification. An odd-looking brand, brought into a district from the outside, having no letters, numerals, or familiar figures by which it might be called, the cowboys dubbed by the enigmatical name of "Fluidy Mustard." The "Whangdoodle" was a brand with a group of interlocking wings

The Gourd
and Vine

Hog-Pen

Porcupine

Kitty-Cat

Currycomb
(Texas)

with no flying central figure. The brand illustrated under the initials MOL was originally intended to be the "MOL," but owing to its likeness to the rear view of a cat, was dubbed "Kitty-Cat" brand by the cowboys. Mexican brands were more complicated and perplexing than the American brands, and the American cowboys, in speaking of these intricate Mexican brands, did not attempt to translate them, but slangily referred to all of them briefly, but descriptively, as "the map of Mexico" or as "a skillet of snakes."

Currycomb
(Northwest)

Paddle

Square and
Compass

The "Tailbone Rafter" was two lines burned on the rump of an animal and meeting at the top of the tail-bone, while the "Bosal Brand" was a stripe burned around the nose. The "Currycomb Brand" in Texas was made as shown and marked (Texas), while one of the same name in the Northwest was made as illustrated and marked (Northwest). The "Paddle Brand" is shown under that name, and also the "Square and Compass" as indicated. The "Four T" could be made in two ways, as shown in illustrations. Other oddly named brands were the "Necktie," the "Bug Wagon," the "Window Sash," the "Booger F," the "Shanghai M," the "Tree L," and the "Lucky 7." The brand shown under the two names "Frying Pan" and "Tad Pole" might be called the "Frying

Four T

Four T

Bug Wagon

Window Sash

Shanghai M

Tree L

Lucky 7

Booger F

Necktie

Frying Pan
Tad Pole

Scab 8

Lazy 8

Turkey Track

Hashknife

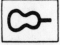

Bar BQ

Pan" in one locality and the "Tad Pole" in another.

One might wonder how the old Texas brand "Scab 8" received its name.

In the early days of West Texas adjoining the old "ROS" Ranch was an outfit using the brand "8" on the side and a "Lazy 8" on the thigh.

In time the "ROS" closed out and the country began to build fences. Another outfit came in and fenced a goodly portion of the "ROS" open range. They used the brand shown in the illustration, marked "Scab 8," thus making two outfits in the same section using the "Eight" brand. Though the two brands were dissimilar, they were a bit confusing in designation.

The "scab" term soon became used by the cowboys because the two "equal marks" often blotched when burned too close together, forming a sore or scar or scab.

In reality the brand should have been called "Eight Equal Eight," but few cowboys knew anything about the equality sign and so named the brand in their own original language.

Ranches commonly took their names from the brand burned on their cattle, as the "JA Ranch," the "XIT Ranch," or the "Turkey Track Ranch." Owners also lost the identity of their Christian names and were called by their brand, as "Hashknife" Johnson, whose brand was the "Hashknife," or "Barbecue" Campbell, who took his name from his brand, "Bar BQ."

Very often a cowboy working upon a ranch

was also called by its brand, as "Fiddle-Back Red," to distinguish him from the other red-heads of the range, and signifying that the one mentioned worked for the "Fiddle-Back Brand."

Calves to be branded were dragged to the fire and "flanked." This word, used as a verb, meant that the one doing the "flanking" caught the rope with the left hand just against the neck of the calf to be "flanked," or the ear on the side opposite him, then slapped his hand into the flank on the corresponding side. By a jerk upward and a pressure of the knees against the calf's side when it made the next jump, the cowboy sent the calf's feet outward and it came down on its side. "Flankers" usually worked in pairs. To "bulldog" a calf was often called "muggin'" him. The "iron man" then "run a brand on" or "slapped a brand on" and called out to the "tally man" the brand, ear-mark, and sex of the calf, and it was entered on the "tally sheet" or "beef book." During this time the "marker" had cut the ear-marks used by the owner. When the "iron" became too cold to scar the hide, the "brander" yelled, "Hot iron," and one was brought from the fire on the run. An animal was said to be "range branded" when it was branded upon the open range away from corrals.

"Tally branding" was taking an inventory of cattle. A "picked brand" was accomplished by picking out tufts of hair in the lines desired by the aid of a jack-knife. It was seldom used except by dishonest men until they could get the animal out of the country, as it was only temporary. A "hair brand" was one whereby the branding-iron was held against the animal just long enough to burn the hair, not the hide. The hair grew out, effacing the signs of the brand, and the rustler could then put his own brand on the animal.

...

"Ear-marks" were an added means of identification to the brand. There were times when it was difficult to read a brand, especially in the winter months when the animal's hair was long, and "ear-marks" proved to be quite convenient and could be seen from a distance. Like brands, each mark had a name that formed a part of the cowboy's language.

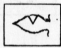

Over-bit

The "over-bit" was a V-shaped mark made by doubling the ear in and cutting a small piece, perhaps an inch, out of the upper part of the ear, an inch in length, and perhaps one third that in depth. (See illustrations.) The same cut made on the lower side of the ear was called an "under-bit."

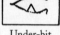

Under-bit

The "seven-over-bit" was made by cutting the ear straight down near the tip for about an inch on the top side, then from near the upper base of the ear, making a cut which sloped to meet the straight downward first cut.

Seven-
Over-Bit

The "seven-under-bit" was made in the same way by making the cut on the lower side of the ear.

Seven-
Under-Bit

A "crop" was made by cutting about one half of the ear off smoothly, straight from the upper side. The "upper half-crop" or "over half-crop" was made by splitting the ear from the tip, midway about halfway back toward the head and cutting off the upper half; the "under half-crop" was the same cut on the lower side of the ear.

Crop

The "steeple fork" was made by cutting two splits into the ear from the end, back one third or halfway toward the head, and cutting out the middle piece, the splits to be an inch apart, or thereabouts.

Upper
Half-Crop

The "split" was made simply by splitting the ear from the tip midway about halfway back toward the head.

Steeple Fork

The "over-split" was made by making the split from the upper edge of the ear to about the middle; the "under-split" being the same on the lower side.

Split

The "swallow-fork" was made by hollowing the ear lengthwise, beginning halfway back, cutting at an angle of forty-five degrees toward the end. The result was a forked notch in the ear.

Over-Split

An "over-slope" was made by cutting the ear about two thirds of the way back from the tip straight to the center of the ear at its upper side; the "under-slope" was the same cut on the lower side. The "sharp" was made by cutting an under- and over-slope upon the same ear, giving it a sharp or pointed appearance and sometimes called a "point." The "over-hack" was made by simply cutting down on the upper side of the ear, perhaps an inch, while the "under-hack" was cutting on the lower side. The "over-round" was made by cutting a half-circle from the top of the ear; the "under-round" by cutting the half-circle from the bottom.

Under-Split

Swallow-Fork

Over-Slope

An unusual ear-mark was the "jingle-bob," made by splitting the ear deeply so that the lower half would flop downward. The "grub" was a cruel

Under-Round

Over-Round

Sharp

Under-Slope

ear-mark made by cutting the entire ear off smoothly with the head. A man who "grubbed" was looked upon with suspicion, as it was resorted to by rustlers to destroy original ear-marks.

There were other marks of ownership made with the knife other than those of the ears. The "dewlap" was made on the under-side of the neck or brisket by pinching up a quantity of skin and cutting it all, but not entirely off. When it healed, it left a hanging flap of skin. Some were slashed up, and called "dewlaps up," others were slashed down, and called "dewlaps down." The "jughandle" was made by cutting a long slash on the skin of the brisket and not cutting out at either end, which, when healed, looked similar to the handle of a suitcase. The "wattle" was made on the neck or jaw of an animal by pinching up a quantity of skin, and cutting it all, but not entirely off. When healed, it left a hanging flap of skin. Earmarks could be used in innumerable combinations.

As a mark of identification the brand was perfect. It was put on in a moment, yet it remained as long as the animal lived, and no matter how far a cow or horse might stray from its home range, identification of the owner, by means of the brand, was positive. The ability to read brands and ear-marks correctly and at a glance ranked almost as high as dexterity with a rope, and higher on a cow-ranch than the ability to ride bucking horses.

✣ XII ✣

THE TRAIL

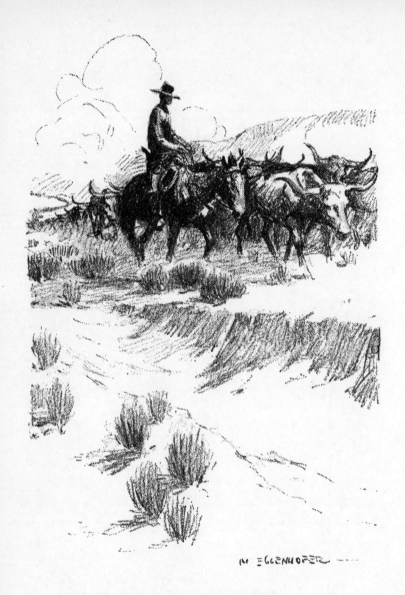

The real driving was done on the first day

No old-time feature of the cattle business was more picturesque or more interesting than that of the movements of herds going "up the trail" to market. As long as the "trail days" lasted, it was the ambition of every ranch boy in Texas to go up the trail to Kansas. It was to him what a college education is to a high-school boy. In this phase of his work, as in the others, the cowboy had his particular words and terms to suit every need.

To begin with, cattle were "trailed," not driven. They were headed in the desired direction as they grazed, and were not driven unless driving was necessary to reach food and water, although this moving of cattle on foot from one location to another was commonly called a "drive." The men who made the "drive" were known as "trail hands," or "trail drivers," and the crew consisted of the "trail boss," his assistant, the "secundo" or "straw boss," the cook, the "wrangler," if the outfit carried one, and sufficient men to control the herd, usually one puncher to every two hundred and fifty or three hundred head of cattle.

The real driving was done on the first day and the cattle were "shoved" or "pushed" to the limit of their speed to get them off their home range and tire them into submissiveness.

When the cattle became accustomed to traveling with a herd on the trail, they were said to be "herd-broke" or "trail-broke." In every herd there was a steer who, by his aggressiveness and stamina, took his place at the head of the herd as a self-appointed leader and retained his leadership to the end of the trail. He became the "lead steer" and was always honored with a name. To the drover he proved himself to be invaluable, and some of them rendered such valuable service that they were retained and driven back home to be used on the next trail trip. The cowboys became as attached to him as they would a fellow rider. Another brute found in almost every herd, and despised by the cowboys, was the "stampeder." This was a nervous cow or steer which habitually started the herd to stampeding.

The running wild of cattle from fright was called a "stampede." The word was from the Spanish *estampida*, meaning a loud noise or crash, and was used both as a noun and verb. The least unexpected noise might cause the cattle to "roll their tails," and the cowboys were in for a night of hard, dangerous work. "Flankers" attempted to "cut in" all outside stragglers, while the men who had gained a place near the head of the column did everything in their power to turn the leaders more and more until the column formed itself into a capital letter "U," and finally the two ends merged together. As this more compact mass raced in a circle, they were said to be "milling," and they continued this until they stopped from exhaustion, and the stampede was over. This same action with horses playing the rôle was never spoken of as "milling," but was called "rounding-in" or "rounding-up." When cattle became confused in water and started swimming in a circle, it was often spoken of as a "merry-go-round in high water." Herds that stampeded often early in the drive did not recover

from the experience for a long time and were "spoiled" to the extent that they would stampede upon the slightest provocation.

The cowboy strikingly showed his aptness and originality in his description of a stampede. We have heard it said that "stampedin' cattle jes' buy a through ticket to hell an' gone, an' try to ketch the first train," and also that a stampede was "like startin' from the back door of hell on a hot day an' comin' out on the run."

The men driving a trail herd had their proper titles. The "trail boss" usually rode far ahead to survey the ground and search out watering-places and good grazing grounds. The "point men" or "lead men" were those who rode near the head of the marching column of cattle and acted as pilots. No one rode immediately in front of the herd, but off to one side near the head. They usually worked in pairs, and, when desiring to change the course of the herd, each would ride abreast of the foremost cattle, then quietly veer in the desired direction, and thereupon the leading cattle would swerve away from the horseman that was approaching them and toward the one that was receding from them. It was the honored post of the drive, and the station of greatest responsibility, since it was these men who must determine the exact direction taken.

About a third of the way back behind the "point men" came the "swing riders," where the herd began to bend in case of a change of course. Another third of the way back rode the "flank riders." The duty of both the "swing" and "flank riders" was to block their own cattle from sidewise wandering, and also to drive off any foreign cattle that tried to join the marching herd.

"Bringing up the drag" were the "drag riders" or "tail riders." Theirs was the most disagreeable of all the jobs of cattle-

driving, since the riders here were exposed to the dust raised by the entire herd, and had their patience sorely tried by the slow or obstinate animals that fell back to this position in the herd. This part of the column was called the "drag" or "tail," and it represented both a hospital and a home for the incompetents. It held all the footsore, the ill, the infants, the weary, and the lazy. The cattle occupying this position were called "drags," and the word was not infrequently applied to lazy humans.

Following the cattle was the "remuda" and the "wrangler," and last came the "chuck-wagon" driven by the cook, though often in the afternoon the "mess-wagon" took the lead that the cook might make camp in the place selected by the "trail boss" and have supper ready by the time the herd was "bedded down." Attached to many of the old trail "chuck-wagons" was what the cowboy called the "coonie," from *cuna*, meaning cradle. This was a rawhide stretched to the running gear of the wagon, while green, the head and fore legs being lashed toward the front of the wagon, the sides to the sides of the bed. The hind legs were lashed to the rear axle, lower behind, to make it easier of access, and the whole filled with rocks or something heavy while drying to make it bag down, thus increasing its carrying capacity. It was used to carry wood and other fuel. Occasionally in the early days some drovers would carry instead a two-wheeled cart to carry "cow-chips" when going over a country where wood was scarce. The vehicle occupying this rather menial social position among camp equipment was termed the "chip-wagon." Also not infrequently a more humane drover would carry a "calf-wagon" to save the calves born en route.

From time to time a "trail-cutter," a man employed usually by a stock association, might "cut the trail"—that is, halt a

marching herd and inspect it for cattle which did not properly belong there. This cutting upon the trail was known as "trimmin' the herd" or "cutting the herd." "Cutter herds" were bunches of cattle held about a hundred miles apart along the trail by cowboys hired, like in round-up season, to cut trail herds for several different ranchmen, each paying a stated amount for such work.

Herds composed of both cows and steers were called a "mixed herd" and were usually more troublesome to drive than a "straight steer herd."

Before dusk the herd was "thrown" or "thrown off" the trail for a half-mile or so to put it on the "bed-ground," so there would be no danger of it becoming entangled with other herds going up the trail. The expression "ridin' 'em down" signified the gradual urging of the "point" and "drag" cattle closer together in preparing to put them on the "bed-ground." The "bedding-down" was a scientific job which required no crowding too closely, nor yet allowing the herd to scatter over too much territory. Putting the leaders in the direction the drover wanted the herd to go was called "headin' 'em up." Narrowing the width of a trail herd was said to be "squeezin' 'em down."

The crossing of rivers with a trail herd was sometimes a difficult task. If the sun shone in the eyes of the cattle, they had difficulty in seeing the opposite bank and would not go into the water. "Starting the swim" was always an anxious task. In this putting of the leaders into "swimmin' water," every effort was made to keep them headed straight across and from "doubling back." When the river was up, it was said to be "big swimmin'." Crossing the river with a herd of wild long horns under any circumstances was no job for a weakling. It took courage, and no higher compliment could be

paid a man than to say that "he'd do to swim the river with."

In the West any "ford" was termed a "crossing." A "dry drive" was one without water for the cattle. A "lay-over" was the voluntary stopping, during a drive, while a "lay-up" was the compulsory stopping of the drive for one reason or another.

If there was anything the trail drivers feared it was lightning. They believed that heat and steel attracted electricity. Fighting a stampede was hot work. Less daring cowboys who wore slickers took them off to let their bodies cool and thus lessen the attraction for lightning. Many a pair of spurs and many a six-shooter were cast upon the prairie during electrical storms. The phosphorous light so commonly seen playing upon the horns and ears of cattle during such a storm was called "fox-fire" by the cowboy.

A "regular" was what the old-time trail driver called a drive that went as "fine as split silk" to the Wichita Mountains and "hell broke loose" from there to the end of the drive.

One of the things which caused severe losses in the trail days, as well as numerous troubles for the drover, such as quarantines, ill-feeling with the settlers along the trails, and numerous other calamities, was the "Texas fever." This was a splenic fever caused by ticks and spread, by the immune but tick-infested cattle of the southern country, to the cattle of the more northern latitudes. The disease was also known as "Southern," and "Spanish," fever.

Romance rode, stirrup to stirrup, with many a rollicking knight of the range as he drove cattle up the old trails. Tragedy had its part in the story, too, for it had its share of deeds of violence and scenes of death. Yet the cattle trails served an excellent purpose in the development of the coun-

try, for they brought the North and South of the Mississippi River Valley into close business relations following the Civil War, a condition which was of great economic and political advantage to both, and in such a measure was educative.

✣ XIII ✦

THE COMMISSARY

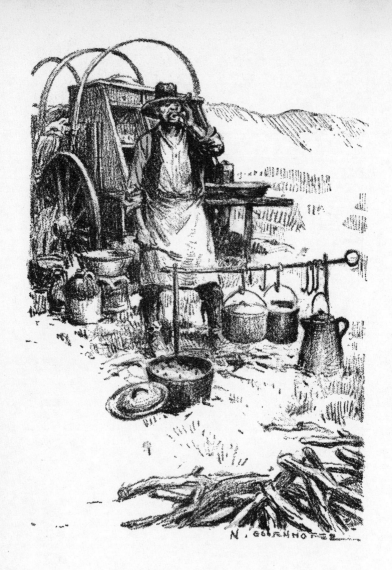

"Grub pile, come a–runnin', fellers"

The "chuck-wagon" came with the great organized round-ups, and was one of the most important institutions of the West. It was more than just a place to feed the men. It was the social center of the outfit while working. To the layman a wagon was just a wagon, and as such meant only a method of transportation, whether it was used to haul wood, feed, or water, but to the cowboy "*the* wagon" meant his home.

The outfit might have a freight wagon, wood wagon, bed or calf wagon, each bearing its proper prefix, but when one said "the wagon," it meant fire, food, dry clothes, and to it he pledged his allegiance once he had thrown his "bedroll" into it. "Which way's the wagon?" was the old-time trail driver's familiar greeting.

The West was not slackish with its food. Line a person's ribs well and he will do his best for the cause. The real cowmen realized this and the well-loaded chuck-wagon, or "groanin' cart," as the cowboy sometimes called it, was the index of good management.

The cowboy did not slight his slang when it came to his "chuck," the unpoetic name he gave to food. "Sour-doughs" were biscuits such as only a cow-camp cook could make; they

were also known as "dough-gods," "sinkers," or "hot rocks."
Light bread was "wasp-nests" or "gun-waddin' bread"; "air-
tights" were canned goods, while canned milk was "canned
cow." This was practically the only kind of milk the cowboy
ever saw, because, as he expressed it, he "allowed he might
steal a slick-ear, but he hadn't got so low that he would steal
milk from a calf." Tenderfoots were always astonished that an
outfit with a hundred thousand cows should not have enough
milk for drinking and cooking purposes. True, "cow" sounds
like milk, but if the cowpuncher got milk it was of the "Eagle
Brand" variety. As Charlie Russell once said, "It sure musta
come from that bird. It's a cinch it never flowed from any ani-
mal with horns on."

One of the staples of his diet was the red Mexican bean
which he called "frijoles" or slangily referred to as "whistle
berries," or "Mexican strawberries." "Texas butter" was made
from the hot lard in which the steak had been fried by
putting some flour in the frying-pan and letting it bubble and
brown, then adding hot water and stirring until thickened.
"Charlie Taylor" was a substitute for butter, consisting of a
mixture of syrup or sorghum and bacon grease. Gravy was
called "sop." "Lick" was molasses, and it was also called "long
sweetenin'" and "black strap," the latter from the black leather
strap which was always through the jug handle. Eggs, of
which the puncher partook when in town, were called "State's
eggs" because they were shipped in.

The cowboy's name for an oyster was "sea plum," and any-
one who has been in the West knows what he called "moun-
tain oysters." His sarcastic name for fried bacon was "fried
chicken," and "sow bosom" or "chuck-wagon chicken" was
salt pork. We once heard two cowboys relating their experi-

ence with an outfit which fed salt pork exclusively instead of beef, and one of them stated that he "lived on hog side 'til he near starved to death." He further stated that his system was "so saturated with hog fat that he sweated straight leaf lard and his hide got so slick he could hardly keep his clothes on," while the second one added that he "et so much hog belly that he grunted in his sleep an' was afraid to look for fear he'd sprouted a curly tail."

Rice was called "moonshine." "Pooch" was the name of a dish made of canned tomatoes, sugar, and bread. Pudding sauce was called "dip"; pie with one crust was called a "boggy top"; griddle cakes were dubbed "saddle blankets." When a guest brought food with him he was said to bring "pot luck." Buck Taylor, in speaking of the cook of the old TJ outfit, said: "He jes' bogged down a few raisins in dough an' called 'er puddin'." Fancy food, such as the cowboy heard of being served to people of the cities, he called "throat-ticklin' grub" or "fancy fluff-duffs." Doughnuts, something he rarely had the opportunity of eating except when he went to town, were called "bear sign."

"Son-of-a-gun stew," a favorite dish of the cowboy, was made of brains, sweetbreads, and choice pieces of a freshly killed calf. If the cowboy wished to be polite he called it by this name, but if no delicate ears were present, he called it by its true name, something that has always been a fighting word. When the law began its march westward and started to question and to clamp down on cowboy government of the happy and carefree early days, the blame for this cramping of liberties was placed on lawyers. This caused the riders of the range to feel somewhat resentful toward the law and soon they began also calling this dish "District Attorney." The im-

plication was obvious. In making this stew, the cook was said to "throw everything in the pot but the horns and hide."

The cook also had his slang titles, such as "biscuit-roller," "biscuit-shooter," "sour-dough," "dough-roller," "dough-wrangler," "sheffi," "dinero," "cookie," "Sallie," "old woman," "belly-cheater," "coosie"—a corruption of the Spanish word *cocinero,* meaning cook—and many others.

The cook, especially when out with the wagon, worked under difficulties and with the scarcity of fuel was often obliged to use "cow-chips" which were also called "squaw wood" or "prairie coal." This fuel was usually carried in the cowhide hanging below the wagon's bed called a "coonie," or "possum belly." But with all his handicaps the real chuck-wagon cook could turn out the finest tasting meat "y'u ever flopped yo' flippers over." If he had a helper he was called the "flunky," "roustabout," or "swamper." From his early reputation for crankiness, succeeding cooks seemed to try and uphold the tradition. "As techy as a cook" became a byword on the range, and some of the old-time cooks were said to be "as good with a gun as they were with a can-opener." When he was forced to make camp where there was no water, he was said to make a "dry camp."

Cooks drove their own wagons in moving camp and as a class they were reckless drivers. Most of them "jes' throwed the lines away an' herded his four hosses across the country." Usually in the lead galloped a "pilot," a man familiar with the country and chosen to pick a route over sagebrush, greasewood, and dry washes for the careening "mess-wagon" hauled at breakneck speed. If a second wagon was hooked onto the chuck-wagon, as was sometimes the case in moving camp, it was called the "trail wagon."

The box, made to fit on the rear of the chuck-wagon, and serving the purpose of a kitchen cabinet, was called the "chuck-box." The canvas which some cooks used to stretch over the "chuck-box" to make shade and shelter was called a "fly."

The receptable for the dirty dishes after a meal in a cow-camp was the "round pan" or "wreck pan." The "squirrel can" was a large can used by some cooks as a general cook-ing utensil. The hook used for holding pots over the fires were "pot-hooks," while the hook used in lifting the heavy lids of the cooking vessels were "gouch-hooks" or "gaunch-hooks."

Back at the ranch one referred more or less elegantly to "breakfast," "dinner," and "supper," but when one hit off the day's work with all outdoors for a dining room, and a sooty Dutch oven on a bed of embers in place of a kitchen range, one became more or less of a savage, and "grub-pile" seemed to fit better in one's rough, outdoor vocabulary. Back at the ranch, too, the cook was likely to be more polite, and to say, in announcing his readiness for a meal: "Sit in, gents, she's on," or, "The banquet awaits my lords," instead of the com-mand given and answered farther out in the brush of "Grab 'er, boys, or I'll throw 'er out." But even at the ranch the cook had no use for dawdlers when he was anxious to get through with his dishwashing, and such were advised to "swaller an' git out."

From the familiar calls of the camp cook we select a few: "Grub-pile, come a-runnin,' fellers"; "Here it is, come an' get it"; "It's all right with me"; "Roll out, roll out while she's hot"; "Boneheads, boneheads, take it away"; and "Wake up, snakes, an' bite a biscuit." If the grub was slim, he expressed his hu-

miliation with "Here's hell, boys." The poetic cook might burst forth with

> "Bacon in the pan,
> Coffee in the pot;
> Get up an' get it —
> Get it while it's hot."

Or

> "Wake up, Jacob!
> Day's a-breakin'!
> Beans in the pot,
> Sour-dough's a-bakin'!"

Perhaps some of the old cooks were religiously inclined, and they put some of this sentiment into their calls. To quote James Cook: "A cheery voice ringing out about daybreak, shouting, 'Roll out there, fellers, an' hear the little birdies sing their praises to God,' or, 'Arise an' shine an' give God the glory!' would make the most crusty waddie grin as he crawled out to partake of his morning meal — even when he was extremely short on sleep."

The round-up cook was not without his quick humor and sharp repartee. Practiced in mild grumbling, when he chose to become vicious in his wit, his ridicule paralyzed the defense of most cowboys, and left them floundering for a good "come-back."

When one cowboy of our acquaintance saw the cook throw out a kettle of raisins, his visions of a pie for supper went glimmering, and he yelled: "Hey, cookie, what 'smatter with them pie-stuffin's?" The cook, feeling that this upstart was prying into his business, answered with biting sarcasm: "Well, son, they got tangled up with one o' them damned whirligigs an' assay 'bout eighty per cent sand. Still, I reckon I oughta saved 'em an' fed 'em to y'u rannies; y'u'd have more grit in yo' bellies

than y'u got in yo' craw." Another puncher, thinking to poke a little fun at the cook's biscuit, said, "Cookie, y'u needn't flavor these washers with leather no more," but he was silenced by the cook's quick retort of "Well, why don't y'u pay ole man Moore for yo' saddle, an' y'u wouldn't have to hide it in my dough-barrel ever' time he passes camp." Again a would-be wit had the laugh turned on him when he said, "Cut down on the sody in them biscuits—I'm gittin' plumb yeller," and the cook retorted, "Y'u always was yeller—don't blame the biscuits."

If, during meals in camp, a man got up to refill his cup of coffee and "man at the pot" was yelled at him, he was duty bound to go around with the pot and fill all the cups held out to him. The cowboy liked his coffee "strong 'nough to float a wedge" or "so strong it would kick up in the middle an' carry double."

The tightening of the belt another notch or two as a substitute for food was called having a "Spanish supper." Many were the times the cowboy "didn't get his meals often enough to hurt his digestion." When he expressed himself as being hungry, he was apt to use such phrases as being "gut-shrunk," "his empty paunch was a-rattlin'," he was "hungry 'nough to eat a saddle blanket," "his tapeworm was a-hollerin' for fodder," or he was "hungrier'n a woodpecker with a headache."

The average cowboy did not care what he ate, nor when he ate, if only he had enough when he was hungry. No frills for him. Bread and meat were all he wanted if he received these in quantity, and he could endure with no food at all for lengths of time incredible to the tenderfoot. A well-managed outfit, however, always provided plenty of staple food. As they used to say, "We don't set out to starve none."

✦ XIV ✦

........................

RUSTLERS
AND OUTLAWS

It meant that the one approaching was not wanted
and had better stay away

The first use of the word "rustler" was as a synonym for "hustler," becoming an established term for any person who was active, pushing, and bustling in any enterprise; again it was used as the name for the "wrangler," and, used as a verb, meant to herd horses. "To rustle the horses" meant to herd them to the desired place. Later, the word became almost exclusively used with reference to cattle thieves, starting from the days of the "maverick," when cowboys were paid by their employers to "get out and rustle a few mavericks," just as one spoke of "rustling some wood" for the fire. These same cowboys soon became interested in putting their own brand upon these ownerless calves to get a start in the cattle business, and this soon became looked upon as thievery. Thus the word became evolved into the meaning of a thief, and is so recognized over the entire West, though Texans preferred the blunter word of "cow thief."

An old saying of the early range was that all a man needed to start a brand of his own was "a rope, a runnin'-iron, and the nerve to use it." The struggle for existence on a fierce frontier developed nerve; ropes and running-irons were cheap, and so cow thieves were developed until "rustling" became quite an industry.

An early name for the genuine rustler, one faithful to his illegal art, was a "waddy"; later this term was also applied to any cowpuncher. He was a "pure" when he was a thorough-bred and loyal to his fellows. He was also spoken of by such names as "brand-burner," "brand-blotter," "brand-blotcher," "brand-artist," "long rope," or "rope and ring man," and he was said to "swing a wide loop." It was often said of one sus-pected of stealing that he was "careless with his brandin'-iron," or, "his calves don't suck the right cows."

Telling any honest cattleman that his cows have twins was fighting talk. A cow with twins generally meant that a "crit-ter" of another brand was bawling for its "rustled" calf. When the rustler worked overtime it was said that he "kept his brandin'-iron smooth." A branding-iron must be smooth and free from rust and scale to give satisfaction.

The practice of "burning" cattle, of altering brands so that the old part and the new would form a perfect and quite dif-ferent brand, was raised to the dignity of an art by the rustler. He had to do the work skillfully enough to deceive not only the average range stockman, but the shrewdest and most ex-pert cowman among them. The bungling of a "worked-over" brand was called "botching," and a botched job was an acute mortification to most rustlers.

He might "blot" the old brand entirely out with a hot flat iron and run a new one on, but this was a crude method. More likely he would change the old brand into a new and entirely different one by adding lines, numerals, curves, or symbols with a piece of hot telegraph wire, or a "cinch-ring," or "run-nin'-iron." Or again he might use the "wet blanket" process whereby a scrap of wet woolen blanket was laid over the old brand and a hot iron applied to it, through the blanket.

He might make use of the "picked brand" or the "hair

brand" already mentioned, or he might "sleeper" the animal. A "sleeper" was a calf which had been ear-marked with the proper mark of the owner by the cattle thief who intended to come back later and steal the animal. The ear-mark was used by the cowpuncher as a quick means of identification; thus, during round-up, should the ranch hands come upon such an animal, they would likely take it for granted that it had been branded at the time it was marked and leave it to roam, the thief returning later and putting his own brand upon it or driving it away.

Another method of the cattle thief was the use of the "slow brand." It was against the law, of course, to mutilate any brand, and it further required that every brand should be recorded in the county of its origin. A man who blotted out a brand, and put another in its place, was naturally chary of putting this new brand on record. He simply ran it, trusting to get the cattle out of the country at the first opportunity, and such a brand was said to be a "slow brand."

When a man killed an animal that belonged to someone else for food or for sale to butcher shops, he was said to "slow-elk" it, and such an animal was called a "slow elk" or "big antelope."

Mother cows and their calves, upon becoming separated, back-track for miles to reach the spot at which each last saw the other. Because of this instinct, the rustler was forced to wean the calves he stole before he applied his brand, or have them so secured that they could not return to their mothers. In doing this he used many different methods. He might "sand" the calves — that is, put sand in their eyes so that they could not see to follow the mother. The calf was then driven off to a distance, and by the time he reached his destination he would be thoroughly weaned.

Another method employed by the rustler was to "hot-foot" the calf—that is, burn it between the toes with a hot iron, making its feet too sore to walk. Often the rustler would cut the muscles which supported the calf's eyelids so that they would droop closed. Thus separated from his mother, he would "bawl his head off" for a few days, but, getting no response and not being able to see to return to his maternal milk, he became hungry, groped around for food, and was soon weaned. The muscles healed, but the lids always drooped slightly and these calves were referred to as "droop-eyes."

Occasionally some rustler followed the even more brutal practice of splitting the calf's tongue so he could not nurse. When the calf was weaned, these "tongue-splitters" placed their own brand upon them. Very often the man following this dangerous industry made genuine orphans of the calves by killing the mother. He was then said, in cowboy language, to "pin crape on the kid." If he was caught, it was said that he "ran a butcher shop an' got his cattle mixed," and he later perhaps spent his time "makin' hair bridles," which was synonymous to being sent to the penitentiary. More than one rustler was said to have "lost his voice explainin' to so many judges how he come to have his brand on somebody else's cows."

As one cowboy said, in speaking of an acquaintance suspected of rustling: "Bill's good-hearted an' hates to see calves wanderin' 'round wearin' no brand. They look so homeless that he's always willin' to stake 'em to a brand with his own iron."

Corrals of some friendly small rancher, or those of the larger ranches placed at a distance from headquarters and used infrequently except in round-up season, were often used by the rustlers for a temporary holding of stolen cattle until

they could be pushed out of the country. These were called "road houses."

If the rustler, while at his fire "workin' over" a brand, or "runnin' a brand" on an animal, was approached by a rider in the distance, he "waved him 'round." In cowboy language this meant that he waved a hat or other object in a semicircle from left to right, and in the sign language of the plains, it meant that the one approaching was not wanted and had better stay away if he didn't want to stop "hot lead."

Other members of the lawless fraternity of the West were "outlaws," "long riders," "high-line riders," "bad men," "killers," "bandidos" (used near the Mexican Border), and "road-agents," the latter being more commonly robbers of stage-coaches, and sometimes called "hold-up men." When one was outside the law and "two jumps ahead of the sheriff," he was said to be "on the dodge," "on the scout," "on the outlook," "on the cuidado," or "in the brush," and "traveled the lonesome places" to find a place to "hole up." He often "made so much dust it didn't settle all day," and his horse "wonders at the hurry they're in." A cowboy once said, in speaking of an acquaintance who formerly had been "a thorn in the sheriff's short-ribs," and who was going through a certain town where his social standing with the law had not been friendly in former years: "Bud keeps his hat-brim well down over his eyes, as he's not sure if they have the same sheriff they had a few years back." "Two names is too heavy to carry if y'u're travelin' fast" was a common saying in the West. The sheriff was sometimes called a "great seizer."

A hanging was a "lynchin' bee," or "necktie social," and the victim did a "strangulation jig," "looked up a limb," "gurgled on a rope," "played cat's cradle with 'is neck," was "used to

trim a tree," "hung up to dry," "exalted," or had "hemp fever," and was said to be a "guest of honor at a string party," or "climbed the Golden Stairs with a rope." To "telegraph him home" was to use his own rope and borrow a pole from the Western Union. We once heard the leader of a posse make a statement, "If we ever ketch that hoss thief, we'll hang 'im so high he can look down on the moon." In the Old West there were no bars for a thief to look through, but "just a rope an' a chance to look at the sky."

The rise and development of the range stock-raising industry opened the gates of opportunity to many enterprising Western men of loose ideas about the rights of property. The conditions that have run with the business from its beginning have been peculiarly favorable to the operations of those who regarded as a dead letter that part of the Tenth Commandment that tells us we shall not covet our neighbor's ox. In years gone by the number of men skillfully and regularly engaged in stealing range-cattle was so large and the extent of their depredations so great that their operations were raised almost to the rank of an established industry.

✢ XV ✢

................................

GUNS

There were many predicaments wherein a man
needed a gun

In the early days guns were a necessary part of the cowboy's accouterment, but the carrying of weapons by him gave to many people the wrong impression. Those guns were not carried for the purpose of killing men. There were many other needs for them, and many a man has carried one all his life who could hardly have been forced to use it upon a man. There were many predicaments wherein a man needed a gun, and in which no other man was involved. There was an unwritten law, almost a religion, that a gun should never be used upon any man who did not himself have one on.

Naturally an object so familiar to the cowboy received its quota of his technical and slang names further to enrich our language.

Colt's first successful gun, the model which became famous, was named the "Texas." A second model was brought out in 1842 with improvements over the old one, but it was a Texas Ranger who suggested the improvements, and it was for him that the weapon was named. Ranger Captain Samuel Walker went to New York to purchase a supply of the latest firearms, and while there arranged to meet the inventor of the "Texas." As a result of this conference Colt made a new pistol, the first military revolver. This weapon was heavier than

the "Texas," had a trigger guard and the "rammer" attached. This was the famous "Walker Pistol."

When the revolver developed from the old "cap-and-ball" one-shot gun into one that would shoot six times, the Texas Rangers coined the word "six-shooter," and it has been in common use ever since. In 1870 the most famous of all "six-guns" made its appearance; the Colt "Single-Action Army," variously nicknamed "Peace-maker," and "Hog-leg," the latter term being transferred to any pistol of the frontier type. This gun made an instant appeal to the frontiersman, because it was built along the same lines as his old cap-and-ball, but was more powerful and faster to load. The old-fashioned, single-action was also sometimes referred to as a "thumb-buster." The "parrot-bill" was a model with a semi-round butt.

The cowboy's slang names for his gun were legion. As most guns upon the range were of a forty-four or forty-five caliber, they often received the name of their caliber, as "forty-fours" or "forty-fives." His personal weapons were spoken of as his "artillery," or they received other such names as "cutter," "iron," "talkin'-iron," "hardware," "shootin'-iron," "blue lightnin'," "flame-thrower," "lead-pusher," "lead-chucker," "persuader," "smoke-wagon," "equalizer," or "man-stopper." While his pistol was always a "gun," the rifle, with the exception of the "buffalo gun," was never called a gun, but "Winchester rifle," the caliber of the gun as "thirty-thirty," and by the slang name of "Worchestershire." Shotguns were called "scatter guns," and held in contempt, though highly respected. Bartenders usually kept one, a sawed-off, behind the bar in the woolly days.

In the strictest technical use of the term the rifle and all "long arms" should be classed as "guns" and the revolver as a

"pistol," but the West made its own distinction. When a "gunman" was mentioned, the speaker did not mean a man possessed of a rifle, but a man specially skilled in the use of the pistol, and one ever ready to demonstrate his skill in blazing gunplay. The word soon became so pliant as to take into account the character of the man under discussion. It became synonymous with "killer." There were men in the early West who leased their services as "gunmen" to relieve some more timid man of an enemy; they were "hired killers," men without fear or scruples.

The more noted he was and the more "notches" he carved upon his gun, the more cautious he must be in every action. He had to analyze every tiny movement about him, for there were other "gunmen" abroad who would continually seek his life for the glory it would bring them. So the average "gunman" became what the old-timers so expressively called "cat-eyed." The more his fame grew, the closer he had to watch to keep from being "downed" by a jealous rival.

"Lookin' for someone" meant that the one spoken of was seeking an enemy to "smoke 'im up." This enemy might get wind of the gunman's intention and proceed to "fort up"— that is, arm himself and lie in wait for the aggressor.

A "two-gun man" was one who wore two guns and could shoot with either hand. This species was rare even in the Old West, and lived mostly in fiction. A conscienceless killer "ain't got no feelin' in his trigger finger," but of a man who had never shot another it was said that "he hadn't shot nobody in so long his trigger finger had gone to sleep." The expression "wore 'em low" signified that the one spoken of wore his guns low and easily accessible; also that the wearer was ready for a gun-fight at any time, and that his gun was for hire.

There was a forty-one caliber gun of short range which

carried a blunt, heavy bullet. It is obsolete now, but used to be popular in the forty-five-frame single-action, as well as the light-weight double-action model. This gun was sometimes called the "gambler's gun" because of its popularity with this gentry. The "derringer" or "bulldogged" pistol was known in the trade as a "stingy gun."

A gun was said to have a "hair trigger" when its mechanism had been filed to produce an explosion upon the slightest touch with the finger upon the trigger. The high hammer of the old "six-gun" was not designed to be cocked by the thumb-tip as were those of modern double-action revolvers, but by hooking the whole thumb over it and simply closing the hand, for the first shot. The recoil threw the gun up in the air, the thumb was hooked over the hammer, and the gun cocked itself by its own weight when leveled. This was where the phrase "throwing down" originated. By this method one could manipulate a loaded gun much faster than an empty one by thus utilizing the recoil. To "throw down" was also used in the sense of "covering" or "getting the drop."

A bullet was slangily referred to as a "lead plum" or a "blue whistler," the latter called thus because of the pistol's blued frame. No cartridges in the cylinder was "no beans in the wheel."

The act of drawing a gun was "diggin' for his blue lightnin'" or "reachin'." The manner of drawing a gun also had its individual language. The "hip draw" was considered by many experts to be the fastest. The gun was worn low on the hip, usually slanted forward with the butt turned to the rear, and was unlimbered with a swift down-and-up movement. The straightening of the wrist lifted the weapon clear of the leather, and when fired as it tipped clear of the holster the shot was known as a "hip shot." A "gun-tipper" was one who

shot through the end of his holster without drawing his gun. This holster was usually of the "open-toed" variety and swung on a rivet.

The "cross-draw" was made from a gun carried at or near the hip, but hanging butt forward. A quick stab of the hand across the body reached the gun, and the continuation of the movement lifted it clear of the holster. This was also often called the "Border Draw" because of its popularity with men in the vicinity of the Mexican line.

The "shoulder draw" was essentially a "cross-draw," but was made from the shoulder holster under the armpit. Such a "hide-out" was often called an "ace in the hole." When guns were carried by thrusting them into the waistband of the trousers they were called "belly guns." The gun was naked and was drawn with a single motion very similar to the regulation "cross-draw." All manner of "drawing" was often referred to as "leather slapping."

"Fanning" was a much misunderstood and overrated gun trick. Like carrying two guns, it was pretty much of a show trick. It came about because of the relative slowness of the single-action revolver. The gun was grasped tightly in one hand, and the palm of the other hand was brought forcibly against the hammer with a stroking or fanning movement. The trigger was held back during the operation, and the hammer fell as soon as the pressure was removed from its "spur." "Gun-fanners" soon learned to tie back their triggers or to dismantle the gun so that the trigger did not function. Some even removed the trigger entirely.

"Slip shooting" was accomplished by thumbing back the hammer of the gun and releasing it to fire the shot. It might be either a one-handed or two-handed operation.

The "single roll" was done by spinning the gun forward on

the trigger finger, and cocking and releasing the hammer as it came under the web or lower part of the thumb. The hammer was released as the gun muzzle lined on the target. The "road-agent's spin" was made the same way except the motion was reversed. This was sometimes called the "Curley Bill Spin" because its first recorded use was when Curley Bill Graham used it to kill Marshal Fred White when the latter attempted to arrest him in Tombstone, Arizona. The "double roll" was done in the same manner as the "single roll," except with two guns.

The "pin wheel" was the act of holding the pistol in virtual firing position except that the forefinger was not in the trigger guard, and flipping it into the air so that it revolved and the butt dropped naturally into the palm of the hand. The movement was started by throwing the butt down with a jerk of the wrist, and the muzzle up.

The "Border Shift" was the throwing of the pistol from one hand to the other and catching, cocking, and, if need be, firing it without seeming to pause. This took a great deal of practice.

The "hair trigger," "double sights," the "fine bead," were terms significant of a weapon adjusted and carefully aimed.

To be armed was to be "heeled," and it was said of one who went heavily armed that he "carried 'nough artillery to make his boss sway-backed," or he "packed 'nough hardware to give him kidney sores," while to be unarmed was "caught short," or he "didn't carry an ounce of iron." In referring to one who had "packed" a gun all his life, it was said that he "packed a gun so long he stood slanchways," or "packed iron so long he felt naked when he took it off."

To start shooting was to "unravel some cartridges," "set his gun goin'," "burn powder," "come a-shootin'," "come a-

smokin'," or "roll his gun." A person who was shot had a case of "lead poisoning," or "leaned ag'in a bullet goin' past," and the shooter "blew his lamp out," or if he shot his adversary through the head, he "put windows in his skull." A gun battle was said to be a "corpse an' cartridge occasion," while of a killing there was said to be a "man for breakfast." To stand one against the wall and execute by shooting, as was so often the case in Mexico, the American cowboy shortened to "'dobe-walled." To "dry-gulch" a person was to kill him and to "bushwack" one was to shoot him from ambush, while to "pecos" one meant to kill him and roll his body into the river.

When two men got into a gun-fight, it was said of the loser to be "another case of slow." A "Winchester quarantine" was a barrier by force of arms, and this was a common occurrence in the earlier days during the fierce struggle for range-rights, water-rights, and other controversies of the frontier.

When one killed another, he "bedded him down," "sent him to Heaven to hunt for a harp," "curled him up," "let sunshine through him like he's a pane o' glass," "had him settin' on a damp cloud learnin' to play a harp," or "sent him hoppin' over hot coals in hell." Perhaps it was said of the deceased that he "wins a pitchfork for the eternal beyond," "fell all spraddled out too dead to skin," or "went to hell on a shutter." If he shot another in the abdomen, he "gave him a pill in his stomach he couldn't digest." If he was considerably shot up, he was "so full o' holes he wouldn't float in brine," "so full o' lead they had to send his body to a sinker factory," "as full of lead as Joplin and Galena," "as full o' holes as a cabbage leaf after a hailstorm," "so full o' holes he couldn't hold hay," or they "had to pick 'im up with a blotter." A "corpse an' cartridge occasion" of magnitude, where "the air was as full of lead as a bag o' bullets," and where several men had been

killed, was said to have "looked like beef day at an Indian agency." If any of the participants were wounded but still lived, they were "sent to the saw-bones to have the lead mined out." When a person continually hunted trouble and gun-fights, it was said that he "liked to dabble in gore."

The "buscadero belt" was made from four to six inches wide with a slotted flap on each hip where the gun was carried. This flap extended two inches below the belt and held the guns low down when the belt was worn above the hips. The holsters were fitted into these slots, making the outfit the same practically as the one-piece belt and holsters. Then the holsters did not ride up when the gun was drawn, making it unnecessary to tie them down, such as the "tied holsters" were.

A bowie knife or a large sheath knife was called an "Arkansaw toothpick" or a "Kansas neck blister."

Coming to replace the buffalo and the Indian and to set up a cattle kingdom, the Texas cowboy became an American institution. Being a horseman, he found the revolver suited to his needs; being a Texan he already knew how to use it. No man, save the Texas Ranger, has ever carried it with the insouciant air and picturesque charm of the American cowboy. He wore it openly, on the outside. Sometimes he used it. Sometimes he needed it. And he made for it and himself and the West a great reputation—not all bad.

✦ XVI ✦

........................

NICKNAMES

"—and took a drink from what he thought was
the water-bucket"

Nicknames were the rule of the West. The cowboy was so peculiarly talented in inventing apt and fitting ones that it formed a part of his lingo. Though the West reserved the right to select a nickname for a man, and to substitute it for the one he had volunteered, in doing so there was intended no reflection upon his truthfulness. As a matter of fact, there might have been a certain courtesy in these descriptive titles.

No one really seemed to take offense at these clinging nicknames, and it was well to accept them without protest. In the simple and direct methods of thought which prevailed, it was considered wise to give a man name by which he would be known easily and precisely.

A curious phase of the West was that many a man passed always by his given name, and that his associates never learned that he had a surname "cached somewhere." Onto these given names were often tacked descriptive nicknames to avoid any confusion of identity. The first few days that a tenderfoot or a new man spent with an outfit were watched closely to pick a fitting nickname if he did not bring one with him.

A man's nickname often extended to his wife, though by doing this the cowboy intended no discourtesy. Men often

forgot the name of their own boys after they had been called by nicknames for so long, and were sometimes obliged to ask the wife if they had ever given the offspring a name.

A red-headed man was sure to be called by such names as "Red," "Brick," or "Sunset." If there were more than one red-head in the neighborhood, one was apt to receive an additional title, such as the name of the brand for which he worked, as "TJ Red" to distinguish him from the others. A man with freckles was apt to be called by such names as "Speck," "Pinto," or "Paint." Every outfit had its "Slim" and "Shorty" which might fit or be the opposite. "Long John" Ellis received his name from the fact that he was of unusual height, and "Needle" Nelson won his because someone remarked that he was so slim that "if he'd close one eye he'd look like a needle." "Skeeter" was another favored name for a slim person. A short, fat person was apt to be called "Squatty" or some such name, while one of diminutive stature might be called by such names as "Peewee" or "Half-Pint."

A man with extremely bowed legs might be called "Wishbone," "Weddin' Ring," or "Rainbow," while one cowboy whose leg had a habit of occasionally doubling up on him was dubbed "Limberleg." I knew one puncher who had a streak of gray through his hair who received the name of "Blaze." "Oberbit" Cox received his name because he had a piece missing from the top of his right ear.

"Whimpy" Jones took his name because when he talked he sounded as if he was ready to cry, while "Foghorn" Lacey was dubbed thus because he talked in such a loud tone of voice. "Gloomy" Thompson looked upon the dark side of life; "Frosty" Ferguson was a high-strung individual who was apt to make biting replies when addressed; "Sudden" Lucas acted upon the impulse of the moment. "Bed-Out" Jones got his

name because he had the habit of sleeping on the ground out-of-doors, even in cold weather, claiming that sleeping indoors "smothered" him.

One cowboy received the name of "Two-Bits" because most of his conversation was preluded with "I'll bet two-bits," and another sunny-dispositioned rider called "Hunky-Dory" always made sure to let you know that life, the world, and everything in it was "hunky-dory" with him. A cook, who was none too clean in his personal habits and whose bread was never overly done, received the name of "Soggy," and the name tuck to him through life.

A man who told long-winded yarns and expected his listeners to believe them was apt to receive the sobriquet of "Windy," or one who talked too much might be called "Lippy," because, as the cowboy would say, "he had more lip than a muley cow." "Post-Hole" Wilson got his name because he was put to digging post-holes as soon as he was hired on the ranch. More than one tenderfoot has been christened "New Ground." A certain cowboy received the name of "Pinky," because his skin seemed immune to the sun tan and he retained an almost girlish complexion, much to his chagrin. "Center-Fire" Pierce was always preaching the principles of the center-fire saddle.

"Dishwater" Martin received his cognomen, because, when he got thirsty one night, he groped his way to the kitchen and took a drink from what he thought was the water-bucket, but which proved to be some dishwater the cook had failed to throw out, and he was foolish enough to tell the joke upon himself. One cowboy who was so partial to bat-wing chaps, and so prejudiced against all other styles, was dubbed "Bat." Another, whose physiognomy was unusually long, was styled "Horse-Face." "Kettle-Belly" Johnson was a

noted character of Arizona who received his name from the contour of his body.

"Studhoss" Mason was a breeder of horses. "Vinegar" Hall was sour on the world. "Anvil" Jordan was loud and hard. "Washout" Duncan was always talking of the big washout that forced him out of the cattle business and made an ordinary cowhand of him. *Pronto* is a Spanish word, meaning quick, and "Pronto" Barnes took his name because he was quick to take exception, quick to right a wrong, and "quick on the trigger." When "Flash" Stillman reached for his gun, it was done like a flash of lightning. "Tumbleweed" Clark was possessed of the wanderlust, and admitted that he liked to wander far and often just as his namesake traveled aimlessly before the wind.

A certain range dandy who spent all of his earnings upon fine raiment and silver-conchaed equipment was unable to admire himself in mirrors because of their scarcity on the range, so much of his time was spent admiring his shadow as he rode the range. From this weakness he earned the name of "Pretty Shadow." Another puncher of a solemn disposition who was never seen to laugh was christened "Hoot Owl."

One usually refers to his home state or town a great deal when he is away from it, and many men received their nicknames from their frequent reference, such as "Colorado" Ike, "Pecos" Joe, "Brazos" Bill, "Yellowstone Kid," "Cheyenne" Charlie, "Tucson" Tom, and practically every ranch had its man from Texas who was called "Tex" for short.

Anyone familiar with Western history will recognize such names as Wild Bill Hickok, Mysterious Dave Mathers, Black Jack Ketchum, Butch Cassidy, Arapahoe Brown, Buffalo Bill Cody, Johnny Behind-the-Deuce, Crooked Nose George, Bigfoot Wallace, and Russian George.

We call to mind many seemingly mysterious monikers, yet each peculiarly fitted the individual upon whom they were bestowed. Some good examples are: Bones, Bean-Belly, Diehard, Limpy, Greasy Sack, Trunk Strap, Never Sweat, Pistol Foot, Jawbone, Thirty-Thirty, Hardwinter, Magpie, Coyote Bill, Alkali, Bell Wether, Kidney Foot, Cranky, Long Shorty, Suicide, Bug-Eye, Swivel-Eye, Graveyard, Blind Bill, Alibi, Big Nose, Dirty Shirt, Iron Jaw, Holy Father, Swayback, Wild Cat, Cherokee, and Eat 'Em Up.

One might receive his name from a song he sang overtime, from some peculiar incident in his life, from some pet word or phrase he used, or from some distinguishing personal peculiarity. The field was limitless, and it would be folly to give more examples of the numberless nicknames men bore in the cattle country.

Some of the women were not exempt, especially those of the honkatonks and resorts. Some of the girls in the resorts on the old cattle trails were: Calamity Jane, Rockin'-Chair Emma, Gar-Face Nell, Jack-Rabbit Sue, Covered-Wagon Liz, Dodge City Kate, Virgin Mary, Bronco Jane, Frog-Lip, Pitchin' Sal, Four-Ace Dora, Ogallala Shorty, Kansas Cow, Three-Face Flora, Buffalo Heifer, Society Mary, Wingless Angel, Rantin' Nell, Razorback Molly, and many other names just as unflattering. *names!*

If one studies the map of the Western country he will appreciate the talent of the early Westerners in giving picturesque names to his creeks and rivers, his mountains and buttes, his settlements and towns. He never neglected his ingenuity in naming anything.

Every horse in the remuda had his name and every horse was well known by every man in the outfit if that man had

been on the payroll long. The names of these horses alone tell an interesting and significant story of range-life. With every horse there was a history as individual as the horse himself, and, though the cowboy may forget many incidents of life on the range, the names of these horses and much of the history connected with each of them lived vividly in their memories.

Many horses were named after some great man, an Indian, a wild animal, a fowl, or creeping thing. Others took their name from some coloration, physical peculiarity, or traits of demeanor. A contrary horse was named after something to correspond with his nature. Here again the cowboy showed his talent for creating appropriate names. In the seventies many horses were named after generals, such as Johnson, Hood, Stonewall Jackson, Robert E. Lee, and Sam Houston. Horses hard to catch were named William Quantrell, Cole Younger, Jesse James, Sam Bass, etc. Horses with bad habits were called Buzzard, Skunk, Wolf, and such other names as fit their disposition. Slow and lazy horses were given such names as Possum, Ox Wagon, Snail, and Molasses. Pacing horses were often called Sand-Sifter, or Trail-Cleaner. All Indian chiefs had name-sakes in cow-ponies, and all Indian tribes were represented. Comanche took the lead. You were almost sure to find some horses by that name in every outfit. Gunmen also had ponies named after them, such as Ben Thompson, Kingfisher, Bat Masterson, Wild Bill Hickok, etc. Horses were often named after the man who owned them; sometimes after the brand on them as Spade, Half-Moon, Diamond Dot, Pot-Hook Gray, Straddle-Bug Bay, or Box M Sorrel.

Very often the bronco-buster named horses as he broke them, and, if the horse had any flesh marks or distinct characteristics, it was apt to come out in name. Any person famil-

iar with the practical could often glance at a horse and guess his name. For instance, if he had peculiar black stripes toward the tail with a little white in the tail, you were pretty safe to guess "Pole-Cat." If his feet were big and looked clumsy, "Puddin'-Foot" was a good first guess.

There was another class of names which were pretty well scattered through the cowboy's list; some of them really funny, but which might not prove altogether polite reading, or, to put it in cowboy parlance, might be "vulgary."

To give you some idea of the representative names selected by the cowboy, we call to mind such titles as Red Hell, Sail-Away Brown, Big Henry, Streak, Leapin' Lena, Old Sardine, Auger Eye, Sugar Dip, Dough Gut, Butcut Billie, Old Slick, Hammer Head, Churn Head, Lightnin', Apron Face, Feathers, Panther, Vinegarron, Leather Lip, Knot Belly, Milk Shake, Old Guts, Widow Maker, Molasses Mouth, Necktie Ball, Diamond Eye, Pickle Simon, Anytime, Mountain Sprout, Chub, Dumbbell, Rambler, Powder, Straight Edge, Scissors, Snake Eye, Peanuts, Shide Poke, Gotch Ear, Gold Dollar, Silver City, Popcorn, Stockings, Louse Cage, Stingin' Lizzard, Bootjack, Whiskey Pete, Sassy Sam, Tater Slip, Cannon Ball, Big Enough, Lone Oak, Pain, Gray Wonder, Buttermilk, Midnight, Rabbit, Fence Row, Sunfisher, Bullet, Ignorance, Smoky, Hop Ale, Barefoot, Lift Up, Boll Weavil, Crawfish, Clabber, Few Brains, Showboy, Rat Hash, Butterbeans, Bull Pup, Tallow Eye, and hundreds of others, each appropriate to the horse that bore it.

The cowboy originated these titles in all gravity. To him it was the method of quick and easy identification. He seemed possessed of a talent to invent a name that fitted the individual so well that it forever "stuck to him like a postage stamp."

✦ XVII ✦

THE COWBOY DANCE

*When the fiddler began thumping his strings, it was a signal
that the dance was about to start*

The "calls" of the cowboy dance rightfully belong to his lingo and to appreciate them fully it may be well to paint a brief picture of the preparations for the dance at which they were used.

Near the southern border the dance was called a "baile," but over the rest of the cattle country it was called by the various names of "hoe-dig," "shin-dig," "hoe-down," or "stomp." To one who had never witnessed such dances, they really appeared to be a "romping, stomping" affair, but to the cowboy they were the supremely important social event of his life. No special messenger was sent out to announce one, yet the news got around by that mysterious plains' "grapevine telegraph." Some cowboy just "happened by" and mentioned it. For anyone to hear of one was to consider himself invited.

Then followed weeks of feverish anticipation. All made plans to attend, no matter how great the distance. A ride of from thirty to sixty miles did not for a moment stand in the way.

Getting ready for the dance was no ordinary affair. The host had beeves to barbecue; his womenfolks had cakes to make — dozens of them; bread and pies to bake, and doughnuts to fry — tubs of them. The cowboy dug into his "war-

bag" for his "Sunday-go-to-meetin' clothes" in order to "slick-up" for the occasion. There were laundrying to do and boots to be greased. Much time was spent in shaving and cutting each other's hair. No thought was given to the fact that a day's ride over dusty trails would mar their shining splendor.

The early arrivals at the dance helped with the last-minute preparations. They came on horseback, in buggies, buckboards, and wagons. Some of the more fortunate women brought along their "party clothes" in a "go-Easter" and dressed for the occasion after their arrival.

By the time supper was announced, perhaps a hundred guests had arrived, and they, in a very short time, consumed the major portion of the food the host's wife had spent two or three days in preparing. No other formal meal was served after this initial one, though there always seemed to be an ample supply of sandwiches, pies, cake, and doughnuts left upon the shelves within easy reach. A pot of coffee was kept upon the stove all the time.

After supper the furniture was removed. Along one of the walls planks and boxes were arranged for the "womenfolks." With the dearth of women, it became necessary for some of the men, in order to complete a set, to volunteer to have a handkerchief tied around their arms to designate that they were to play the part of a female when there were "not enough ladies to go 'round." They were then said to dance "lady fashion." No woman was a "wallflower." She was fortunate if she could sneak out unseen to miss a set and rest her tired feet.

When the fiddler began thumping his strings, it was a signal that the dance was about to start. The old-time fiddler was a unique character. As a rule he was a lazy, shiftless individual who was never known to refuse a drink. Many of the

figures of speech in the cowboy's lingo referred to these shortcomings. Such examples as "He had more friends than there's fiddlers in hell," "Lazy 'nough to be a good fiddler," and "Drunk as a fiddler's clerk," show in what light the cowboy held him in ordinary times, but at the dance—ah, that was different. Here he was the man of all importance.

He spent some time in tuning up his instrument before the admiring crowd, seemingly enjoying the importance of his office. When he started playing, all signs of his habitual laziness vanished and he became strangely animated. He "kept time" with his head, his feet, and his whole body. All of them played "by ear"; therefore, each of them had a different interpretation to the tunes they knew. They could play by the hour and never play the same tune twice, and if they were occasionally slipped a "nip" to keep their spirits up, they would play the whole night through without complaint.

The "caller" was another important individual. He was always some person who was "leather-lunged" and "loud-mouthed," and was usually more forward than the average. Ordinarily he was a carefree character both in manner and dress, and, though he was looked upon as an important official, he seemed utterly unaware of this importance. He sometimes led the dance and "called" for it at the same time. He called from memory, often filling in the forgotten parts with words of his own, and frequently invented new calls as he went along. His calls were chanted in a monotone that fitted well with the rhythm of the music of the fiddle.

The "calls" of the cowboy dance were exceedingly picturesque. They were difficult to catch, as every "caller" sang them in a perfect meter and cadence of his own.

The following are but a few examples, and the reader will note the similarity of some of the wording, yet they are all a

little different. This was often due to the fact that the "caller,"
as we have mentioned before, invented words to take the
place of some he had forgotten.

A familiar call was:

> Hark ye, partners,
> Rights the same,
> Balance you all.
>
> First lady to the right;
> Swing that man that stole the sheep,
> Now the one that hauled it home,
> Now the one that ate the meat,
> Now the one that gnawed the bones.
>
> First gent, swing yo' opposite partner,
> Then yo' turtle dove,
> Again yo' opposite partner,
> An' now yo' own true love.
>
> First couple to the right,
> Cage the bird, three hands 'round,
> Birdie hop out an' crane hop in,
> Three hands 'round an' go it again.
>
> All men left; back to the partner,
> An' grand right an' left;
> Come to yo' partner once an' a half,
> Yallerhammer right an' Jaybird left,
> Meet yo' partner an' all chew hay,
> You know where an' I don't care,
> Seat yo' partner in the old arm chair.

Perhaps the "caller" might use:

> Choose yo' partner, form a ring,
> Figure eight, an' double L swing.
>
> First swing six, then swing eight,
> Swing 'em like swingin' on the old gate.

Ducks in the river, goin' to the ford,
Coffee in a little rag, sugar in a gourd.

Swing 'em once an' let 'em go,
All hands left an' do-ce-do.

You swing me an' I'll swing you,
An' we'll all go to heaven, in the same old shoe.

Chase the possum, chase the coon,
Chase that pretty girl 'round the room.

How'll you swap, an' how'll you trade,
This pretty girl for that old maid?

Wave the ocean, wave the sea,
Wave that pretty girl back to me.

Swing yo' partners, once in a while,
Swing 'em all in Indian style.

Rope the cow an' kill the calf,
Swing yo' partner, a round an' a half.

Swing yo' partner before you trade,
Grab 'em back an' promenade.

Grab yo' partner an' sail away,
Hurry up, it's breakin' day.

Swing 'em 'round an' 'round an' 'round,
Pocket full of rocks to weight 'em down.

There comes a girl I used to know,
Swing 'er once an' let 'er go.

Meet yo' partner, pat 'er on the head,
If she don't like coffee, give 'er corn bread.

Three little sisters all in a row,
Swing 'em once an' let 'em go.

Old shoe sole is about wore out,
Grab a girl an' walk about.

Swing 'em east an' swing 'em west,
Swing that girl that you like the best.

Another favored call was:

Swing to the right
An' back to the left,
An' don't forget yo' double L,
Now yo' honey an' farewell.

Throw yo' loop an' jerk yo' slack,
An' meet yo' honey an' turn right back.

Yallerham look an' log chain hook,
An' the more you look the better you hook,
An' keep hookin' on.

Hang the dogs an' kill the cats,
An' double yo' dose on rough on rats.

Swing the cow, now the calf,
Now yo' partner once an' a half.

Watch 'em hands an' watch 'em close,
Meet yo' honey in Arkansaw style,
An' flop yo' ears an' go hog wild.

Pull off yo' shoes an' smell of yo' socks,
An' grab yo' a hiefer an' rattle yo' hocks.

Double U an' double O,
Double yo' time an' a little more dough.

Come on boys an' show some ditty,
Shake yo' feet an' ketch yo' kitty.

Swing yo' corner once in a while,
An' meet yo' honey an' go hog wild.

Swing yo' corner like swingin' a gate,
Now yo' honey an' pull yo' freight.

Hands in yo' pockets an' neck to the wall,
Take a chaw o' tobacco an' balance all.

Grab yo' partner by the paw,
An' swing 'er 'round old Arkansaw.

A little more sass an' a little more gravy,
Once an' a half an' swing yo' baby.

King bolt out an' the axle draggin',
Swing yo' honey an' keep on raggin'.

Ducks on the mill pond, geese on the ocean,
Swing yo' honey while you got 'em in motion.

Another prevailing call was the "Chase That Rabbit":

Swing yo' partner 'round an' 'round;
Pocket full o'rocks to hold me down;
Ducks in the river goin' to the ford,
Coffee in a little rag, sugar in a gourd.

Swing 'em early, swing 'em late,
Swing 'em round Mister Meadow's gate.

Ladies to the center, how you do?
Right hand across, an' how are you?

Swing six when you all get fixed,
Do-ce, ladies, like pickin' up sticks.

Chicken in the bread tray kickin' up dough,
"Granny, will yo' dog bite?" "No, by Jo."

Swing corners all,
Now yo' partners, promenade the hall.
You swing me an' I'll swing you;
All go to heaven in the same old shoe.

Same old road, same old boy,
Dance six weeks in Arkansaw.

With the huckleberry shuffle an' the Chinese cling,
Elbow twist an' the double L swing.

Everybody dance as fast as you can;
Ketch yo' partner by the hand.
Two little sisters form a ring,

When you form it everybody swing.
Meet yo' partner, pat 'er on the head,
If she don't like coffee, give 'er corn bread.

Bird hop out, crow hop in,
Eight hands up an' goin' again.

Girl after boy!
Chase that rabbit, chase that coon,
Chase that baboon 'round the room!
Reverse!

Chase that rabbit, chase that squirrel,
Chase that pretty girl 'round the world!
Promenade!

All hands up an' circle 'round.
Don't let the pretty heifers get out of town!
Everybody dance!

Swing yo' partners, swing 'em one an' all,
Corral them pretty mavericks up an' down the hall!
Whoop-ee, everybody prance!

Four ladies domineck, four gents shanghai,
Then build yo' hopes on the sweet bye an' bye!

Do-ce, ladies, ain't you old enough to know
That you'll never get to heaven till you do-ce-do?

The "Ocean Wave" was another popular call:

Break an Indian home, in the Indian style,
Stop an' swing the lady behind you once in a while—
The lady behind you once in a while;
Swing the lady behind you once in a while,
Now yo' partner an' go hog wild.

Swing 'em right an' swing 'em wrong,
Now yo' partner, an' carry her along.
Wave the ocean, wave the sea, wave my true love back to me.
Wave 'em up an' wave 'em down, six hands up an' 'round an'
 'round.
Do-ce-do. Watch 'em dance an' watch 'em prance.
Swing 'em all 'round the Swenson Ranch.

Wave the ocean, wave the sea, wave that pretty girl back to
 me!
Circle eight till you all get straight;
Walk the huckleberry shuffle an' the Chinese cling!
Elbow twist an' the double L swing.

You swing me an' I'll swing you,
An' we'll all dance in the same old shoe;
The same old boys, the same old trail,
Watch that possum walk the rail!

Wave 'em up an' wave 'em down, an' wave 'em all way 'round
 an' 'round.
Circle eight till you all get straight,
An' swing them ladies like swingin' on a gate.
Swing 'em right an' swing 'em wrong, all night long,
Watch yo' partner an' watch 'er close,
When you meet 'er double the dose!
Swing 'em right an' swing 'em wrong,
Now yo' partner an' carry 'er along.

Wave the ocean, wave the sea, wave my true love back to me.
Wave 'em up an' wave 'em down,
Six hands up an' 'round an' 'round.

Wave the ocean, wave the sea, wave my true love back to me.
Circle eight till you all get straight,
Swing them ladies, first by the right, then by the wrong,
Now yo' partner an' carry 'er along.
Wave the ocean, wave the sea, wave my true love back to me.
Wave 'em up an' wave 'em down, wave 'em all the way 'round
　　an' 'round.

Circle eight till you all get straight,
Swing them ladies like swingin' on a gate,
Left foot up an' right foot down,
Make that big foot jar the ground.

Swing yo' corner if you're not too slow,
Now yo' partner an' 'round you go,
For the last time—swing an' go somewhere,
You know the place an' I don't care.

At the beginning of the dance most of the guests were shy. Perhaps it had been some time since the cowboy had been in the presence of the opposite sex, but when all the noise and action got well under way, all shyness was forgotten. The whining of the fiddle, the shouts of the caller, the stomping of high-heeled boots got into the blood and dispelled all traces of self-consciousness. Soon everything was a continuous noise and action that seemed to cast a spell over all.

Perhaps there was some pious person present whose church strictly forbade dancing, and he merely came to be sociable and look on. The longer he looked, the more weakly he refused the invitation to "jine in," and the more tantalizing the music of the fiddle became. The lure of the gaiety soon

got the best of him, and it was not long until he was "shakin' a good hoof." He was then said to have "danced himself out of the church" and had to be "saved" at the next revival.

The dance always lasted until daybreak, and not infrequently for two or three days. No matter when it ended, the caller was hoarse and the fiddler worn out. The guests were sleepy and tired as they rode wearily back to their ranches, but through their minds the words and rhythm of those old calls ran with mechanical monotony.

→ XVIII ←

............................

MISCELLANEOUS EXPRESSIONS

He was apt to be referred to by such contemptuous titles
as "churn-twister," "plow-chaser," or "fool hoeman"

The cowboy had his own terms for practically everything that came under his observation. The various characters with which he occasionally came in contact each had their apt and striking titles. The farmer, of whom the earlier cowboy had so little use, was called a "granger" in the Northwest, but was more commonly called a "nester" in the Southwest. In either section he was apt to be referred to by such contemptuous titles as "churn-twister," "plow-chaser," or "fool hoeman," while the cotton-picker was a "lent-back." The farmer's work was spoken of as "lookin' at a mule's tail all day," or as "turnin' the grass upside down." A farmer of irrigated land was called a "dry lander." A rustic was referred to as a "sunpecked jay."

A "squatter" was one who settled on State or Government land to take up a "claim" or "homestead," often referred to as a "squat" or "hundred-and-sixty," while one who unfairly or unlawfully appropriated a homestead, or a mine claim from a prior or rightful owner, was said to be a "claim-jumper." One habitually moving from one range to another in a covered wagon and temporarily "squatting" on land was called a "mover."

Held in still greater contempt by the cowboy was the "snoozer," or sheepman, a man who "favored mutton instead

of beef." His occupation was said to be "walkin' sheep" because the work was done on foot, and the animals under his care were called "baa-a-ahs," "woolies," "stinkers," or "under-wears." It was said in the West that "a snoozer has always got a grouch an' a Waterbury watch, an' when he ain't a-nursin' the one he's a-windin' the other."

Near the Mexican Border the cowboy's contemptuous name for a Mexican was "pelados," and this term was resented by all of the latter.

A "batch" was an unmarried man, usually one living alone, and one who was living the life of a recluse was often referred to as a "buck nun." A "remittance man" was usually the "black sheep" of some English family of nobility, sent to the American West to relieve the family of his further social misconduct. He was called thus by the cowboy because he depended upon the remittance of monies from overseas. A man "with a load of hay on his skull" was a long-haired one; one possessing little hair "had about as much hair as a Mexican dog, an' they're fixed for hair about like a sausage." A white man married to an Indian woman was a "squaw man"; a very black man was said to be a "headlight to a snowstorm," while a black soldier, such as served at the frontier forts, was called a "buffalo soldier."

A person suffering from tuberculosis and going West for the benefit of the high, dry air was a "lunger." Bud Cowan once told us of a "lunger" visiting his ranch in search of health, and he ended his description of the invalid by saying, "His lungs wasn't stronger than a hummin'-bird's an' he didn't have 'nough wind to blow out a lamp." A hare-lipped person was a "can't whistle"; a person who lived upon the Pacific Coast was called a "sloper."

Doctors were "pill-rollers" or "saw-bones"; a preacher was a

"sky pilot" or "converter"; and school teachers were "wisdom-bringers." A homely woman was referred to as a "Montgomery Ward woman sent West on approval"; a wife obtained through a matrimonial bureau was a "catalogue woman" or "Heart and Hand woman." There being "no calico on the range," woman-hungry men sometimes secured wives through these agencies. Dishwashers in restaurants were slangily called "pearl-divers." A "saddle-blanket gambler" was one who played for small stakes, often spoken of as a "tin-horn," this latter term also being applied to others not proficient in their chosen calling. A man who frequented the gambling-room, and who, by being allowed by the dealer to win large sums, led the unwary cowboy to buck a "brace game," was a "capper."

People who were looked upon as meddlers and "horned in" on things that did not concern them were said to be "feedin' off their range," and were called "wedgers-in," "Paul Prys" or "eye-ballers."

In the early days the "buffalo-skinner" was one employed in skinning buffaloes. This word was often shortened to "skinner," "peeler," or "stripper," and was also used to designate men employed in skinning or "peeling" cattle after a wholesale "die-up." The word "skinner" further meant a teamster or freighter if he used mules or horses, an ox-team outfit making such service of him a "bull-whacker." In range English one did not "drive" a "jerk-line string," but instead "skinned" it.

A "jerk-line" was a single, continuous rein, starting from its fastening at the top of the brake-handle, extending to and through the hand of the driver, who either was astride the "wheel horse" (the near one, if two) or was seated on the wagon's seat. The line continued thence along the long line of

horses' backs, and to the left side of the "lead animal's" bit, without touching the bit of any intermediate animal. A single steady pull on the line guided this lead animal to the left. Two or more short jerks turned it to the right. A "jerk-line string" was a string of horses or mules harnessed either in single file or in a series of spans, and, in either case, following a highly trained leader controlled by the "jerk-line." The saying, "a-hold of the jerk-line," meant to be in control of the situation in question.

A "mulero" was also a driver of mules, or a "mule-skinner." A man who aided the driver of a "string team" by swinging the whip, pushing on the brake handle and co-operating in the swearing, was the "lasher." The man, who, in the days of the stagecoach, rode beside the driver and was hired to defend the company's or shipper's property with a sawed-off shotgun, was called a "messenger" or "shotgun messenger." The ox trains of the early freighters were called "grass trains," because their motive power could live on grass whereby horses and mules had to have corn.

A "pack-train" was a group of animals carrying packs of freight. This was one of the West's principal modes of transportation in earlier days, especially in rough country. A "prairie schooner" was the wagon of early days, the canvas cover of which suggested a schooner under sail.

A veteran prospector of the desert country, usually without a mine or any other property, was often spoken of as a "desert rat." Men who made the gold rush to California in 1849 were referred to as "forty-niners." Men who had the gold fever were said to have "gold colic." Prospectors were sometimes called "coffee-coolers." The "vigilants" were the men who took the enforcement of the law into their own hands in the early days. A "mustanger" was a man engaged in catching

mustangs. A resident of the arid lands was called a "sage rat," or "sagebrushers."

The word "stiff" was used as a synonym for "corpse." As the lifeless body of a human being soon became rigid, the easier spoken word "stiff" was substituted for corpse, and was later applied in a contemptuous way to suggest worthlessness or to "dead ones." "Stinker" was a word applied to another person when the latter was held in contempt. The word was originated in this sense by the buffalo hunters, and was applied to newcomers on the range who skinned the buffalo that the former had killed, but were unable to secure the hides immediately on account of freezes or other natural causes. "Bone-pickers" were men who gathered buffalo bones after the hunters had exterminated the buffalo. It was a short but lucrative vocation. The name was also applied to buzzards.

The cowboy had his own names for the different formations of the country. In the Southwest he called a dry creek an "arroyo," while the Northwesterner called it a "coulee." The "bad lands" was a section of the country with very little vegetation and was composed principally of buttes, peaks, and towers and other badly erosioned soil. The "brush country" or "brasada," as it was sometimes called, was a country covered with low-growing trees and mesquite. The Southwesterner called brush "chaparro," and "chaparral" was a plantation of evergreen oaks. The desert was often spoken of as the "cactus."

A "box canyon" was a gorge with but a single opening, the inner terminal being against a wall of rock of the mountain mass. It was also called a "blind canyon." The cowboy spoke of a precipitous hillside as a "cut-bank," a slope as a "sag," and a shallow drain for rainfall as a "draw." A "mesa" was a flat-

topped hill or a mountain shaped like a table; a "motte" a clump of trees; a "paso" could be either a pass, a ford, or meant a double-step or six feet. The "buffalo wallow" so common on the prairies was a depression which had been hollowed out by the wallowing of buffaloes. A flat, open prairie was sometimes spoken of as a "llano," while a "sendero" meant a path through the brush. A dwarf pine was often called a "piñon." The brushy weed that, when dry, rolled before the wind was a "tumbleweed."

Animals, other than the ones he tended, also had their various titles and slang names. The "lobo" or "loafer" was a gray wolf, while coyotes, on account of their yipping, were dubbed "prairie lawyers." Mules were called "hard tails" or "knob heads," and burros "desert canaries." Hogs were "wooshers" or "rooters," and the "javalina," a musk hog native to the brush country, was said to "look like a ball of hair with a butcher knife run through it." Skunks were "stink cats," "wood pussies," "sachet kittens," or "pikets," sometimes shortened to "P.Ks." The "piasano" was a "road-runner" or "chaparral bird." The dog trained and used to catch cattle by the nose and hold or throw them until they could be tied was a "ketch dog." The rattlesnake usually found in the desert which strikes by swinging its head and part of its body to left or right was a "sidewinder." This title was also applied to humans of little principle. Those pesky little insects which the boys in the World War called "cooties" were called "pants rats" or "seam squirrels" by the cowboy.

The "blizzard" was a high, cold, searching wind, accompanied by blinding sleet and smothering snow. The word was derived from the old Anglo-Saxon *blazon,* meaning "blow." In Texas and the Southwest a driving gale from the north

that hurtled over the country, and, coming into collision with the preceding warm, moist breezes from the Gulf, causing sudden and extreme depressions in temperature, was called a "norther." A "chinook" was a warm wind in the Northwest from the Japan Current which melted the snow even in midwinter. This same term was also used in speaking of the universal Indian language—the Esperanto of the red men, understood by all tribes of the Northwest. A "silver thaw" was rain that froze as it hit. A very hard rain was a "gully-washer," "fence-lifter," or "goose-drownder." A sandstorm was an "Oklahoma rain," and a whirling sandstorm was often spoken of as an "Idaho brain-storm," or a "dancing devil." A cyclone was called a "hell wind" or "twister," and a cyclone cellar was a "'fraid hole."

When the cowboy spoke of hiding something, he invariably "cached" it. This word was from the French *cacher*, meaning to conceal, and was used both as a noun and a verb. "Grub-stake," used as a verb, meant to furnish provisions, and as a noun meant the provisions themselves. The term required its recipient to pay to its donor an agreed share of whatever profit might accrue from the enterprise on which the recipient was about to embark. "Adobe" might mean, according to its context, either earth from which unburnt bricks were made, the bricks themselves, or a house made of this material.

The cowboy's name for jail was "hoosgow," from the Spanish *jusgado*, a prisoner's dock in a Spanish criminal court. By "prairie-dog court" he meant kangaroo court. A "jacal" was a hut or cabin.

The "skunk boat" was a heavy canvas shaped like a narrow scow boat with sides about a foot high, which, when propped

up at each corner with a small stick, formed a barrier about the sleeper's bed over which it was believed no skunk could make his way to bite the one thus protected.

The Mexican *vaquero* had a sport called "pulling the chicken," in which the rooster was buried in the earth, his head only being left above the ground, and the contestants were mounted on horses. They dashed by, one after the other, and as they passed the rooster each man swung himself from the saddle and reached for its head. The chicken naturally dodged more or less, rendering it no easy matter to catch him. Finally secured, however, by a lucky grab, the body was brought out by a jerk which generally broke the neck, and the horseman, chicken in hand, dashed away at his best speed, all the rest giving chase for the possession of the rooster. If another overtook him and wrested it from him, then he led the race until someone else could take it.

When the cowboy spoke of the "long ear," he meant the placing of a silk neckerchief on hard ground and listening by placing the ear upon it. Frequently this was used by old plainsmen, and sounds otherwise inaudible were somehow magnified by this means.

"Pulling for the Rio Grande" was an expression meaning that the one spoken of hit for that line which had for so many men on both sides meant life or death.

In pioneer days carrying a chunk of fire so that it would not go out was something of an art and required care and speed. If anyone wanted to "borrow" fire from a neighbor, he generally made his call brief. From this fact arose the old saying, once common, but now dying out, "Y'u must have come after a chunk of fire," in protest to a brief call.

If a man had been in the cattle country long and was ex-

perienced in the business, he was referred to as "old," even though he might be young in years.

Anything large or powerful was "hefty." A large amount was a "slew" or "slug." Anything small was sometimes "half-pint size," while a collective whole was a "whole shebang."

A range peddler's wagon, usually loaded with clothing, cinches, straps, stirrup leathers, and other cowboy supplies, was called the "band wagon" by the cowboy. Driving any wagon so that the hubs would strike gate-posts and other objects was called "hubbing."

In the extreme Northwest a few words were borrowed from the Chinook jargon of the coastal traders and trappers. "Skookum," meaning great; "siwash," meaning an Indian and used in the sense of not being up to the white man's standard; and "cultus," meaning worthless, were the ones most commonly used.

A "voucher" was an Indian scalp; "Indian sign-board" was the shoulder-bone of a buffalo, so often seen upon the prairie in early days; and a "skull-cracker" was a tomahawk. One old-time rangeman said that in the Indian days inability to "read sign" and a mistake in observation "might undo yo' hairpins and cause yo' scalp to migrate from yo' skull to a koo-stick." Another, in speaking on the subject, said that "an Indian haircut called for a certain amount of hide which makes it handier to trim leggin's with."

"Prairie wool" was grass; "Mexican iron" was rawhide; to "gin around" meant to chase around; while to "lay for" meant to lie in wait for, and in a special sense "elected" meant doomed.

Reference to the Panhandle of Texas was spoken of as "down in the Skillet." "Getting down to cases" was confining

one's activities to the matter in hand. Digging for something in the earth was called "gophering," and "pirooting" meant meandering or fooling around. A "pasear" was a journey or trip, and to "talk turkey" was to mean business. Cigarette material was called the "makin's," while the cigarette itself was referred to as a "brain tablet." His book of cigarette papers was often spoken of by the cowboy as his "prayer book" or "bible." One cowboy, in speaking of another rolling a smoke, said, "He jerked a leaf out of his prayer book an' commenced to bundle up a new life of Bull Durham."

To "buffalo" was to bluff or confuse one. The catalogue of a mail-order house was called a "wish book." To "blow-in" was to arrive or to spend money, while a "blow-out" was a celebration. When the cowboy acknowledged defeat, he was said to "holler calf rope." To do one's best was to "cut a rusty"; to perform an antic was to "cut a shine"; and to make oneself ridiculous was to "cut a big gut." To make a person angry was to "get a rise from," and to succeed in one's efforts of whatever kind was to "get the bacon." To complain bitterly was to "kick like a bay steer." To lay down the law or give positive orders to one was to "read the Scriptures."

→ XIX ←

FIGURES OF SPEECH

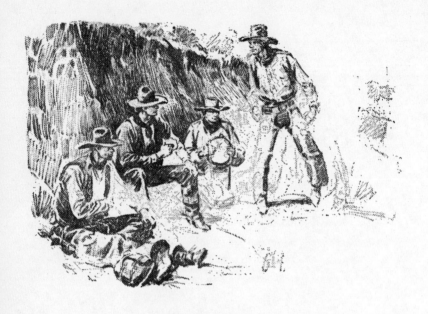

When among his fellows he often displayed his
"talkin' talents"

More than any other avocation of mankind, the pastoral life and industry have enriched modern language with metaphors and similes of striking beauty, concrete significance, and charming simplicity. These two figures are the great expressive powers of language. Not only are these figures of similarity available as means of renewing the vitality of living speech, but their fossil forms enter largely into the composition of the formal state of the language. By means of metaphors we express more vividly and strikingly our feelings on any subject.

The cowboy's language is full of strange, exaggerated, peculiar illustrations, comparisons, and similes. His rich choice of synonyms embodies a latent chapter of life and habits. It is a phase of the same lawlessness, the same reliance on self, that makes for his taciturnity and watchfulness. His language, seasoned as it is with Mexicanisms and metaphors peculiar to the range, is as much a part of his lore as life itself.

On his lonely rides he had ample time to reduce his thoughts to clear-cut phrases which he would store in mind against the time when they should be summoned into active use. The solitude and hazards of his life developed to a high degree his resourcefulness and his power of mental observa-

tion. Humorous intent was back of most of his metaphorical shifts in meaning.

Above all, he was epigrammatic, and his terseness developed him into an artist as a painter of word pictures. We do not believe he has an equal for aptness in his figures of speech. Does not the expression "sloshed on his hat" picture in four words a man putting on his headgear in a careless manner better than it could be told in a paragraph? Who but a cowboy would express the act of a man blowing the dust from his hat by such a phrase as "he whistles on it with his breath"?

Where the ordinary man might express the sudden appearance of horsemen in the road ahead in various inadequate forms, the cowboy pictured it completely by creating a verb in a new sense and saying, "Four men *bulged* into the road ahead," thus depicting in one word suddenness in the strongest possible terms. Again, "they came skally-hootin' into town" paints a complete picture of men riding recklessly down the dusty street and drawing their sweating horses to a slithering halt before the hitch-rack. "Comes rackin' to town" is another expression he used to convey the same idea.

The cowboy, in expressing his idea of something that he considered of much prominence, was likely to use such figures as being "as public as a zebra," "as plain as paint," "as plain as plowed ground," "as plain as the horn on a saddle," "as plain as the ears on a mule," "as plain as the hump on a camel," "as prominent as a boil on a pug nose," "as prominent as a new saloon in a church district," or he might say that it "showed up like a tin roof in a fog."

An unpopular man was spoken of as being as "popular as a tax collector," "as popular as a wet dog at a parlor social," and his company was "as welcome as a rattler in a dog town," or

"as welcome as a pole-cat at a picnic," while a popular man was said to "have more friends than ther's fiddlers in hell."

Whatever else could be said of the cowboy, he "had sand in his craw," and in speaking of a brave man was likely to use such terms as "he's got plenty of sand in his craw," "got more sand than the Mohave Desert," "had plenty of gravel in his gizzard," or was "gritty as fish eggs rolled in sand." Anyone not possessing these qualities had a small place in his life. Anyone who "ran his boot-heels over side-steppin' trouble," "had a yellow streak down his back so wide that it lapped plumb around to his brisket bone," or was "yellow as a dandelion," would be advised to "hunt up somethin' y'u can use for a backbone." Such a person's "guts had turned to fiddle-strings," and you "could take a bunch o' corn cobs an' lightnin' bugs an' make him run till his tongue hung out like a calf rope," and there was "no more harm in 'im than in a chambermaid." A cowardly person was also said to be "cold-footed." *Cowboys don't like cowards*

The cowboy took pride in his calling and his ability as a horseman, but when asked to do something on foot the old-time puncher informed you he was "too proud to cut hay an' not wild 'nough to eat it." In speaking of pride in someone else, he might say that "he swelled up like a carbuncle," or "he swelled up till he busted his surcingle." The antonym for pride might be such a phrase as "proud as a lost sheepherder," plenty to be ashamed of, to say the least.

Trying to accomplish the impossible was "like tryin' to scratch yo' ear with yo' elbow," "barkin' at a knot," "like an elephant tryin' to use a typewriter," or "as easy as trimmin' the whiskers off the man in the moon." When the cowboy believed he had little chance of finding a hunted object, he would perhaps say that he "might as well try to find hair on a

frog," or "might as well hunt for a hoss thief in Heaven." If it was a contest, be it a fight or a frolic, where he had small chance of winning, he was said to "have as much chance as a wax cat in hell," or "about as much chance winnin' as a grasshopper that hops into an anthill." We have also heard the expression, "he couldn't get as far as I could throw a post-hole," in speaking of the impossibility of an escape. On the other hand, something easily accomplished was said to be "as easy as guttin' a slut," or "as easy as eatin' striped candy."

A useless object was said to be "as useless as a twenty-two cartridge in an eight-gauge shotgun." If it was impossible to convince another of your side of an argument, you "might as well argue with the shadow of death," and your argument had "no more effect than pourin' water on a drowned rat."

It was said of a worthless person that "he wasn't worth a barrel o' shucks," "his family tree was a scrub," or "he ain't fit to shoot at when y'u want to unload an' clean yo' gun."

When a person grew older and wiser in experience, he was said to have "gotten more wrinkles on his horns." A sagacious person was also said to be as "wise as a tree full of owls," "looked as wise as a pack-rat," "a pet fox was foolish alongside of him," or "he ain't needin' advice more'n a steer needs a saddle blanket."

On the other hand, an ignorant person "don't know sic 'em," "couldn't drive nails in a snow bank," "don't know as much about it as a hog does a side-saddle," or "knowed about as much about it as a hog does a hip pocket in a bathin' suit."

A mentally weak person was said to be "feather-headed," and his condition may be expressed by any of such terms as "his thinker is puny," "he don't know dung from wild honey," "he didn't have nuthin' under his hat but hair," "his brain cavity wouldn't make a drinkin' cup for a canary bird," he was "as

shy of brains as a terrapin is of feathers," "he's off his mental reservation," "he's crazy as popcorn on a hot stove," "all he knew about brains was that y'u could buy 'em with scrambled eggs," or "his memory's pulled its picket-pin an' gone astray." If the one spoken of was childishly foolish, "he ought to be playin' with a string of spools," or "he can't tell skunks from house cats an' needs a wet nurse."

The cowboy's idea of the superlatively beautiful was "pretty as a basket o' chips," "pretty as a painted wagon," "pretty as a heart flush," "handsome as an ace-full on kings," "soft an' pretty as a young calf's ear," or "prettier'n a spotted dog under a red wagon." Naturally, in speaking of his sweetheart, she was "so sweet bee trees is gall beside her."

Ugliness was not without such expressions as "ugly as galvanized sin," "uglier than a Mexican sheep," or "uglier than a new-sheared sheep." One puncher said of another that the latter was "so ugly the flies wouldn't light on him"; another likewise described a cook as being "so narrow between the eyes he could look through a keyhole with both eyes at once."

Anything large was "bigger'n an eight-mule baggage wagon," "bigger than a load of hay," or "y'u couldn't crowd it into a wagon-box." An extra large covering for an object "covered it like a carpet," and an unusually large man was "big enough to hunt bears with a switch."

A fat person "shore had tallow," or was "so fat y'u'd have to throw a diamond hitch to keep him in the saddle." Losing weight was "gettin' rid of yo' leaf lard," "fallin' off like persimmons after a frost," and if one lost much weight he was said to be "gettin' as thin as a cow in April," or was as "poor as a whip-o'-will."

A very thin person was said to be "so thin y'u couldn't hit him with a handful of corn." Often we've heard the expres-

sions, "he's built like a snake on stilts," "he had to stand twice to make a shadow," "he's so narrow he could take a bath in a shotgun barrel," and "if he closed one eye, he'd look like a needle." Very poor cattle were "as gant as a gutted snowbird," or "so thin they looked like they had only one gut." On a Texas ranch we once heard a puncher say of a certain thin comrade that "he's so long he has to shorten his stirrups to keep from wearin' out his boot soles." Of a very short person it was said "he had to borrow a ladder to kick a gnat on the ankle," or "he dragged the ground when he walked." A short object was often expressed as being "as short as the tail-hold on a bear."

We once heard a cowboy who was feeling bad declare that he "felt like the frazzled end of a misspent life." In speaking of others who looked or felt bad, he was apt to say "he looks like a motherless calf," "he's off his feed," "his lip hangs like a blacksmith's apron," "he looks so bad his ears flop," or "he looks as sad as a tick-fevered dogie."

A weak person was said to be "paper-backed," and if he was soft it was "like he's built o' butter." It was also said of a puny person that "he can't lick his upper lip," "he's so puny he couldn't pull off my hat," or "he's so weak a kitten is robust beside him."

In speaking of people who got along harmoniously, the cowboy was likely to use such expressions as, "they got along like two shoats in the same pig-pen," "they had no more trouble than between a kitten an' a warm brick," "they got along like two pups in a basket," or they "took to each other like a sick kitten to a warm brick," or were "gettin' 'long as peaceful as two six-shooters in the same belt." An agreeable person might be spoken of as being "genial as a bartender to a sheriff." An inhospitable person was "sociable as an ulcerated

tooth," "as polite as one strange dog to another," or "as polite as a hound to a stray pup after his bone."

His idea of any objects or persons being thick was "as thick as cloves on a Christmas ham," "as thick as feathers in a pillow," "as thick as hoss-flies in May," or "as thick as seven men on a cot." Of a certain spurred and chapped Damon and Pythias it was said that they were "thicker'n splatter."

If the cowboy attempted to describe a group of people who were in a joyous frame of mind, he probably would say that they were "happier than a lost soul with hell in a flood" or "enjoyin' life as much as a kid does pullin' a pup's ears." On the other hand he may speak of an unhappy person as being "sad as a bloodhound's eye," "happy as ducks in Arizona," or speak of that individual as "his luck was runnin' kinda muddy," or that someone or something had "swiped the silver linin' off his cloud." We heard a weather-beaten puncher, in telling of an incident that touched his heart, say, "I didn't shed no tears, but I damned near choked to death." At another time when someone told a touching story, a tenderhearted cowboy, brushing away a tear that he was trying hard to conceal, said, "The smoke of yo' campfire got in my eyes." Still another one, in relating a touching incident finished by saying that "it squeezed me together inside till it hurt." Anything sad was referred to as a "tear-squeezer," and a moody or downcast person was said to be "daunsy."

Slowness in action was pictured as "slow as a snail climbin' a slick log," or a slow person was "too slow to grow fast." Of a man or horse that was not up to his expectations in running, he classed as "runnin' like he had hobbles on." A lazy person was held in contempt by the cowboy and was said to be "lazy 'nough to be a good fiddler," "lazy as a hound dog in the sun," or "molasses wouldn't run down his legs."

COWBOY LINGO *quicker*

Quickness, on the other hand, was often expressed in the one word "pronto." "First rattle out of the box" expressed prompt action, while "like the devil beating tan bark" meant fast and furious, and "from who laid the chunk" was an expression used to denote action or quality in the superlative degree. Other phrases denoting quickness were "before a flea could hop out of danger," and "quicker'n hell could scorch a feather." Something consumed quickly "didn't last as long as a keg o' cider at a barn-raisin'," "didn't last as long as two-bits in a poker game," "didn't last as long as a rattlesnake in a cowboy's bootleg," "didn't last as long as a drink o' whiskey," or, as one said, going a little stronger, "didn't last as long as a pint o' whiskey in a five-handed poker game." One cowboy, in speaking of an enemy's quickness on the draw, once said "lightnin' hangs fire by comparison."

Westerners, as a class, were free-hearted and held nothing but contempt for a stingy person. Such an individual was scornfully said to be "stingy 'nough to skin a flea for his hide an' tallow," "so stingy that if he owned a lake he wouldn't give a duck a drink," "wouldn't give a dollar to see an earthquake," or "wouldn't give a nickel for a front seat at the Battle of Waterloo."

A restless person was said to be "junin' around," "movin' about like a hen on a hot griddle," "wanderin' 'round like a pony with the bridle off," or "movin' 'round like hornets in a bonnet." "Paint" Parker, whom we met in our own wanderings, was noted for his frequent change of location and his restlessness, and in discussing these qualities we once heard another cowboy remark that "Paint" was "like a loose hoss, full o' cockle burrs, an' always lookin' for new pastures." Broaching him upon the subject myself, "Paint" merely shrugged his shoulders and "reckoned he had so much iron in

his system that if he hung 'round one place long he'd rust," but we later learned that he was trying to stay "two jumps ahead of the sheriff."

Anything with objectionable odors might be said to have "smelled stronger than a wolf's den," "smelled like a packin' plant before the pure food law," or "smelled like hell on house-cleanin' day." Joe Carter, telling us of the time he sat next to an Indian at a "pow-wow," described this Indian as being "considerable whiffy on the lee side."

When the cowboy "went a-wooing" he was said to be "sittin' the bag," "sittin' her," "cuttin' a rusty," or "gallin'." If he had no chance to win the girl, he had "no more show than a stump-tailed bull in fly-time," or was said to "stand as much show as a hen at a mass-meetin' o' coyotes." Jealousy was often expressed as "jealous as a hound with her first litter o' pups."

If the cowboy did not understand you and failed to grasp your meaning of a statement, he would ask you to "chew it finer," or "cut the deck a little deeper." If a statement was hard for him to understand, he might let you know that it was "too boggy a crossin'" for him, or he might request you to "cinch up a little, yo' saddle's slippin'." If he wanted you to repeat your statement, he would ask you, "Would y'u mind ridin' over that trail again?"

To the Easterner a black night was merely "black as midnight" or some such mild phrase, but the Westerner again brought into play the strength of his metaphors with "black as a black cat's overcoat," "black as a blacksmith's apron," "dark as the inside of a cow," "dark as a stack o' black cats," or said the "night's so black the bats stayed at home."

In speaking of a cold object, it was "cold as frog legs," "cold as a dead snake," or "colder than a bartender's heart." The

weather came under such classifications as being "colder than hell on the stoker's holiday," "as sodden and cold as a clay farm in the month o' March," or "colder than a well-chain in December." The speaker, if he was out in such weather, expressed himself as being "cold as a well-digger in Montana," and was "blue as a whetstone," not to mention "shiverin' like a dog in a briar patch," or "shakin' like a dog in a blue norther." Weather of the opposite nature was "hotter'n hell with the blower on," "hot as the backlog o' hell," "hot as election day in a hornet's nest," "hot as the underside of a saddle blanket after a hard ride," "hotter'n a burnt boot," "so hot it would slip hair on a bear, or was "so hot an' dry y'u had to prime yo'self to spit," and the weather "sweated him down like a tallow candle."

Following a long drought the condition was spoken of as being "dry as a covered bridge," "drier'n a cork leg," "drier'n jerked buffalo with an empty water barrel," "it hasn't rained since Noah," and, as one puncher told us, he had "forgot what water looked like outside of a pail or trough." Of course, during such weather the grass was burned up, and there "wasn't grass 'nough to chink the cracks between the ribs of a sand-fly," or "wasn't grass 'nough to wad a smooth-bore gun," and the whole country "looked like hell on a holiday" or "looked like hell with the folks moved out." Then, when the rains did come, perhaps instead of "cussin'" the dry weather "ever'body wished they'd growed fins instead of feet," and if it rained long enough it got "wet 'nough to bog a snipe," or was "so swampy it'd bog a butterfly."

Noise was described as "noise like hell emigratin' on cart wheels." A person or object making an unusual amount of noise was "makin' more noise than an empty wagon on a

frozen road," or "makin' more noise than a jackass in a tin barn."

It was unusual to find one native to the open air of the West with a high-pitched, or raspy voice, but when the puncher did meet such a person he described him as having an "E-string voice," "a voice as frosty as a November night," or his "voice squeaked like a rusty gate hinge," or "sounded like an iron tire on frozen snow." Many of the boys had musical voices and sang to the cattle in a manner which was a pleasure to listen to, but on the other hand, there were some with no singing ability who were kidded about "singin' in a coyote key." We remember one night at the round-up wagon when Joe Jackson came riding in from night-herd singing in an atrocious manner to be greeted by Bill Bryant with "Y'u call that singin'? I thought y'u was garglin' yo' throat or givin' the death-rattle."

As a rule the cowboy was not talkative when around strangers, but when among his fellows he often displayed his "talkin' talents," especially when "tellin' a windy" or boastful story. A "mouthy" person was said to have "plenty of tongue oil," or "more lip than a muley cow," and the boss "ought to hire him to keep the windmill goin'." Such a person could perhaps "talk a cow out of her calf" or "argue a gopher into climbin' a tree." If such a person talked too much while at work, he might be advised to "quit yo' pantin' an' sweat a little," "save part of yo' breath for breathin'," "keep yo' gate shut," or "keep a plug in yo' talk-box." If one talked until it became boresome to his listeners, he might be commanded to "put yo' jaw in a sling, y'u're liable to step on it," "hobble yo' lip," "button yo' lip," "dally yo' tongue," or "tighten the latigo on that jaw o' yourn."

An "auger" was a man with unusual "talkin' talents," a great and inveterate talker; one who could "bore you"; "get his auger into you," as the cowboy expressed it. Frequently "augerin' matches" were arranged between two such men to see if they could prove their boast of never being "talked down by no damn man." A person who talked much and was a braggart was sometimes called a "flannel mouth," or was said to have a "medicine tongue." To deceive one by telling "tall tales" was said to be "loading," and a teller of such tales was a "peddler of loads." When one led or turned the talk in a certain direction, he was said to "haze the talk."

By nature and breeding the cowboy was quiet and unassuming, but the braggart, though rare, was occasionally met. Punchers had little use for the man who "got calluses from pattin' his own back," and such a person soon "bragged himself out of a place to lean against a bar."

Coin was called "hard money," and to have plenty of wealth was to "wallow in velvet," have a "roll as big as a wagon hub," or "enough money to burn a wet mule." A "short bit" was a dime. To be bankrupt was to be "between a rock and a hard place."

Though the cowboy seldom ran on foot, when the occasion did demand such action he was said to be "heatin' his axles," "makin' far-apart tracks," or "goin' like the heel-flies were after him." If his efforts in a race were successful, he was "leadin' that race like an antelope would a hog." We remember one day during calf-branding when Jim Houston was charged by a cow, whose calf he was "flanking." It taxed his utmost speed to reach the corral fence ahead of the angry cow, and one cowboy remarked that he was "runnin' like he was tryin' to keep step with a rabbit," but Jim, from his safe perch on the top rail of the fence, only grinned foolishly until

he "got enough wind in his bellows," then he good-humoredly said, "A cow with a fresh-branded calf might be a mother, but she shore ain't no lady." A high compliment to pay to either man or horse was to say that he could "run like a Nueches steer." One cowboy, in bragging on the running ability of his horse in a race he had won, said that "he passed 'em so fast they looked like they was a-backin' up."

Upon the old-time cattle range, although "vamoose" might merely be a word, "get to hell out of here" only a phrase, "git" was, under all circumstances, an ultimatum and had better be heeded. Other commands to "go" were: "lean forward an' shove," "punch the breeze," "hit the breeze," "pull yo' freight," "hit the trail," "rattle yo' hocks," "high-tail it," "drag it," "light a shuck," "amble," "brindle," "slope," or "dust." If the one spoken to left in a hurry, he was "draggin' his navel in the sand," or "foggin'," and "didn't stop for no kissin'." An animal leaving in a hurry "rolled his tail," "curled his tail," "made a nine in his tail," or "humped his tail at the shore end." A person "takin' to the tall timbers" was "pullin' his freight for the tules." Taking ordinary leave was apt to be preceded by "Well, I got to be weavin' along." "Tie yo' hats to the saddle an' let's go" was an order for a hurry-up trip. When the rangeman spoke of the act of going diagonally, or in a roundabout direction, he called it "anti-godlin." One cowboy, in describing the sudden departure of a comrade, said "he quit us like a scorpion had crawled down his neck."

MORE FIGURES OF SPEECH

When all is said, it was the man on horseback
who made the West

In looking over our notes we find a liberal collection of expressions used by the cowboy to signify his idea of a description of meanness or of someone being or looking mean. These various phrases may be heard around any campfire where booted riders gather. Among this collection we find, "as mean as gar soup thickened with tadpoles," "cross as a snappin' turtle," "looked meaner'n a new-sheared sheep," "as crooked as a snake in a cactus patch," "he's jes' as long as a snake an' drags the ground when he walks," "dirty as a flop-eared hound," "so disagreeable a shepherd dog couldn't get along with him," "poisonous as any reptile as ever made a track in the sand," "so crooked he could swaller nails an' spit out corkscrews," "looked meaner'n a centipede with the chilblains," "looked so wicked he was sure of a reserved seat in hell," or "his biography would have to be written on asbestos paper." If the one spoken of was tough-looking, it was "he's so tough he's growed horns an' is haired over," "so tough he had to sneak up on the dipper to get a drink o' water," "tougher than a basket of snakes," or was the "toughest longhorn that ever shakes his antlers in Arizona" (or any other state from which the party happened to hail). If he was exceptionally mean, he was "plumb cultus," "had snake

blood," or would "eat off the same plate with a snake," but to the cowboy the superlative degree of meanness was expressed in the phrase, "low down 'nough to carry a bucket o' sheep-dip."

To be mad was to be "ringey," "riled," "on the prod," "on the peck," "gets his bristles up," or "gets his back up." When he got into a fighting mood, he "paints hisself for war," "digs up the tomahawk," "arches his back like a mule in a hailstorm," and went "hell bent for trouble," and was liable to "crawl yo' hump" at any time. We have also heard the expressions, "sullen as a sore-headed dog," "mad 'nough to eat the devil with his horns on," "so mad he could bite hisself," "he's in a sod-pawin,' horn-tossin' mood," "swelled up like a poisoned pup," "shuts his face hard 'nough to bust his nut-crackers," and "grittin' his teeth like he could eat the sights off a six-gun," and such a person generally used his "private cuss-words when he's bilin' mad" until he "gets over his frothy spell." Wrangling and quarreling was called "whittle whanging."

Fighting furnished a good many examples of the puncher's aptness in his use of figures of speech. Around a campfire where men gather, it is a common occurrence to hear them tell of former fights they have had, and without any preliminaries we will give some of the different expressions we have heard some cowboy use at various times in recounting his own fights or those he has witnessed. One said, "He used language ag'in me that I didn't take from no one but my wife, so I combed his hair with a six-gun." Another, "I busted his talk-box an' he had to go to the dentist to get his bridle teeth fixed." Another, "I popped him between the horns an' knocked his jaw back so far he could scratch the back of his neck with his front teeth." Most all fights were preceded by preliminary threats, and of these we have heard such exam-

ples as, "I'll knock y'u so far it'll take a bloodhound a week to find y'u," "haul in yo' neck or I'll tromp yo' britches," "wash off yo' war-paint or I'll fog y'u till y'u'll look like an angel in the clouds," "pull in yo' horns, y'u don't scare nobody with bones in his spinal column," "I'll kick yo' pants up 'round yo' neck so tight they'll choke y'u to death," "I'll knock yo' ears down to where they'll do for wings," "I'll collect 'nough of yo' hide to make a saddle cover," "I'll skin y'u up till yo' folks won't know y'u from a fresh hide." We heard one puncher say, "I'll clip yo' horns, y'u got too much spread," and the other answered, "Hop to it! There ain't nobody settin' on yo' shirt-tail."

Buck Weaver, in telling of a fight of an old-timer "who'd stood up to fight 'fore he was weaned till he was as bowlegged as a hoop," said, "He'd fight a rattler an' give him first bite, an' his scars was a reg'lar war map"; and, continued Buck, "This other party had some sensitive disposition hisself an' was impulsive with a gun. That fight made an ordinary fight look like a prayer meetin'. This first old-timer was hit, too, an' when that fight was over, he's as worn an' weary as a fresh-branded calf, but he's still got strength 'nough to carve another scollop on his gun." Another, in relating of a fight he had seen, said, "He gives this other pelican such a shake his bones rattled in his skin like throwin' down an armful of wood, an' he's so skinned up he looks like the U.S. flag." Cowboys called fist-fights "dog-fights," and when one put his adversary out of commission he was said to "hang up his hide." To "clean his plow" or "sharpen his hoe" was to whip one. Such expressions as "didn't leave enough of him to snore" and "wasn't enough left of him to make a bull-fighter's flag" have often been heard around the campfire.

If the cowboy really liked you, he'd "go to the end of the

trail for you." He'll stick to you "as long as there's a button on Job's coat," "follow you right up to hell's hottest backlog," "stay with you till the hens have the toothache," or "till Sittin' Bull stands up," and "hell'll be a glacier before he'll quit you." A sticker in a fight will "fight you till hell freezes over, then skate with you on the ice." If he was hanging on to anything, he was "stickin' like a fresh-water leech" or "holdin' on like a sick kitten to a warm brick." We once heard a deputy say, after he had returned from a long, but successful, chase of a rustler, that he "hung on his trail till he got saddle sores."

The Westerner's names for whiskey were legion, so we will only mention a few of the most commonly used, such as "snake water," "tornado juice," "dynamite," "snake poison," "coffin varnish," "conversation fluid," "tonsil varnish," "bug juice," "tarantula juice," "red ink," and an endless list of others. To take a drink was to "h'ist one," or "paint yo' tonsils." He may just start in to "gather up a talkin' load," but often didn't stop until "the likker he's freightin' in his crop" made his "sights double up on him" until he is "drunk as a biled owl," "drunk as a fiddler's clerk," or "so drunk he couldn't hit the ground with his hat in three throws," and is "reelin' 'round like a pup tryin' to find a soft spot to lie down in." If he made a night of it, he was said to "stay out with the dry cattle," or got on a "high lonesome," and perhaps the next morning was "so shaky he couldn't pour a drink o' whiskey into a barrel with the head out," and "had a taste in his mouth like he'd had supper with a coyote." To have many and varied experiences was to "hear the owl hoot." "Savin' money for the bartender" was riding a freight train to save fare. If he particularly liked the bartender, he might refer to him as the "best bartender that ever waved a bar rag."

An habitual drunkard, who was always "sloshin' 'round a saloon," was said to "wear calluses on his elbows leanin' on the bar" and "couldn't quit no more'n a loser in a poker game." A hard drinker, especially one who was inclined to fight while drunk, was sometimes called a "dehorn." We once heard a puncher telling of a time he and a friend were in the city and went to a low dive "where a rattlesnake would be ashamed to meet his mother," to have, as he put it, a "couple of burnin' sensations" (two drinks), but after they'd had a "few cow swallers o' that liquid fire, they was plumb numb an' unconscious." He further stated that "with every five drinks they got one snake free." When the cowboy saw a person drinking champagne from "bottles with pretty labels an' silver-foiled bonnets on," he said of that person that "he had an educated thirst." He might describe his thirst as being "thirsty as a mud hen on a tin roof," while a saloon was often called a "water-hole" and his reference to the "sober side of the bar" is obvious.

Many gambling terms are used in a figurative way by the cowboy. Dice, faro, poker, casino, seven-up, and keno each contribute. The dicer's "at the first rattle out of the box" expresses prompt action, while poker's "a busted flush" meant plans gone awry, and poker's "jackpot" signified either a general smash-up or else a perplexing situation. Poker also contributed such terms as "bluff," "ante," "kitty," "show-down," "freeze-out," "call," "see you," and "raise," all self-evident.

Whatever idea or physical asset was expected to bring success was one's "big casino." If expectations miscarried, the disappointed person ruefully asserted that his "big casino" had been trumped.

Faro terms permit one puncher to "keep cases" on another,

and further permit this puncher, if dissatisfied with these actions, to "copper" them by initiating a diametrically opposite performance or scheme. From faro also came "getting down to cases" as an antonym for "beating about the bush."

From seven-up's "it's high, low, jack and the game" was meant the successful accomplishment of any task. Keno lent its name to the cowboy for exclamatory use when heralding the end of any act. The conquering of a horse, the throwing of a steer, anything might evoke "keno!"

When a man played a deuce spot in a card game he was said to be "layin' down his character." "Sweatin' a game" meant doing nothing but sitting around looking at a card-game. If a cowboy lost his money in a poker-game and "luck shore sit on the shirt-tail" of his opponent, the loser was apt to say, "He could outhold a warehouse," or that "he'd lost his money like he had a hole in his pocket as big as a pant's leg." When he was broke, it was said that "he'd sold his saddle." We once heard a cowboy telling about an acquaintance who had lost all his money in a game of chance, and he described it in this manner: "When he come he had a roll that'd choke a cow—one o' them rolls that needs a rubber band. When he left he didn't need the rubber an' his roll wouldn't choke a chickadee." Chips were called "ivories." To "cold-deck" was to take unfair advantage; a bluff was a "cold-blazer," and a bluffer was a "four-flusher." To cheat was to "gig," "gouge," or "deal from the bottom."

The cowboy's life was daily full of perils, and he had many close calls to death from various causes. After coming out of some such perilous situation, he has been heard to say that he had been "near 'nough to hell to smell smoke," or "when he wakes up he don't hear harps nor smell smoke," so finds out he is still in the land of the living. We heard one puncher, in

telling of another's frequent mishaps, say, "For a man who's gone through so many close shaves I don't see how he ever saved his whiskers."

In the early days tragic death was of common occurrence, and perhaps to the outsider the cowboy did not seem to have the proper reverence for the mysterious future. He referred to death as the "misty beyond," "death's got the runnin'-iron on him brandin' him for the eternal range," "he's sacked his saddle," or said that "the grass is wavin' over him." To him death meant to "buck out," "cash in," "take the big jump," "pass in his chips," "go over the range," "lay 'em down," "shake hands with Saint Peter," "take his place with the angels," be "dead as a can of corned beef," or be "dead as Santa Anna." When one met death in a prairie fire, it was "fried gent," "no breakfast forever," or "the long trail to Kingdom Come."

"Boot-Hill" was the name given the frontier cemetery because most of its early occupants died with their boots on. Other slang names were "bone yard," "bone orchard," and "Campo Santo," the Mexican name for graveyard. To bury was to "plant."

Though it was homely and crude, the old cattleman was not without his philosophy. Of the various expressions of unpolished logic we have jotted down in our gathering we quote a few: "Rilin' water makes it muddy." We heard this uttered by an older man in admonishing a younger one to cease stirring up certain trouble. "Another man's life never makes a soft pillow at night," "Never interfere with nothin' that don't bother you," "A cowboy is a man with guts an' a hoss," "There ain't much paw an' beller to a cowboy," "A wink is as good as a nod to a blind mule," "Y'u're pawin' the hackamore without knowin' what's hurtin' y'u," "Y'u never can tell which way a dill pickle is goin' to squirt," "Y'u can't always tell how far a

bull-frog'll jump by the color of his skin," "Givin' some folks likker is like tryin' to play a harp with a hammer," "Y'u never can trust women, fleas, nor tenderfoots," "A hard-boiled egg is always yeller inside," "Real bottom in a good hoss counts more than his riggin'," "Color don't count if the colt don't trot," and "When in doubt trust to yo' hoss"—advice which has saved much trouble and more than one life. The expression "measured a full sixteen hands high" was the common measurement of the Texan's specifications of the worth of a man.

With reference to the old-time cowmen we have heard such expressions as we quote below: "He'd been all over the cattle country an' could tell by the riggin' an' ridin' of a man jes' what State he was from an' almost what county he was from," "he'd forked a boss so long he straddled chairs instead of settin' like a human," or "was so bow-legged he couldn't sit in an armchair," "so bow-legged a yearlin' could run between his legs without bendin' a hair," "he's had a hoss under him so long his legs is warped," "he's a cowman from the boot-heels up," "the cow business is an open book to him an' he knows every leaf in 'er," "he wanted to go somewhere where he could spread his loop without gettin' it caught on a fence post," "he was a big cowman 'fore the nesters grabbed all the water."

Something to be avoided was "go 'round it like it was a swamp"; something fragile "wouldn't hold no more'n a cob-web would a cow"; while becoming confused or mixed up was expressed by "he got his spurs tangled up"; "buffaloed" also meant mentally confused. "I ain't got any medicine" meant the speaker was without information, while "he's taken a little more hair off the dog" meant that he had gained more experience or knowledge.

"Coyotin' 'round" was sneaking; "chuckle-headed as a prai-

rie dog" was contrary; "campin' on his trail" meant following someone; "lookin' for a dog to kick" was disgusted; "airin' his lungs" was "cussin'"; "airin' the paunch" was vomiting; "washin' out the canyon" was taking a bath; and a "good come-back" was a quick retort.

Taking a chance was "grabbin' the brandin'-iron by the hot end"; "staked to a fill" was to be given a good meal; "blow in with the tumbleweeds" was to come unexpectedly; a determined man had "hell in his neck"; to "rib up" was to persuade; "stood up" meant robbed; and "calf around" or "soaked" was the cowboy's expression for loafing, while "sweat" was to work for board without other pay.

A cowboy never spoke of carrying anything, but always "packed" it, as "packed a gun," or "packed his saddle." To him late afternoon meant in the "shank of the afternoon." "Light" meant to dismount from a horse. A "jamboree" might be anything from a dance or a drinking party to a gun-fight or a stampede. "Mix the medicine" was a phrase of Indian origin. To an Indian, "medicine" was any procedure that procured the results he desired, whether in disease, war, love, hunting, fishing, or farming. "No medicine" meant that he had no information.

There was a directness about the cowboy's mind which was very simple. A cowboy from another ranch got to the Old Spur headquarters about ten at night, and at three o'-clock in the morning the rising bell rang a few minutes before breakfast. As he left, he remarked that "a man can shore stay all night quick on this ranch." Another one, in indicating that it might take him some time to pay for something, said, "I'll give y'u so much cash an' a slow note for the balance." Bankers will appreciate how slow a "slow note" can be. Buying on credit was "on tick."

The same directness of thought entered into everything he said, whether serious or in flashes of wit. Cowboys often had to drink pretty tough water, particularly after cattle had gone through it and "riled it up." A cowboy, when asked if the water over in a certain draw was all right, replied: "It's a little thick an' y'u may have to chew it a little before y'u swallow it, but it's damn good water." A cowboy came into a train and met another puncher, whom he greeted with "Where y'u goin'?"—getting the reply, "Me? Why, I'm goin' crazy." Then like a flash, the retort, "Well, y'u won't have to camp airy a night."

A cowboy of our acquaintance whose "home was where he spread his blankets" prepared to leave our outfit because, as he put it, "snakes was so thick y'u'd have to parade 'round on stilts to keep from gettin' bit." In speaking of a nester with a large family, Tom Garver said, "He shore kept the stork flyin' an' the saw-bones made a plain trail goin' to his shack." He further stated that this nester "had 'nough offspring to start a public school." Another, in describing someone who was half Indian, said, "His folks on his mother's side wore moccasins." One cowboy, in speaking of another for whom he had no use, said, "I wouldn't speak to him if I met him in hell carryin' a lump of ice on his head."

To the cowboy something soft was "soft as a goosehair pillow"; something unsullied, "clean as a baby's leg"; untrustworthiness was "unreliable as a woman's watch"; emptiness was expressed by "empty as a church"; something unlooked for was "unexpected as a fifth ace in a poker deck"; his idea of sourness was "so sour it'd pucker a pig's mouth"; loneliness was "lonely as a preacher on pay night"; speaking of a thoughtless person might be expressed as "careless as a cow walkin' through standin' grass"; something smoothly or cleanly done was "slick

as a gun barrel"; comfort was "cozy as a toad under a cabbage leaf," while uncomfortable was "uncomfortable as a camel in the Arctic Circle." "As peaceful as a church," "as scarce as sunflowers on a Christmas tree," "as calm as a toad in the sun," "as solemn as a tenderfoot trapper skinnin' a skunk," "as worried as a bull-frog waitin' for rain in Arizona," "as scared as a rabbit in a wolf's mouth," "as dangerous as walkin' quicksand over hell," and "as slippery as calf slobbers," are all strong cowboy figures of speech which leave no doubt in the mind of the listener of their strength. "Two whoops and a holler" meant a short distance, and a bump in the road was humorously called an "excuse-me-ma'am."

Cowboys had their own unique way of speaking of another person. They seemed to weave their figures of speech into everything they said. We heard one cowboy, in referring to a lawyer of whom he did not have a high opinion, say, "He thought he was the greatest lawgiver since Moses." Another, who had long been "flounderin' in the mire o' sin," in speaking of a "sky pilot" whom he did not like, said that this preacher "had been laborin' in the Lord's vineyard for ten years an' ain't picked one grape yet." The average man in speaking of anyone creating a disturbance would say that they "raised hell," but the cowboy carried it to a higher degree and spoke of them "raisin' hell an' puttin' a chunk under it."

A peevish person was "techy as a teased snake," or, if extremely so, was "salty as Lot's wife." A gay or frolicsome person was "as chipper as a coop full o' cat-birds." One lacking in moral faculty had "no more conscience than a cow in a stampede." The cowboy's idea of a great handicap was "like cuttin' the hands off a dummy"; one who was undiscerning was said to be as "blind as a snubbin'-post"; "flat as a wet leaf" expressed his idea of superlative flatness. A cowboy never "cried

over spilled milk." We heard one express the sentiment of the class when he said, "I chew my vittles well before I swaller 'em, an' when they're down they stay. No cud-chewin' 'bout me."

We heard one puncher telling about a gun-fight in a saloon, and in speaking of the swift exit of the spectators declared that they "came pilin' out like red ants out of a burnin' log." Another, admiring the effrontery of his companion, said to the latter, "I shore gits from under my hat to yo' gall."

To further illustrate the cowboy's manner of speech we recall a story Hunk Bouden told one night as we were around the campfire, "down on our hunkers takin' comfort." Hunk "unloaded his jowls of spit or drown tobaccer" and proceeded to tell us of an old-timer who "was as wrinkled as a burnt boot" and was "foaled back in the hills so far the hoot owls roosted with the chickens." "This old catawampus comes rackin' to town," said Hunk, "an' orates as how he's got more troubles than a rat-tailed hoss tied short in fly-time. He proceeds to guzzle snake pizen an' hell 'round town until he's knockin' about like a blind dog in a meat shop. He tries to make it appear he's as tough as tripe an' lets out a yell that'd drive a wolf to suicide. He's standin' on the high gallery of the Silver Spur Saloon when the city marshal swoops down on 'im like forty hen-hawks on a settin' quail, and he pronto gets as harmless as a pet rabbit. He starts to bowin' an' bendin' to the law like a pig over a nut, but he loses his balance an' falls down the steps, boundin' 'long like a barrel downhill. When he hits bottom, he begins feelin' over his carcass for broken bones, an' when he don't find none, he heaves such a sigh y'u could feel the draft, but he's considerable sobered. I never laughed so much since I wore three-cornered pants."

One puncher, in telling of his good friend, the sheriff,

characterized him as, "His business was to discourage hoss thieves an' cattle rustlers. When Nature built him, she throwed off on the job for looks an' his legs looked like a wishbone, but gold was plain dirt alongside o' him." Another, in describing the stubbornness of an acquaintance, said he was "so obstinate he wouldn't move for a prairie fire." This same puncher, in speaking of the astonishment of a friend over a certain incident, said he was as "surprised as a dog with his first porcupine." Another, upon noting an old trapper puffing energetically upon his pipe, remarked that he was "makin' more smoke than a wet-wood fire."

Further to illustrate the cowboy's natural ability to paint word pictures we quote Charlie Russell, in one of his letters to a friend: "Charley Cugar quit punchin' and went into the cow business for himself. His start was a couple of cows and a work bull. Each cow had from six to eight calves a year. People didn't say much till the bull got to havin' calves, and then they made it so disagreeable that Charley quit the business and is now makin' hair bridles. They say he hasn't changed much, but wears his hair very short and dresses awfully loud." In another typical letter Mr. Russell writes: "Pat Riley was killed while sleepin' off a drunk at Grass Range. Pat took a booze joint and, after smokin' the place up and runnin' everybody out till it looked like it was for rent, fell asleep. The booze boss gets a gun and comes back and catches Pat slumberin'. Pat never woke up, but quit snorin'."

The cowboy's intimate conversation was itself distinctive. Pithy, terse sentences were expected of him; in a lively group the conversation sometimes sparkled with a quick, slangy wit. Such original combinations as we have cited won for some Westerners a pleasant notoriety.

Writers have for many years been telling us about the

"passing of the cowboy." True, his field of activity has been more and more cramped, but we still have him with us. The wire fence has changed many of his methods; the advance of civilization has changed much of his picturesque style in dress and accouterment, but his language has been bred in him. The present-day cowboy speaks the same language as his earlier brother and he will cling to this lingo as long as men handle cattle. It fits his calling and is his "mother tongue." It is a part of him, a part which modern civilization has been unable to despoil.

THE END

INDEX

Black as a black cat's overcoat, 215

Blanket, split the, 35; wet, 154

Blue lightnin', 162

Blue whistler, 164

Bog-camp, 23

Boggy top, 145

Boiled over, 96

Boneheads, boneheads, take it away, 147

Bone-pickers, 199

Bone-seasoned, 26

Bonnet-strings, 33

Booger F, 125

Book, beef, 127; prayer, 204; wish, 204

Boot-Hill, 229

Boots were so frazzled he couldn't strike a match on 'em without burnin' his feet, 36

Bosal, 48

Boss, buggy, 21; range, 21; straw, 21, 133; trail, 133

Botching, 154

Bottom, deal from the, 228

Bow-legged, so, a yearlin' could run between his legs without bendin' a hair, 230; was so, he couldn't sit in an armchair, 230

Bows, ox, 44

Boxed E, 120

Bradded Dash, 121

Bradded L, 121

Bragged himself out of a place to lean against a bar, 218

Brain cavity wouldn't make a drinkin' cup for a canary bird, 210

Brain tablet, 204

Brand, barbed, 126; bench, 120; Bob, 123; Bosal, 125; boxed, 120; bradded, 121; county, 118; Currycomb, 125; Diamond and a Half, 122; Diamond Dot, 122; Dotted Diamond, 122; drag, 120; Fiddle-Back, 127; flying, 120; forked, 120; Four J, 123; hair, 127; lazy, 120; LX, 123; Monogram, 123; Nine K, 123; open, 120;

Paddle, 125; picked, 127; Pup, 123; rafter, 120; road, 118; rocking, 120; running, 121; set, 119; Seven-up, 123; Seventy-Six, 123; slow, 155; stamp, 119; swinging, 121; tumbling, 121; Twenty-Four, 123; vent, 117; walking, 121

Brand-artist, 154

Brand-blotcher, 154

Brand-blotter, 154

Brand-burner, 154

Branding-chute, 14

Brandin'-iron, kept his, smooth, 154; careless with his, 154; grabbin' the, by the hot end, 231

Brasada, 199

Breachy, 72

Bread, gun-waddin', 144

Bridle, 46; war, 48

Broke in two, 96

Bronc, 79; oily, 84; salty, 84; snappin', 102

Bronc-breaker, 95

Bronc-buster, 95

Bronc-peeler, 95

Bronc-scratcher, 95

Bronc-snapper, 95

Bronc-squeezer, 95

Bronc-twister, 95

Broomies, 80

Broom-tails, 80

Brush-buster, 23

Brush-hand, 23

Brush-popper, 23

Brush-splitters, 66

Brush-thumper, 23

Brush-whacker, 23

Buck his whiskers off, 101

Buck nun, 196

Buck out, 229

Buckaroo, 22

Buckayro, 22

Bucker, 97; blind, 97; pioneer, 96; show, 97

Bucket-man, 22

Buckhara, 22

Bucking, on a dime, 96; pump-handle, 97; straight away, 96

Bueno, 68

Buffalo, 204

Bug on a Rail, 121

Bug Wagon, 125

Built like a snake on stilts, 212

Bull nurses, 22

Bull-bat, 95

Bulldogging, 102

Bulldogs, 44

Bullet goin' past, leaned ag'in a, 167

Bull's mansh, 14

Bull-tailing, 67

Bull-whacker, 197

Bum, range, 27

Bushwack, 167

Bust 'er wide open, 94

Buster, 27; contract, 95

Butter, Texas, 144

Butterfly, 62

Button, 25

Caballado, 78

Caballo, 83

Cactus-boomers, 66

Calf, acorn, 70

Calf-wagon, 136

California, the, 59

Calluses, wear, on his elbows leanin' on the bar, 227

Calm as a toad in the sun, 233

Came apart, 96

Campo Santo, 229

Camps, line, 15; sign, 15

Can, squirrel, 147

Can-openers, 34

Cantinesses, 45

Cantle, 32

Canyon, blind, 199; box, 199; washin' out the, 231

Caporal, 21

Capper, 197

Cart, groanin', 143

Cartridges, unravel some, 166

Casino, big, 227

Cat-back, 97

Cattaloe, 73

Cattle, can't hook, 70; grubs, 72; hospital, 71; open-faced, 73; poverty, 70; running, 107; to mustard the, 72

Caught short, 166

Cayuse, 79

Cedar-breakers, 71

Chance, as much as a wax cat in hell, 210

Chaparral, 199

Chaparro, 199

Character, layin' down his, 228

Charlie Taylor, 144

"Chase That Rabbit," 187

Cheaper to grow skin than to buy it, 36

Cheekin', 94

Chew it finer, 215

Chicken, chuck-wagon, 144; fried, 144; pulling the, 202

Chigaderos, 32

Chihuahuas, 34

Chinkaderos, 32

Chinook, 201

Chipper as a coop full o' cat-birds, 233

Chuck, 143

Chuck-eater, 26

Chuck-wagon, 143

Chuckle-headed as a prairie dog, 230

Churn-heads, 80

Churn-twister, 195

Chutes, 55

Cimmarron, 73

Cinch, front, 43; hind, 43; rear, 43

Cinch 'er when she bucks, 94

Cinch-binder, 97

Cinch-ring, 154

Circle, riding, 109

Claim-jumper, 195

Clean as a baby's leg, 232

Clean straw, 36

Clear-footed, 85

Memory's pulled its picket-pin an'
 gone astray, 211
Merry-go-round, 61; in high water,
 134
Mess-house, 14
Mesteno, 83
Mexican iron, 203
Mexico, the map of, 125
Miller, 23
Milling, 134
Mill-rider, 23
Moccasins, California, 33; sunned his,
 100
Mochiler, 45
Mocho, 70
Mockey, 79
Money, lost his, like he had a hole in
 his pocket as big as a pant's leg,
 228
Montura, 45
Moonshine, 145
Moonshinin', 111
Moros, 86
Morral, 46
Moss-back, 66
Motte, 200
Mount, flying, 102; pony express, 102;
 running, 102
Mouth, flannel, 218; just run off at
 the, to hear his head rattle, 4
Mover, 195
Muggin', 127
Mulero, 198
Mule-skinner, 198
Muley, 45
Mustang, 78
Mustanger, 198

Navvy, 84
Neck, played cat's cradle with 'is, 157;
 hell in his, 231
Necking, 66
Necktie, 125
Nest, boar's, 16
Nester, 195

New Moon, 123
Night-hawks, 25
Night-mare, 83
Noise, like hell emigratin' on cart
 wheels, 216; makin' more, than a
 jackass in a tin barn, 217
Nose, monkey, 44
Nose-bag, 14
Nubbin', 42; grabbin' the, 100
Nurses, bull, 22

Obstinate, so, he wouldn't move for a
 prairie fire, 235
Occasion, corpse an' cartridge, 167
Ocean wave, 189
Oklahoma rain, 201
Open A, 120
Open Diamond O, 122
Open-range, 11
Orchard, bone, 229
Orejana, 68
Outfit, 13; greasy-sack, 16; one-hoss,
 16; pot-rack, 16
Over half-crop, 128
Over-bit, 128
Over-hack, 129
Over-round, 129
Over-slope, 129
Over-split, 129

Pack-covers, 34
Packed, iron so long he felt naked
 when he took it off, 166; 'nough
 hardware to give him kidney
 sores, 166
Paddled, 85
Pads, kidney, 45
Pan, round, 147; wreck, 147
Pants, California, 32; hair, 32
Paper-backed, 212
Parfleche, 35
Parfleshes, 35
Parkers, 34
Parrot-bill, 162
Pasear, 204

Strayman, 23
Strays, 71
String, 77; horn, 45; jerk-line, 197; rough, 84; saddle, 45
Stripper, 197
Strippers, 66
Strong 'nough to float a wedge, 149; so, it would kick up in the middle an' carry double, 149
Struttin' like a turkey gobbler at layin' time, 35
Stump-sucker, 85
Sudadero, 42
Suggans, 34
Sunfishing, 96
Sunpecked jay, 195
Supper, Spanish, 149
Swallow-an'-git-out trough, 14
Swallow-fork, 129
Swallow-forkin', 35
Swamper, 146
Swapped his bed for a lantern, 25
Swapping ends, 96
Sway-backed, 85
Sweat, 231
Sweatin' a game, 228
Sweetenin', long, 144
Swelled up, like a carbuncle, 209; till he busted a surcingle, 209
Swim the river with, he'd do to, 138
Swing a wide loop, 154
Swinging J, 121

T Anchor, 121
T Bar O, 119
Tad Pole, 126
Tail, curled his, 219; humped his, at the shore end, 219; made a nine in his, 219; rolled his, 134, 219; wring, 85
Tailbone Rafter, 125
Tailing, 67
Talk a cow out of her calf, 217
Talk-box, keep a plug in yo', 217
Talkin'-iron, 162

Tallow, factory, 73; shore had, 211
Tally branding, 127
Tanking, 73
Tanks, 13
Tapaderos, 44
Tarpaulin, 34
Taste in his mouth like he'd had supper with a coyote, 226
Techy as a teased snake, 233
Teeth, grittin' his, like he could eat the sights off a six-gun, 224
Teguas, 36
Telegraph, grapevine, 17, 181
Telegraph him home, 158
Tellin' a windy, 217
Tenderfoots, 26
Terrapin, 124
Texas, the, 161
Theodore, 48
Thick, as cloves on a Christmas ham, 213; as seven men on a cot, 213
Thicker'n splatter, 213
Thinker is puny, 210
Thirsty as a mud hen on a tin roof, 227
Throw-back, 97
Thumb-buster, 162
Thumbing, 102
Tick, on, 231
Tickle 'er feet, 94
Tinhorn, 197
Tongue, medicine, 218
Tongue oil, plenty of, 217
Tonsil varnish, 226
Tonsils, paint yo', 226
Took to each other like a sick kitten to a warm brick, 212
Tool chest, 47
Top screw, 21
Topping off, 100
Tougher than a basket of snakes, 223
Track, an elephant in three feet of fresh snow, 25; a wagon through a bog-hole, 25; bees in a blizzard, 25
Tracks, didn't leave enough, to trip an ant, 24

Trail, cold, 24; plain, 25
Trail-broke, 138
Trail-cutter, 136
Trains, grass, 198
Tramp, saddle, 27
Tree, 42; Ellenburg, 45; skeleton
 bronc, 45
Tree L, 125
Triangle D, 119
Trigueno, 86
Trough, swallow-an'-git-out, 14
Tumbleweed, 200; blow in with the,
 231
Tumbling K, 121
Turkey Track, 126
Turn, on a biscuit and never cut the
 crust, 81; on a button and never
 scratch it, 81; on a quarter and give
 you back fifteen cents in change,
 81
Twister, 48
Twitch, 48
Two-Pole Pumpkin, 124

Uncorkin', 100
Under half-crop, 128
Under-bit, 128
Under-hack, 129
Under-round, 129
Under-slope, 129
Under-split, 129
Underwears, 196
Unexpected as a fifth ace in a poker
 deck, 232
Unreliable as a woman's watch, 232
Unroostering, 100
Unwound, 96
Upper half-crop, 128
Useless as a twenty-two cartridge in
 an eight-gauge shotgun, 210

Velvet, wallow in, 218
Voucher, 203
Vuelting, 60; dale, 60

W, 55
Waddie, 22
Waddy, 154
Wagon, hoodlum, 25; which way's
 the, 143
Wagon-sheets, 34
Wahee, 73
Wake up, snakes, an' bite a biscuit, 147
Walked like a man with a new suit of
 wooden underwear, 35
Walkin'-beamin', 97
Walking down, 88
Walking R, 121
Walkin'-sticks, 84
Wallop, 124
Waltz with the lady, 94
War-bag, 35
Warbles, 72
War-bonnet, 33
War-paint, full, 35
War-sack, 35
Wasp-nests, 144
Water, it's a little thick an' y'u may
 have to chew it a little before y'u
 swallow it, but it's damn good, 232
Water, snake, 226
Water-hole, 227
Water-rights, 12
Wattle, 130
Wave him 'round, 157
Wave, ocean, 61
Weaners, butter-board, 72; spike, 72
Weaver, 96
Weavin' along, I got to be, 219
Welcome, as a pole-cat at a picnic,
 209; as a rattler in a dog town, 208
Went to hell on a shutter, 167
Wet, blanket, 154; Moon, 123; 'nough
 to bog a snipe, 216
Whangdoodle, 124
Wheel chair, couldn't ride nuthin'
 wilder than a, 102
Whey-bellied, 85
Whistle, can't, 196

Whistles on it with his breath, 208
White faces, 73
Whittle whanging, 224
Willow-tails, 79
Wind, hell, 201
Wind-bellied, 85
Wind-belly, 70
Windies, 71
Windmiller, 23
Windmilling, 97
Window Sash, 125
Wings, bat, 32; buzzard, 32
Wipes, 36
Wisdom-bringers, 197
Wise as a tree full of owls, 210
Wolves, 72
Woman, catalogue, 197; Heart and
 Hand, 197; Montgomery Ward,
 sent West on approval, 197
Wood, squaw, 146

Wool, prairie, 203
Woolies, 32
Wooshers, 200
Worchestershire, 162
Wore 'em low, 163
Workin' over, 100
Worried as a bull-frog waitin' for rain
 in Arizona, 233
Wrangatang, 25
Wrinkle-horn, 66
Wrinkles, gotten more on his horns,
 210

Y Bench, 120
Yard, bone, 229
Yearling, 65; bull, 65; long, 65
Yellow streak down his back so wide
 that it wrapped plumb around to
 his brisket bone, 209
Yokes, ox, 44

Ramon F. Adams (1889–1976) was a cowboy, musician, and folklorist and the author of numerous books on Western Americana, including *Six Guns and Saddle Leather*, *A Fitting Death for Billy the Kid*, and *The Adams One-Fifty*, among other works. He was a member of the Texas Institute of Letters, the Western History Association, and Southwest Writers and received an honorary doctorate from Austin College in 1976, the year of his death. A lifelong student and chronicler of the West, Ramon Adams is remembered for his colorful, careful depictions of the American cowboy, his lifestyle, his work, and most notably his speech.

Elmer Kelton is the best-selling author of more than forty westerns. His works include *The Time It Never Rained*, *The Day the Cowboys Quit*, and *The Good Old Boys*, which was made into a movie directed by Tommy Lee Jones. Kelton graduated from the University of Texas with a degree in journalism. He was a writer and editor for the *San Angelo Standard Times* for fifteen years, the editor of *Sheep & Goat Raiser* magazine for five years, and an associate editor of *Livestock Weekly* until his retirement.

Nick Eggenhofer (1897–1985) was born in Bavaria and came to the United States in 1913 at the age of sixteen. Thereafter he became a student of the West and a well-known illustrator of Western life.